POWER CHORD

ONE MAN'S EAR-SPLITTING QUEST TO FIND HIS GUITAR HEROES

THOMAS SCOTT McKENZIE

*it***books**

AN IMPRINT OF HARPERCOLLINS PUBLISHERS

To protect the privacy of the people in this book who aren't famous rockers, the names and identifying details of a small number of individuals have been changed, and there is a composite character.

HarperCollins books may be purchased for educational, business, or sales promotional use. For information please write: Special Markets Department, HarperCollins Publishers, 10 East 53rd Street, New York, NY 10022.

All photographs courtesy of the author unless otherwise noted.

FIRST EDITION

Designed by Renato Stanisic

Library of Congress Cataloging-in-Publication Data

ISBN 978-0-06-196496-1

12 13 14 15 16 OV/RRD 10 9 8 7 6 5 4 3 2 1

FOR MOM AND DAD,
*who bravely didn't try to protect my young
eardrums and generously gave untold thousands of hours to
listening to me blabber about music.*

AND FOR MY AUNT CECIA,
*who provided the little red eight-track player and
encouragement that fueled many of these dreams.*

CONTENTS

PROLOGUE IX

1

THE HARDEST WORKING SLACKER
IN THE WORLD 1

2

FIRST SIGHTING 21

3

MUSICAL DEBATES AND THE SAVING
GRACE OF VIDEO GAMES 37

4

A ROCKING TOUR OF EVANSVILLE
GUITAR STORES 53

5

THE GUITAR HERO CONSTELLATION
AND PLANS FOR A PILGRIMAGE 75

6

A MIDWESTERN METAL ESCAPE 87

7

HITTING THE ROAD 103

8

A SOGGY COUNTY FAIR 109

9

GUNS, BLADES, A MECHANICAL BULL,
AND SOME USEFUL CHORD TIPS 117

10

A PHONE CALL FROM SPACE 133

11

PLAY FROM THE HEART 147

12

THE VIRTUOSO 165

13

GUITAR HERO CALLING 181

14

BLOOD, SWEAT, AND STRATS 197

15

GRANDPA SEX, RINGER TAMBOURINE
PLAYERS, AND ROCKING THE WHISKY 213

16

THE MAN WITH THE POINTY GUITAR 239

17

BENDING BEHIND THE NUT 251

18

THE VIEW FROM THE KISS STAGE 261

19

STAGE FRIGHT 273

20

GOING KAMIKAZE 291

EPILOGUE 305
ACKNOWLEDGMENTS 307

PROLOGUE

My band, Riot in the Temple, waited in a restricted area overlooking the stage at the storied Whisky a Go Go in Los Angeles, the same club that was rocked by everyone from the Doors to Van Halen to Guns N' Roses. Some people dream of visiting Yankee Stadium or Wrigley Field. When I was a child, I longed to see the Whisky.

But now that I was in that hallowed hall of heavy metal, I desperately wanted to sleep. Sweaty palms, racing heartbeat, and the other stereotypical symptoms of stage fright never trouble me. Instead, an immense wall of exhaustion crashes down. I don't want to face the challenge; I just want to nap through it. I gripped my Telecaster as hard as possible, digging my fingertips into the strings, imagining them as cheese slicers cutting through the flesh of my fingers, trying to distract myself by focusing on the pain.

My bandmates had traveled from the Bay Area, New Mexico, and New York for this gig. I had come in from Columbus, Ohio, but my journey to the stage was far from a direct flight. Rather, it was the culmination of a strange quest that had taken me to rural campsites, dive bars, yoga communes,

county fairs, and other bizarre locations in search of famous guitar heroes and forgotten legends.

Rudy Sarzo, a bass player who had rocked with Ozzy Osbourne, Quiet Riot, Whitesnake, and Dio, stood next to me in the wings and readied my bandmates to take the stage. He gave last-minute advice—watch for changes, stay on the beat—and told the two drummers to watch for his cue.

My emotions swung from pride to embarrassment. I had reached a milestone of sorts by playing this famous rock club. But at the same time, it was a stretch to claim I would actually be *playing* since my skills were fairly limited.

Somewhere in the building was Ace Frehley, the original guitarist for KISS, whose riffs and solos were the soundtrack of my childhood. As a kid, I didn't have a security blanket or beloved toy that kept me safe. Instead, I had posters of Frehley on the wall to protect me from the bogeyman. I imagined those posters would come to life and the Spaceman would shoot lasers out of his guitar at any threatening creature. When trouble came walking, he'd keep me safe.

And now, thirty years later, Frehley was going to play "Rip It Out" from his 1978 solo record with us. During rehearsal earlier in the day, I was wedged between Frehley and the wall. He was a much bigger man than you might expect, but I could lean around his shoulder and catch a glimpse of his blue-painted fingernails flashing across the fret board.

I had devoted years to hunting down and meeting my guitar heroes. And now I was about to play on the stage that had showcased so many of them. There was a Mötley Crüe banner hanging over one of the bars, a relic from when the Whisky welcomed their prodigal sons home. Photos of Eddie Van Halen hung over the booths.

Guitar heroes command the stage and the audience. They exude total mastery of their instrument and their environment. I was doing the exact opposite.

The guitar tech looked confused when I told him about my intention to move the dial on my guitar in the *opposite* direction than normal. Instead of going to 11, I wanted to go into the negative numerical range.

"Really?" he asked. "You sure?"

"Yeah, it's not a mistake. It's on purpose. Don't try to fix it."

He had probably fielded countless strange requests over the years from rockers. His face remained blank. Don't argue with the talent.

Sarzo gave us the thumbs up and my bandmates started filing down the stairs that led to the stage as the audience applauded. I caught the guitar tech's eye and nodded. He clapped me on the back and said, "Don't fix it. Got it."

And then we were onstage at one of the most legendary rock venues in the world. It was an incredible accomplishment for a country kid from a small town in Kentucky. This was the culmination of years, decades even, of fandom and obsession, and now I was about to live my dream. Physically, it might not be the perfect representation of my childhood visions, but in my head it was certainly equal. And just getting to this point, simply going through with the whole enterprise, was a huge accomplishment.

As I hit the stage, the lethargy evaporated and I fingered my silent guitar, waiting for the guys to pick up the beat and lead us into rock and roll.

I was about to play the Whisky with a guitar that no one could hear.

But for a brief instant, in a way, in my mind, I was a guitar hero. That was good enough for me.

1

THE HARDEST WORKING
SLACKER IN THE WORLD

I t wasn't easy for a seven-year-old boy to procure radioactive material in Bourbon County, Kentucky, during the seventies. So after careful consideration and much research, I decided to get struck by lightning.

On a muggy summer evening, as heat lightning fried through ominous purple clouds, I eased the screen door shut and started toward the back of our horse farm. Near the rear property line of our fifty-acre farm, a dead tree stood alone on a barren hill, normally a perfect setting for saving imaginary compatriots from an evil overlord's noose. But that evening, instead of pulling off a daring rescue, I would use what I called the Tree of Sorrow to offer myself up to thunderbolts from the heavens.

In preparation for this experiment, I had loaded a Boy Scouts canteen, a cherry Pop-Tart, a tattered spiral notebook with a red cover, my metal orthodontic headgear, and a guitar pick in my backpack. The canteen and snack were a nod to sword-and-sorcery novels, where the hero packed for long quests

accordingly. I didn't have mutton, mead, or ale, so tap water and foil-wrapped goodies would suffice.

The notebook was falling apart from use, the wire spiral distended and unevenly spaced. I had used a ruler and multiple colored pencils to rigorously document scientific examples of origin stories in which ordinary dudes transformed into larger-than-life figures, capable of unimaginable feats.

Astronaut Steve Austin crashed to Earth before being made better, faster, stronger. Billy Batson was selected by a race of wise elders who taught him to bellow "Shazam!" when trouble approached. The comic-book villain Juggernaut snatched a magic ruby from a cave while Molten Man spilled synthetic liquid metal all over himself. Even my heroes, the band KISS, who consumed my most every waking moment, were powered by pulsating red talismans, as they explained in the 1979 TV movie *Attack of the Phantoms* when Peter Criss says, "Without those, we're just ordinary human beings."

The majority of the transformations in my notebook involved exposure to radioactivity. Even casual pop culture observers knew about Peter Parker's glowing spider or the Hulk's laboratory gamma rays. But I was an exhaustive researcher, so my ledger also included lesser-known fictional folks like a misshapen four-foot-six-inch Soviet evildoer named the Gremlin and a Chinese Communist physicist creatively named Radioactive Man.

Consoling adults had assured us Central Kentucky schoolchildren that we were a long way away from the Three Mile Island catastrophe, so I deduced it would be challenging to obtain radioactive waste.

But electricity seemed equally dangerous and intriguing as radiation. And there were more than just one or two examples

of lightning-induced transformations in comic-book lore, most notably the green-and-yellow-clad baddie Electro who had been a simple power-company lineman working during a thunderstorm when a shock provided the ability to shape electricity into lashes, whips, and other forms of weaponry.

Even my *KISS Alive II* eight-track featured an ode to the effects of high voltage, with the Ace Frehley–penned tune "Shock Me," written after the guitar player was electrocuted onstage in Lakeland, Florida.

I had thrown in the headgear because wisecracking adults were always asking if I could pick up radio waves while wearing the metal device, so maybe it could help attract a jolt or two. I considered myself lucky that I had the cooler style that wrapped around the back of the neck, as opposed to the far geekier apparatus that rested on the top of your skull like some Erector Set geek's attempt at designing a yarmulke.

The final component of my backpack, a tortoiseshell guitar pick, was the whole reason I had embarked on this adventure.

My parents were supportive and they encouraged any of my goals or interests, but even at that young age, I knew I wasn't truly remarkable. I was a good student, but I didn't get straight As because my teachers said I needed to apply myself more. And while I was never the last person selected for kickball, I wasn't the first either. I had friends, but I wasn't the most popular. On some level, I understood that I was good—very good at some subjects, maybe—but not great. I was looking at a life of mediocre accomplishment, of restrained success: the honor roll, but not the valedictorian slot.

Those limitations were made painfully obvious every time I picked up my cheap acoustic guitar and struggled to get anything resembling music out of the instrument. In my small

town, the only place that offered lessons was a Catholic school. Once a week, I had to show a school bus driver a permission slip to let me take a different route. He chewed tobacco and spit into a milk carton lifted from the school cafeteria each day. He dropped me off outside the facility, which was really just a large brick house, and I lugged the cumbersome guitar case up the stairs.

At the very first lesson, I was dismayed to learn that the nuns would not instruct us in the fine art and subtlety of KISS tunes. Instead, I got a stack of sheet music for "He's Got the Whole World in His Hands" and "They'll Know We Are Christians." Somewhere along the line, I missed the detail that every string isn't involved in every chord. In spite of how it might look when Pete Townshend wildly windmills his arms while playing guitar, you don't actually strum every string. For example, a D chord only uses four of the six strings, a C chord five. But when I practiced as a child, I hit every stinking one, the musical equivalent of coloring outside the lines. So nothing sounded right. And somehow, the concept of practicing for hours on end in order to improve escaped me. As a child I was an avid watcher of the news programs like *20/20*, and I saw these six-year-old Asian violin prodigies who performed with the Boston Pops. How much sweat could those kids actually have devoted to their craft if they'd only been out of diapers a few years? I was willing to work, but only to a point. After that, I figured some innate natural talent would take over.

Or, I would suffer some catastrophic accident that would give me superpowers.

The wind picked up and clouds rolled overhead as I set my backpack down at the base of the Tree of Sorrow. Abandoned green army men were scattered among the roots, casualties of

attempts to scale some sheer cliff in a forgotten battle between my older brother and me. Lightning illuminated the sky and sent groups of broodmares running with each thunderclap. Generally the sound of pounding hooves in the darkness terrified me because of an unhealthy preoccupation with Disney's *The Legend of Sleepy Hollow* cartoon, something that continues to this day as I have recurring dreams involving the haunted Hessian even as an adult. But on that evening I wasn't scared. I was excited about the changes I would experience.

I assumed there would be some amount of pain involved. The *Encyclopedia Britannica*, which consumed an entire two-shelf bookcase in our hallway, indicated that possibly a million volts of electricity could be contained in a single bolt of lightning. I figured my clothes would get ripped and singed, so Mom wouldn't be happy about that. But I would have powers unimaginable. I would be able to blister up and down the guitar neck and belt out KISS tunes at my next guitar lesson. Soon I would be musically invincible!

But it didn't happen.

The anticlimactic truth is that I ate the Pop-Tart, gulped down some metallic-tasting water from the canteen, watched the clouds for a few minutes, and walked home. I could have climbed the tree and gotten higher in an effort to attract a lightning strike. I could have taken metal poles from the barn and fashioned a lightning rod. Or, I could have been at home practicing the guitar. But I did none of those things. I just quit after a few minutes of boredom.

As I trudged to the house, I knew that most kids wouldn't have gone to such lengths as I had that evening. Many of my friends were happy with the most simplistic of imaginary pursuits. They just played war, while I drew up extensive maps for

my campaigns. They wrapped sheets around their necks and pretended to be superheroes, but I could have told you the color of my fantasy hero's shoelaces. I was proud of my planning and execution of the audacious adventure to get electrocuted, even if it didn't bring about the desired results. Some part of me also knew that other children—probably those Asian violin prodigies—would simply have put in a few more hours of practicing instead of concocting elaborate plans that involved electrocution. But I pushed those thoughts aside as I climbed into bed and went to sleep.

The next morning I told my parents that I didn't want to take guitar lessons anymore.

FOILED IN MY efforts to generate a superhuman metamorphosis, I turned my daydreams to obtaining a magical instrument that would transform me into the world's greatest guitar player. Like Arthur pulling the sword from the stone or a Tolkien furry-footed fuddy-duddy discovering the Rings of Power, I thought that the right instrument would unleash my inner guitar hero. But the media messed up my plan.

A reporter from the local paper came to our class, took snapshots of each student, and inquired about the one thing we most wanted for Christmas. My response was easy: an electric guitar. I was apprehensive about my picture appearing in the paper since the headgear and other orthodontic humiliations had not visibly affected the pronounced overbite that made me look like a corn-fed version of Bugs Bunny. It was so bad I couldn't effectively eat the sandwiches my mom made. My front teeth wouldn't come together to cut the bologna, so I pulled at my food, which invariably left a slice

of lunch meat dangling from my mouth, slapping my chin, throwing mustard everywhere.

But the photo was a small price to pay for making my Christmas wishes known. I was on the fence about Santa Claus, beginning to doubt the old man's existence, but not willing to destroy any North Pole connections by openly refuting him either. I figured my request in the paper would let Santa, my parents, my grandparents, and assorted relatives know in clear and uncertain terms what I wanted for Christmas. Or maybe a childless wealthy couple might read the article and reach out to make my dreams come true, a precocious Pip depending on the kindness of strangers. Maybe a copy of the *Bourbon County Citizen* would end up at KISS headquarters, and my heroes would sense my innate desire to rock and roll all night and party every day, and they would send me a guitar equipped with smoke bombs and lasers. The band had famously made an appearance at a small high school in Michigan to inspire the football team, so what was stopping them from swinging down to Millersburg Elementary?

But when the newspaper came out, my request was mistakenly attributed to a red-haired kid named Tommy Coates. Under my name and bucktoothed photo was his statement about wanting a BB gun, which forced me to endure years of Christmas jokes about shooting my eye out as opposed to the adulation and accolades of guitar fans across the planet.

TODAY, I KNOW everything there is to know about guitars.

Except how to play them.

Over the years I've compiled a fairly respectable collection of eleven guitars—at least for someone who isn't a rich dotcommer trying to affect a rocker vibe or a fat-cat baby boomer

dropping three hundred grand on a '59 sunburst Les Paul for investment purposes. Scattered among several Epiphones and Squires and PRS SEs (entry-level gear mass-produced in Far East factories) are a few guitars worth pondering if the house catches on fire.

There's the 2008 Fender Classic Series '72 Telecaster Custom, black with a black pick guard and a maple neck. If the years seem confusing, that's because guitar manufacturers base a huge segment of their business on re-creating instruments from the past. Gibson, for example, trots out reissues and tosses around years like wine snobs discuss vintages. They sell a Les Paul Studio 50s Tribute, the 50th Anniversary 1960 Les Paul Standard, the 1955 Les Paul Custom Exclusive, the 1958 Les Paul Plaintop Reissue VOS, and on and on and on. Imagine strolling into your local car dealer and being able to purchase a '57 Chevy or a '67 Lincoln that was actually produced by contemporary equipment in contemporary factories only a few months earlier.

Then there's the 2007 B.C. Rich Bich Exotic with a spalted maple top and two ebony strips down the middle of the body. I've also got a black 2003 B.C. Rich Warlock. The manufacturer is known for radically angular and pointy guitar shapes, and the Warlock, in particular, looks more like something you would brandish in battle instead of a fan-packed arena.

Doubling as a Halloween prop for a space invader costume, my 1984 Roland GR-707 guitar synthesizer features a weird graphite stabilizer bar above the neck that makes it look like Marvin the Martian's ray gun. Some critics referred to the bar as a "coat hanger." Usually seen in pop videos of the day, this guitar could—in theory—produce a huge variety of tones and sounds, just as keyboards were doing at the time. But the

technology proved to be too cumbersome and guitar synthe-
sizers didn't gain widespread acceptance.

The prizes of my collection were a late nineties ESP George
Lynch Kamikaze with a red, black, and yellow paint job and a
2010 Charvel Warren DeMartini with a white skull and red
blood drips over a black body. Both instruments are based on
custom gear that my high school idols played in rock videos
that were in constant rotation.

Visitors always commented on my collection. A bit obses-
sive about my instruments, I kept them dusted, polished, and
prominently displayed.

"You must be a helluva guitarist," the handyman remarked.

At that time, I lived in a Baltimore duckpin bowling alley
that had been converted into a loft, and my guitars were dis-
played on a second-floor mezzanine. His name was Carl and
he was going bald on top, but had long hair down his back.
Ben Franklin meets hippie. A droopy handlebar mustache
like Floyd's on *The Muppet Show* completed his look. I saw the
bushy mustache move as he licked his lips while staring up at
the guitars.

"No, actually I don't play. Just accumulate," I responded.

"Come on, man. You're just being modest. The rockin' dudes
always act like they don't know what they're doing. We just
talked about Ace's pentatonic scales. How can you know that?"

"No. Really. I can't play. I just know a lot about it. I also
understand how a helicopter works, but that doesn't mean you
want me with my foot on the pedals and a hand on the joystick."

He didn't believe me and looked to my wife, Lara, for
confirmation.

"It's true," she confirmed. "He can't play a note. He's more
of a professional appreciator."

Carl's e-mail address contained the name of his favorite member of KISS. He and I got along perfectly—except that Carl could actually play the instruments. He picked up a black Les Paul, jammed a few bars of "Strutter," and smiled at me.

"It's easy. You should try it," he said.

At that time, I didn't see anything unusual with guitar obsession being a purely intellectual pursuit. People can collect and appreciate art without being expected to throw on a smock and grab an easel. Fantasy football geeks know every stat about yards per carry and yards after the catch but no one tells them to put on a helmet. A gearhead friend named Jake discusses understeer, oversteer, F1 telemetry, and the stitching on a Bugatti Veyron for hours and hours but he has never raced around a track. Instead he drives a Toyota Camry every day. What was so unusual about being a guitar expert who didn't play? At least, that's what I thought.

WHEN I WAS in first grade, on March 5, 1977, KISS played Rupp Arena in nearby Lexington, Kentucky. My older brother was allowed to go with a friend. However, my parents deemed me too young for the spectacle. "If they ever come back again, I'll take you," my father promised.

He gambled on the belief that I would either (a) outgrow my unhealthy obsession with the band, (b) Gene Simmons would swallow his tongue and the band would break up, or (c) that I would forget about the conversation.

He was wrong.

For six years, I pored over the Events Calendar in the *Lexington Herald-Leader* with the fervor of a biblical scholar. The calendar appeared every Sunday and if I was out of town for a

weekend, I made my parents save the newspaper. I didn't trust them to review the concert schedule one bit.

Researchers on the shores of Loch Ness don't have the patience I displayed in biding my time until KISS returned to town. My old-school father's John Wayne sense of honor wouldn't let him renege on a promise. So on a frigid night in early January 1983, while Gene Simmons blew fire and Paul Stanley bragged about his love gun, my father stood in the Rupp Arena bathroom and frantically crammed toilet paper into his ears.

Goddamn, that show was loud. I grew up on a farm and was accustomed to big tractors, chainsaws, and power tools. I come from a family of hunters and learned early on that Grandpa's double-barreled shotgun kicked like a mule and sounded like thunder. I thought I was accustomed to loud noises, but that concert was powerful enough to make me think my heart would stop.

My father went straight for the bathroom stall, ripped off a length of toilet paper as long as his arm, and jammed it into his ears. His plan to save his sanity, and my young ears, was to abandon our floor seats and make our way to the top of Rupp Arena, as far from the cacophony as possible. Unfortunately, as country rubes, we didn't understand the acoustical specifics of the God of Thunder. The amplifiers you see onstage don't really do much. Quite often, they're just for visual appeal. For example, in an episode of Dick Clark's *American Bandstand*, George Lynch of Dokken performed with a stack of fake Randall Speaker Cabinets that folded up so that he could fit ten stacks in his trunk. A concert's real volume comes from the PA system, and in the rafters of Rupp Arena, we were staring right at a Death Star–like monolith of speakers hanging from the roof, blasting power chords at us.

So midway through the KISS show, we were sitting as far up as we could get in the arena, with about three inches of napkins and toilet paper protruding from our ears, getting blasted by volume, and too far away from the stage to really see anything.

Nonetheless, I was in heaven. Rock-and-roll heaven. Except for one thing . . .

I was concerned that Ace Frehley wasn't playing his normal guitar. At the time, I didn't yet know about guitar brands and endorsement deals. All I knew was that in the posters covering my bedroom walls, Ace played a roundish guitar, with one notch taken out at the bottom, under the neck. But that night in Rupp Arena, he was playing a pointy V-shaped guitar.

There was too much distance to discern the musician's makeup. So that was no indication. I asked my father what he thought about the pointy guitar. "I think there's ten thousand fools in this arena dumb enough to pay for this noise," was his only reply.

In those pre-Internet, pre-entertainment news days, it took a while for announcements to reach my Redmon Road farm in Bourbon County. But eventually I convinced Mom to buy a music magazine that explained the mystery of the pointy guitar. Ace Frehley had quit KISS and had been replaced by Vinnie Vincent.

Real name Vincent Cusano, he was a session player recording in Frehley's absence on the *Creatures of the Night* album. Vincent was also working as a staff songwriter for the *Happy Days* television series at the time. As a non-original member, the organization allegedly assigned him the KISS alter ego of the Egyptian Warrior (also sometimes referred to as the Wiz), complete with ankh motif makeup. Vincent favored what I would come to know as the Jackson Randy Rhoads–style Flying V guitar.

That guitar—which looks just like what it's called: a pointy V—was named after the legendary Randy Rhoads, a baby-faced, slender, blond virtuoso. Originally in Quiet Riot, Rhoads reached guitar god status while playing for Ozzy Osbourne's band until he perished in an airplane accident on March 19, 1982. At the time of his death, Rhoads was developing a signature instrument with Jackson Guitars. They ultimately named the instrument (and body shape) after the deceased guitarist. That was the axe I saw in Vinnie Vincent's hands that night at Rupp Arena.

There were so many things to notice and see at that KISS concert, so many amazing visuals for a young boy to remember. But I was hung up with the shape of a guitar.

BY JUNIOR HIGH and high school, I had expanded my KISS preoccupation to include the burgeoning heavy metal scene. Hard rock, hair metal, glam metal, eighties metal, whatever label you apply, I was fascinated by the bands of the day, particularly those originating out of Hollywood: Mötley Crüe, Ratt, Keel, L.A. Guns, Mr. Big, Warrant, Guns N' Roses, and so forth. Hard-core headbangers might argue with my inclusion of a fairly lightweight band like Warrant in the heavy metal genre, preferring to restrict the label to *really* heavy outfits like Slayer or Cannibal Corpse. But mainstream radio listeners don't discriminate. If there's long hair, volume, and a stack of Marshalls, they consider it heavy metal, so that's the term I use.

Back in school, I amassed a pile of *Circus* magazines and ripped out photos of my favorite guitars. I hung cutouts from the *Sports Illustrated* swimsuit issue on my bedroom walls because I felt it was something an adolescent male was expected

to do. But it was the pinups of ESP, Charvel, and Jackson guitars that most captivated me.

To me, wielding one of these guitars was like a Dungeons & Dragons character brandishing a sword of power into battle. This relic imbued the hero with superhuman powers, mastery of his surroundings, the ability to vanquish enemies, and the power to make a groupie's clothing magically disappear. Even obtaining the talismans seemed like an insurmountable quest. The guys in Ratt scaled chain-link fences late at night and went dumpster diving for castoffs from the Charvel factory. Eddie Van Halen actually MacGyvered a historic instrument out of spare parts and assorted junk. It was such a DIY, low-tech affair that he resorted to using a 1971 quarter to fill a gap between the guitar body and a floating tremolo unit. Forged in mastery and myth, the guitars weren't available at the local Walmart. They were icons of another realm—and certainly not anything I had obtained in my own life.

Absent a suitable instrument that would make me a master without practicing, I directed my attention toward obsessively researching guitars while devoting about 90 percent effort to everything else in life. I was captain of my school's soccer team and even received All-District accolades once, but I never worked on my skills outside of organized team practices. I was on the honor roll and in the school play, but generally only as a result of last-minute cramming as opposed to any habits of long-lasting hard work. The orthodontic metalwork in my mouth had finally come off so I had cute girlfriends, but I couldn't summon the courage to chat up the blond cheerleader. I was an all-around good kid. And that's the problem. My guitar heroes weren't all-around-anything. They were—to borrow a label from biker gangs—hard-core, obsessive, fanatical 1 percenters:

people willing to devote the time and sweat that the vast majority of other human beings aren't willing to invest.

The mainstream remembers the era for the tales of naked chicks beneath the Def Leppard *Hysteria* stage or Ratt's collection of bras and panties hung from the tour bus ceiling. And, in some ways, the musicians didn't do themselves any favors. Mick Brown of Dokken once said, "I play music for fun. Partying is my real job." Warrant's Steven Sweet echoed those sentiments by saying, "Our philosophy? Have fun, get laid, get drunk." Understandably, debauchery is the lasting image of the era.

However, lost among the more salacious memories was the fact that these guys were often incredibly diligent and skilled musicians. They struggled mightily to hone such technically amazing chops. Interviews were full of references to starvation and sweat as the rockers strived to build a career. They worked for hour upon hour to master the riffs and leads that shaped my childhood. The guitar heroes had a focus and single-minded determination that most people—myself included—lacked. But it was one that fascinated me.

I NEVER OUTGREW that fascination with the guitar and the men who played it so well. While my friends ditched their Shark Island and Faster Pussycat cassette tapes and settled in to a middle-aged collection of U2 and Coldplay CDs, I searched the Internet for rare bootlegs of Keel and the Japanese metal band Loudness. And I spent way too much time on eBay looking for a rare red-and-black Ace Frehley Washburn AF-40 guitar or maybe a Charvel with a cracked mirror paint job.

Late one night, I turned the volume down on my music to avoid disturbing my wife's sleep. I had relocated to Columbus,

Ohio, and was working as a project manager for a software consulting company at the time. I found myself in a career dead end, tired of project plans and resource allocation percentages. I would surf the web into the early hours of the morning, initially looking for job postings and the courage to do something different, but inevitably ending up with a Google search with the phrase, "Whatever happened to Vito Bratta from White Lion?"

I stared at my guitars and thought about the fascination they've held for me over the course of thirty years. Guitar heroes are often woefully imperfect men, beset by addictions, poor life choices, and even worse fashion statements. They are as flawed as heroes can be. Yet when they strap on an axe and crank the amplifier, they exude complete command, total mastery, and an unwavering knowledge of what to do: qualities so many of us lack in our own lives. Forget the hairspray jokes for a moment. These guys can fucking play.

Although Nirvana's 1991 monster hit "Smells Like Teen Spirit" was originally played on MTV's *Headbangers Ball*, the grunge era it ushered in crushed the hair metal genre. "Practically overnight, MTV shifted its programming focus from glam to grunge," writes Lonn Friend in his 2006 book *Life on Planet Rock*. "You couldn't find a Winger video if you had a search warrant. The network that broke '80s metal worldwide was now breaking the back of its artists and fans." Since the grunge apocalypse, metal's guitar heroes had gone underground, surviving off teaching guitar lessons, endorsing various pieces of equipment, and playing in an odd, incestuous subculture of tribute CDs and cover versions. It wasn't unusual to see a guy who once headlined arenas play to a dozen people in a guitar store clinic in a Cleveland strip mall. Sure, some remained big-time stars like Slash and Eddie Van Halen. And

others like C. C. Deville of Poison rode a crest of nostalgia circuits and summer package tours. But for many of my guitar heroes, today was never as good as yesterday.

In spite of their reduced circumstances, the guitar gods retained their mastery. They kept playing, kept performing, and kept plugging away. If anyone has a right to curl up and bitch about their lot in life, it's these guys. There are a hell of a lot easier ways to earn thirty grand a year than lugging a Les Paul through economy class all over the goddamned country. But the pursuit of the mastery of their instrument kept them going: that single-minded obsession, no-other-option lifestyle, and focus to do one thing and one thing only.

It dawned on me that maybe I could learn something from them. It wasn't just their hard work, although I certainly found that admirable. Over the years, I had worked like a Trojan. In college, I was simultaneously employed at a regional and urban planning firm, a bookstore, the career center on campus, a steak house, and was even paid to tutor sorority girls in the *Kama Sutra*, all while maintaining a full-time course load. My average workweek was about fifty-five hours, before I sat down to any classes. But I never really gave any single pursuit my full effort, whereas the guitar heroes couldn't conceive of an alternative. I felt like an imposter when bosses praised my performance, because my successes were all the result of last-minute heroics as opposed to sustained, methodical investment. I came to see myself as the hardest working slacker in the world.

I received a degree in creative writing, but built a career in information technology because it was safer, with a more defined path. I relegated literary pursuits to the occasional weekend and evening hours, picking up the odd journalism assignment here and there. I worked long hours, got

promotions, and received favorable reviews from my technology managers. But there was a final bit of effort—and risk—that I never mustered. I always held back, always gave up after getting the B+, always walked away, whereas my guitar heroes cranked it to ten and rocked forward. I wondered what I could have accomplished with my life and career had I gone all-in on a pursuit, like my guitar idols had.

And maybe I could learn something from the guitar if I actually invested the time to play the damn thing. In one of those absurd plans that can only be hatched in the middle of the night accompanied by a soundtrack of the Vinnie Vincent Invasion and Ratt, I resolved to track down the guitar heroes of my youth. Maybe my meager resume of publications and halfhearted media credentials would be enough to gain access to the rock gods who appeared on all those tattered posters on my childhood bedroom walls. On the simplest level, my quest was about meeting the people I had idolized as a kid.

But in a deeper way, it was about taking personal risks, setting audacious goals, and accomplishing something that seemed extraordinary. I knew I wouldn't become a master of the instrument myself. But if I could manufacture meetings with the men who were, if I could travel the country and see this thing through, that would be my equivalent of a standing-room-only bravura performance.

Some guys want to visit every major-league ballpark. Other people retrace their family's history through Europe. My mission simply had more ear-shattering volume.

In today's Internet age, many of the guitar heroes maintained websites and Facebook pages. So I searched for Bruce Kulick of KISS. A guy that Gene Simmons said was actually *too*

good a guitar player. I found Kulick's website and dashed off an e-mail, requesting an interview and a lesson.

And he responded.

Seeing an e-mail from a childhood hero, mixed in among the offers to increase my manhood and my miles per gallon, ignited the idea that I could really do this. That I *would* really do this. Finding my heroes, learning from them, and tackling the guitar would be a journey that I would complete, fully, wholly, and without reservations. I was going all-in on this one—even if it meant standing around for hours at a notorious crime scene.

FIRST SIGHTING

After responding to my original e-mail, the one that started this whole hunt for guitar heroes, Bruce Kulick went silent. These musicians leave home to tour the world, they enter the studio for long stretches of time, they pick up jobs delivering pizzas, and maybe some of them fulfill the stereotype and end up facedown in a bed full of bleached-blond strippers and blow that renders them incapable of simple e-mail correspondence. So I was casting about for other musicians to meet.

I was a consultant IT project manager, and my client had removed the gray-fabric-covered walls from an entire floor of cubicles. As far as the eye could see were desks, one right after another, in straight lines, like rows of corn. I was luckily situated on the end of a row but constantly aggravated by the older guy with a flattop who sat at the desk to my right. Seemingly unaware or unconcerned with the lack of privacy, he spent hours on the phone telling his wife to head to the Payday Loans shop off Olentangy River Road or haggling with the repo man to get his daughter's car out of hock.

"Are you going to see Great White?" a system tester asked me. "I heard they're coming to town."

I had always admired the band's guitar player, Mark Kendall. He was known for a bluesy touch and I also loved the additional level of power he seemed to possess. On songs like "Lady Red Light," there were brief salvos of power, as if he hit the turbo boost on his guitar.

He also possessed a massive mane of blond hair, mashed under one of those flat gaucho hats in the band's video for "Once Bitten, Twice Shy." How in the hell did cowboy fashion move from Marty Robbins's West Texas town of El Paso wardrobe and into the tour cases of eighties metal bands? He seemed like an interesting guitar player to meet and begin my quest.

I called the record company and left a message requesting an interview with Kendall. I e-mailed the booking agent. But no response.

The next day I phoned again, still with no luck.

My friend Henry is a longtime rock insider. He was in between roadie gigs and worn out from life on tour. He wasn't so well connected that he had Eddie Van Halen on speed dial, so he couldn't pull any strings for me. But he could provide tips for navigating the rock-and-roll system of publicists and bodyguards. Henry was a beefy guy with ever-changing facial hair designs and the vocabulary of a Parris Island drill instructor that borders on ridiculous.

"They're bored off their fucking nuts in the afternoon," he said. "That's your shot. After the show, they're yanked in too many different directions from fans and radio stations and shit. Get there in the fucking afternoon, around the goddamn sound check."

So I called the nightclub owner and asked to come by in the afternoon.

"Sure," he said, "if you're on the band's guest list. And the manager or the publicist are the ones to put you there."

Even though I couldn't get through to anyone on the phone, I figured I would go anyway, and worst case just listen to local bands I'd never heard of, even if I never got to speak with Mark Kendall.

"You're an idiot if you don't go to this gig," my buddy Biggs told me. We had originally worked together in Northern Virginia prior to Y2K. He escaped information technology for a journalism career writing about gadgets, fine timepieces, cigars, and whatever else men decide to blow their money on. Whereas I had built up a few publications here and there, scattered in the off-hours from my day job, he wrote full-time and served as a counselor to my literary efforts. He frequently encouraged me to give up "working at the PO," a reference to the famous Eudora Welty story, and write for a living as opposed to marking time through a day job. I resisted, insistent on keeping a day job, convinced I could balance multiple endeavors. The built-in excuse of having multiple endeavors was also alluring. As a result, Biggs was justifiably skeptical of my guitar quest. He had simply heard too many ideas bandied about in the past only to be abandoned because I manufactured this or that reason.

"With this band, in this venue, in this situation, you have to be there. Hell, if you don't go, then I will. I hate metal, but this is too dramatic to miss."

He was referring to the fact that Great White was scheduled to play the Alrosa Villa in Columbus, Ohio—a scenario that an industry watchdog labeled "a match made in hell."

THAT FIRST SHOW—the initial step in my quest to meet an array of rockers—was colored by two tragedies converging in an event that provided easy sensationalistic opportunities for the media.

On February 20, 2003, Great White performed at the Station in West Warwick, Rhode Island. Just after taking the stage and launching into "Desert Moon," a pyrotechnics special effect lit up the backdrop behind the group. Some type of foam material lined the wall behind the stage and part of the roof. The material was, supposedly, for soundproofing. In actuality, the stuff was for display and packaging and was never intended for sound control; nor did it have any flame-retardant qualities. Also, the Station did not have adequate sprinkler systems to handle a fire. A government investigation determined that proper sprinklers would have sufficiently contained the blaze to allow concertgoers to evacuate the building safely. But lacking those precautions, the pyro effect caused an inferno that engulfed the entire stage in less than one minute. A stampede of concertgoers clogged the exits and a hundred people died as a result of either burns or smoke inhalation. The band's guitar player, Ty Longley, was among the lives lost. Today, an empty lot covered with makeshift crosses commemorating the victims is all that remains of the Station nightclub.

So Great White itself was bad news. Then there was the location where I would watch them perform, an old club hidden next to some railroad tracks on the wrong side of town.

On December 8, 2004, Damageplan performed at the Alrosa Villa nightclub in Columbus, Ohio. Dimebag Darrell Abbott had rocketed to the heights of guitar stardom in the band Pantera. When that group fell apart, he and his brother

Vinnie formed Damageplan. Almost immediately after the band opened their set, twenty-six-year-old Nathan Gale stepped onstage, lifted his Columbus Blue Jackets jersey, and drew a Beretta 92 pistol. He shot Dimebag five times in the head at point-blank range.

In the ensuing melee, Gale also shot and killed three others.

Police officers were on the scene within minutes. Officer James Niggemeyer took to the stage and blasted Gale in the head with a 12 gauge Remington 870 shotgun. Nathan Gale was killed instantly.

Troubled by a history of mental illness and drug use, Gale had been given an early discharge from the United States Marine Corps as a result of his instability. Some claimed that Gale hallucinated that Pantera had been spying on him and stealing his life to use in their songs. Others alleged that Gale was distraught at the breakup of Pantera and blamed Dimebag.

Dimebag Darrell Abbott was laid to rest on December 14, 2004, in Arlington, Texas. The memorial service was attended by guitar gods like Zakk Wylde, Jerry Cantrell, and Eddie Van Halen. He went out in true guitar hero style. He was buried in cutoff camouflage pants, a black T-shirt, and his Black Label Society colors. A lifelong fan of Ace Frehley, Dimebag was buried in a KISS-themed casket. Van Halen shocked those in attendance when he placed the black-and-yellow-striped guitar featured on *Van Halen II* into the casket with Dimebag.

These two unrelated rock-and-roll tragedies were twisted together as Great White's date at the Alrosa Villa approached. The local newspaper quoted Paul Wertheimer of Crowd Management Strategies, a concert-safety consulting company in Los Angeles, as saying, "Why would you bring those two negative forces together?"

Although I understood a certain macabre tone to the media coverage of the concert, Wertheimer's objections were emotional and sensationalistic. He couldn't specify any facts to support concerns about the show's potential danger. Instead, he resorted to Vincent Price–quality proclamations such as "match made in hell" and "negative forces."

But as much as I disagreed with Wertheimer's sensationalism, I have to admit that I felt a twinge of apprehension and nervousness as I walked through the Alrosa Villa parking lot and heard a cover band playing Dio's "Holy Diver."

THE SECURITY GUARD who patted me down said they'd sold four hundred tickets to the show. The bar was on the left and an area with pool tables was on the right. Straight ahead was a sunken dance floor in front of the stage. A local band called Bad Mojo played Ozzy's "Bark at the Moon."

I would be lying if I said that I did not look up to the ceiling and take note of the sprinklers.

A short older man behind the bar made an announcement over the PA during a break. I realized he must be the club owner I'd spoken to earlier.

"I never heard back from the band's manager," I said to him. "Is there anything you can do to help?" He told me the band was doing a meet and greet after the show. There might be some time then.

"They're real happy to be here," he said. "But you only want to talk about guitars, right?" He squinted as he spoke, as if gauging my intentions.

As I watched the opening bands, it dawned on me that there is a certain slender, pasty-faced, stringy-long-haired look that

is equally at home on rural white trash meth addicts as Norwegian satanic death metal musicians. Looking around the club, I saw several people who could easily be named either Billy Joe Turley or Aarseth Glamdring the Defiler.

I also realized with a certain frustration that the guys onstage were as good as they were. They were a local Columbus, Ohio, cover band that realistically speaking would never be anything more than a local Columbus, Ohio, cover band. And yet the difference between my meager squeaks on the guitar and their blazing licks was astounding. It's a paradox of music in that it is incredibly sophisticated and intellectual yet also reliant on gut feel and blindly ignorant swagger. Mixolydian modes, sweep picking, arpeggios, sixteenth note rhythms with legato, intervals, diminished seventh chords, dominant seventh sus4 chords, and so forth cause many beginners to doze off as they attempt to learn the instrument. And yet you encounter many people who seem incapable of comprehending a Garfield comic strip who can absolutely rock.

AFTER THE FIRST opening act finished, I experienced a familiar moment of self-doubt. In the 1977 documentary *Pumping Iron*, Arnold Schwarzenegger says it's the last couple of exercises that make champions, but most people aren't willing to go through the pain. "The last three or four reps is what makes the muscle grow," he says. I had always put in the equivalent of seven out of ten reps. Working hard at sports practice but not staying a minute later when the coach blew his whistle. Putting in long hours at work, but not giving that final 1 percent because I had some other job to go to. There were still hours before Great White even took the stage. I

had no reason to believe I would even get a chance to speak with Kendall.

But I resolved to take it as far as I could go. Tonight I would refuse the easy route.

I started jotting down a note about one of the security guards—is it now a law, or maybe a requirement of the bouncers' union, that security guards must be bald with a goatee?—and as I closed my notebook, I noticed a blond staring at me. She wore a pink tank top, a short pinkish tweed skirt, and high heels. She posed in front of the speakers to one corner of the stage. At first glance, you'd probably say that she "danced with abandon." But on further inspection, you'd realize that she gyrated with calculated intent. Her eyes darted from side to side as she banged her head, looking to see who was watching.

"Find the hottest fucking girl you know to go with you, and make sure she's willing to show her tits," Henry once advised when I asked how to get backstage at a Mötley Crüe concert. He had spent about a quarter of his life working the rock-and-roll circus of tour buses, concert halls, and hotels. If anyone knew the secret of gaining access, it was him.

Maybe the dancer could help me get some time with Kendall. Every time I looked up from my journal, she was staring at me. That is, when she wasn't wildly tossing her long hair around in maneuvers from a Whitesnake video.

Just then, I felt a tug on my jeans. I was standing on a step, but it was crowded with people sitting down like students outside the biology building on a sunny afternoon. I looked down to see a woman in her early forties with brown hair.

"My friend wants to know what you're writing in that book," she said as she pointed to a dishwater blond seated nearby. In the coldhearted calculus of rock-groupie evaluation, they were

not attractive enough to help me get backstage. But there was no reason to be impolite.

"I'm a writer. I'm covering the show," I answered. The blond introduced herself as Jennifer and the brown-haired girl was Megan. They asked a few more questions about my interviews and I didn't lie, not directly. But I certainly didn't go out of my way to clear up misconceptions. I mentioned that I had recently returned from Los Angeles and suddenly they thought I lived in the City of Angels.

"Why in the hell would you leave Hollywood to come to this dump?" Megan asked.

"Just thought it would be interesting," I said. "Great White had the tragedy in Rhode Island. This place had the Dimebag murder. Seems like a good story."

"I guess," Jennifer said. "Still, you coulda have found a better place to go. I was here when the Jackyl played. He took a chainsaw to the roof and cut out a bunch of tiles. I bet if you were to go onstage, them tiles are still missing."

The soundboard was nearby and during a break in the succession of opening bands, the guys overheard our conversation. They came over to ask questions and Megan and Jennifer answered on my behalf: "He's from L.A." and "He's here because of the Dimebag thing." The dudes all grinned and gave me fist bumps, saying, "Cool" and "Right on, man." I just smiled and tried to act like I do this all the time. My thoughts were that I could create this journalist persona and maybe it would help me grab some time with Kendall.

A long-black-haired guy in an Ozzy T-shirt had been onstage during breaks throughout the night and he strolled over with a lanky bleached blond on his arm.

"Are you a reviewist?" the girl asked.

At this point, the pink dancer by the speakers didn't even attempt to hide her stares. The dude in the Ozzy T-shirt said he could hook up a chat with the band after the show. His girl kept pressing up against me, as though she had to yell in my ear, but there wasn't a band onstage at the time and the house sound system wasn't that loud.

After a few minutes of chatting, we all cheered as the house-lights dimmed and Great White came onstage.

The humongous blond mane that I recalled from high school was gone and Mark Kendall was now bald. He, like the army of bouncers, wore a goatee but somehow managed to look cool instead of serving as a Stone Cold Steve Austin impersonator.

After just a couple of songs, vocalist Jack Russell stepped to the front of the stage and said it was great to be back in Ohio. He looked much thinner than I remembered from the eighties and even from the TV news footage after the fire tragedy. He was also heavily tattooed in what, from a distance, seemed to be a haphazard assortment of pieces, as opposed to complete sleeves featuring a unified theme. He was moving well, sounded good, and seemed thrilled to be onstage.

For three hours, I had conspicuously tried to inflate my image as a big-time rock journalist. Women flirted with me and men laughed at my jokes. But they all turned against me when Russell unleashed a tirade between songs.

"I did an interview in the paper here a while back for this show," he said. "And this guy was kinda talking about the tragedy in Rhode Island and our good buddy Dimebag Darrell, God rest his soul. Somehow had something to do with us playing here tonight, which I don't fucking understand. But that's the fucking media for you, trying to make something out of nothing."

Everyone looked at me. I felt like I was isolated in a spotlight. The attractive blond dancer in the pink tank top turned her head away. Jennifer and Megan, the not-terribly-attractive women on the step, stood up and stormed off. The guy in the Ozzy T-shirt muttered, "What an asshole" and walked away, leading his blond girl by the hand.

I wanted to scream, "That wasn't me! I'm a fan! I didn't write that article." But instead I put my notebook into my pocket and I walked to the bathroom. My note taking stopped at that point.

AFTER MOVING TO a different location and trying to blend in with the crowd, I enjoyed the show. It took Kendall a few songs to get the amps adjusted to his liking, but then he settled in. He played a cream-colored Stratocaster and alternated between bluesy runs and really heavy rhythms.

After his rant about the media, singer Jack Russell seemed warm, honest, and sincerely happy to be performing in front of the audience. In the eighties, I always thought he came across as surly and belligerent in interviews. I distinctly remember *not* liking him at all. I argued with friends about how much better Great White would be with a less-prickly singer. But in Columbus, he interacted with the audience, thanked them profusely, and put on a good show. The band worked so damn hard that I felt bad that my thoughts kept returning to the Rhode Island fire. And I was also weirded out by the fact that the small dressing room off the stage, the one I could look right into from the audience, is where Nathan Gale collapsed after Officer Niggemeyer took him down.

We rarely know the history of any given place. Your favorite

coffee shop might be the scene of a violent robbery gone wrong. The pizza parlor booth where you cuddle with your girl might be where a toddler choked on a pepperoni. We just don't know about those tragedies.

But in this case, I not only know what happened on that stage, I had seen the police evidence photos. Guitarist/keyboardist Michael Lardie was standing next to a wall of amplifiers on the side of the stage. That's where Gale stepped out of the darkness on that night in late 2004. He walked across the center stage area, where Russell was now singing, and drew down on Dimebag. The guitarist crumpled into a corner of amplifiers where Kendall's rig now sat. And Gale died on the threshold of the dressing room. His legs were still in the stage area, his torso and head inside the room.

While I was picturing evidence photos in my head, the fans enjoyed the show and just wanted to get on with their lives. Have some good times. Honor and remember the victims. And hear some great music. Although the band would later fall apart, they seemed to have fun that night.

THE GREAT WHITE show offered a prime example of how some eighties metal bands made their living, in spite of playing such small venues. Our concept of being "on the road" is formed by images such as Led Zeppelin's customized jet plane with fake fireplaces or Mötley Crüe's tour bus with all the lingerie trophies. We think of concert videos such as Bon Jovi's "Wanted Dead or Alive" or Def Leppard's "Pour Some Sugar On Me" that feature massive stages, armies of crew members, and a convoy of bulging tractor trailers hauling equipment around the continent for months—even years—on end.

In the late 2000s, however, touring was a much more stripped-down enterprise for bands such as Great White. Instead of traveling for months and months, many of the bands conducted fly-in sorties that focused on a certain geographical area and then got the hell out. The musicians plus one or two roadies, for example, would travel economy class into Cleveland on a Friday morning. They would either carry on their guitars and microphones or check them as luggage if they were willing to risk it. The drummer would sometimes be stuck with local gear at the venue, sometimes borrowed from an opening act, sometimes provided by the club. The back line of amplifiers and PA would also come from the club.

The intrepid group would rent a cargo van for transportation, play in Cleveland on Friday night, Columbus on Saturday night, and then Cincinnati on Sunday. They would either sleep in the van or at Holiday Inn types of establishments along the highway, get up on Monday morning and catch a flight back home to Southern California, mark the Buckeye State off the list, and start planning to hit the Memphis-to-New Orleans corridor next. Sometimes the routing and legs were longer; things didn't always fit into the space of a weekend. But it certainly wasn't like the mammoth two years of touring that Metallica did for their *Black Album* in the early nineties.

After each performance, most of the bands held "meet and greets." The venue would set up folding tables and metal chairs, and the sweaty musicians would come out and sit around signing autographs, taking photos, and selling merchandise.

Bands that still perform to packed arenas charge substantial amounts to attend a meet and greet. KISS collects more than $500 for a photo op with the group. Rob Zombie offers packages at $125. Rush has some around $200.

Groups that play small bars don't charge a fee for the meet and greet. As the audience members queued up for Great White, I took a position at the back of the line. It was a questionable strategy because they could cut things off and leave at any moment. But the band didn't seem to be in any hurry. Russell, in particular, seemed genuinely happy to chat with each fan, pose for pictures, and hug every man, woman, and child who came his way. And these weren't casual lean-in-and-tap-on-the-back hugs either. These were full-on, wrap-your-arms-around-and-hold-on hugs that he seemed to appreciate.

"Hey, Mr. Patient," Mark Kendall said to me as I finally approached the table after standing in line for almost an hour. I quickly spilled out a string of words that involved, in some manner, interviewing him. He agreed without hesitation and after one or two more people went through the line, we stepped over to a booth near the wall.

"I don't have a whole lot of time," he said. "But I'll be glad to chat while the crew is finishing up."

I looked over his shoulder, out the back door, and saw a white cargo van and dudes scurrying in and out, toting an assortment of cases and gear.

"What separates the hobbyist and the hero?" I asked. "Why did you guys make it when so many other people failed in their dreams?"

"We succeeded by leaving ourselves nothing to fall back on," Kendall replied. "We were just full of determination, believing in ourselves. We played anywhere. We played for free a lot."

I noticed the crew had gathered on the stage. I heard one of them say, "I think that's it." I spilled out a second question, a

non sequitur about inspirations that felt as awkward as throwing a speeding car into reverse.

"What attracted you to this guitar player or that one? What made you admire someone's work?" I asked.

"The people that inspired me to play seemed at one with their instrument;" he said.

One of the roadies yelled Kendall's name and he glanced over his shoulder.

"What tip would you give a beginner? I'm just starting out on the instrument; what should I do?" I blurted.

"Take a music theory class," he responded. "Play with friends who are better musicians; learn from them." Both tips seemed too advanced for me at the time and I thought I should concentrate on my mechanics before getting into theory. Kendall stood up and said they had to leave. I thanked him for his time and he walked out the back door and piled into the van.

It was about 4:30 in the morning when I got home. My ears rang and my feet felt like I was walking on firecrackers. Lara rolled over, brushed her blond hair out of her eyes, and asked how the evening went.

I hadn't learned anything earth-shattering from the guitar player. I hadn't seen any crazy event, no topless groupies, no piles of dope, no televisions thrown out the window. Nonetheless, I felt a sense of accomplishment, a strange sense of pride that I had seen the evening through and managed to manufacture an encounter with a childhood hero.

And I was also resolved to take guitar lessons again, putting forth more effort than my halfhearted attempts in elementary school.

3

MUSICAL DEBATES
AND THE SAVING GRACE
OF VIDEO GAMES

oug's business card indicated that he was a bear impersonator in addition to being a guitar instructor. The dudes at the guitar shop said he was a decent all-around teacher for whatever type of music you wanted to learn.

"It's sixty dollars. You pay for packages of four lessons up front, fifteen bucks each," the clerk said as I selected my time slot: every Tuesday at 6:00 PM.

In the days leading up to my first lesson, I paced the floor of my apartment, eyeballing my guitar collection like a new student worries about the cool kids judging a first-day-of-school outfit. It was important that I make the right choice and take the proper instrument. My favorite guitar was the ESP George Lynch Kamikaze. It's certainly the axe that drew the most comments from visitors to my house.

George Lynch was a guitar hotshot on the Sunset Strip in the late seventies and early eighties. In fact, Gene Simmons

from KISS had made the effort one night to see Lynch perform when he was distracted by the virtuoso in the opening slot, Eddie Van Halen. Lynch later came to prominence in Dokken, a band named after lead singer Don Dokken, known for poppy tunes punctuated with Lynch's guitar mastery. A lot of metal fans sneer at the band. Comedian and fanatical rocker Brian Posehn's song "More Metal Than You" even uses the band as a taunt for folks who ain't heavy enough. But few people deny Lynch's skill on guitar.

And no one could ignore his eye-catching instruments either. Lynch was an early adopter of ESP Guitars from Japan and he rocked a series of axes with outlandish paint jobs. I first saw the Kamikaze in Dokken's 1985 "In My Dreams" video. The guitar has a camouflage pattern, but instead of greens and grays, it is a red, black, and yellow combination. The headstock has a hockey-stick-like curve and is reversed, so it points up rather than down. The fret board is wide, almost uncomfortably so, but that can actually be helpful for a beginner. Your fingers have to cover more real estate on a wide fret board, so the muscles hurt more. But the increased gaps between strings mean that picking can be somewhat easier. The guitar also has a Floyd Rose tremolo arm on it, so you can make crazy dive-bomb sounds by drastically raising and lowering the pitch. It's a cool axe and one that I incessantly dreamed of rocking when I was a kid.

However, it's so garish, so outrageous that I'd look like a complete fool carrying that thing around. Beginners have no business with anything that showy.

Ultimately, I settled on the B.C. Rich Bich, still a "metal" guitar that suited my musical tastes, but one with a groovy seventies vibe. Joe Perry played Biches and Mockingbird models

from the manufacturer during Aerosmith's heyday, so it wasn't just for Scandinavian death metalers named Grishmankh the Awful. And the ebony fingerboard of my guitar featured cloud inlays that suggested an almost art deco feel as opposed to a raping-and-pillaging motif. So I thought I could pull it off.

But I was concerned about transporting the axe to my lessons. That could attract a bit of attention.

The B.C. Rich is a weird-shaped guitar, so it won't fit in a normal, run-of-the-mill guitar case. I hauled mine around in a Coffin Case, a carrying device that looks exactly like its name. Whereas traditional cases are simple rectangles, the Coffin Case's wider end (where a corpse's shoulders and head would be placed) accommodate quirky body shapes, like that of my B.C. Rich. All guitar cases are lined with plush material to protect the instrument, but the Coffin Case has a velvet burgundy diamond-tufted environment just like Grandpa's final resting spot. The company's advertising featured adult film star Jasmin St. Clair, a woman who came to fame for gang bang flicks, including a record-breaking effort in which she, uh, "interacted" with three hundred men in a twenty-four-hour period of time.

The other students at the guitar shop waiting for lessons were all children, eight- and nine-year-olds plucking away on acoustic guitars while anxious parents paced, phoning their spouses: "We're running late, can you grab Bobby at soccer?"

And there I was: a clean-cut, unassuming midthirties guy with a metal/seventies guitar in a fucking casket hocked by a porn star.

When I walked into the small practice room, I had the urge to yell for a zookeeper. Doug really *could* serve as a bear impersonator. Short and stocky, with reddish-blond hair and a bushy beard, he appeared to be a hippie straight out of central casting,

complete with fleece pullover, shorts, and sandals. His main musical influences were improv acts like Frank Zappa and the Grateful Dead. In addition to a day job at an elementary school, Doug played in a local classic rock band and performed as a character in a group dedicated to "bringing cool quirky kids' rock music to all the children of the cosmos."

"I certainly know of most of those guys," Doug said when I reeled off my favorite guitarists. "But I'm not an expert in their work."

He pulled out a blank sheet of guitar tablature, with five sets of horizontal lines running across the page. The guitar is an interesting instrument because you don't have to read music in the traditional sense to play it. Instead, you can rely on *tablature*: graphic depictions, easily understood by novices, in which each line represents a string. Tablature generally doesn't indicate which digit to employ on these different maneuvers, so a beginner often has to go through a period of trial and error to determine the most effective fingering. Jazz guitarists use different fingering than rock guitarists and the self-taught often look different than the Juilliard grad.

At the bottom of Doug's paper there were six boxes with both vertical and horizontal lines in a grid. These were chord frames, which act as a zoomed-in version of a fret board.

Doug flipped his acoustic guitar over to use as a desk and started marking the paper with a dull pencil. He handed it to me and then explained the major scale, or *diatonic*, a succession of notes arranged in specific order of intervals. He plucked out each note slowly, allowing it to ring individually, and then progressed to a faster speed at which the notes seamlessly blended together. Scales are the ultimate beginner's exercise because

they develop dexterity with the instrument. They're also a good way for experienced musicians to show off.

GUITAR HERO IS a relative term, and one that can be end-lessly debated. Everyone has different qualifications for what they consider greatness on the instrument. To many, speed is a determining factor while other listeners react to the emotional quality of a guitarist's performance. Tone, precision, phrasing, image, and many more qualities come into play. And, as with any subjective arguments, personal biases certainly color a critic's opinion.

Case in point is the aging hippies at *Rolling Stone* magazine. In a roundup of the 100 Greatest Guitarists of All Time, they ranked Johnny Ramone at number 16 while relegating Eddie Van Halen, *the* guitar hero of all fucking guitar heroes, to number 41. Sure, Johnny was an influence to guitar heavyweights such as Kirk Hammett and Paul Gilbert, but Van Halen changed the history of the instrument and is cited as being an influence on just about every human being who touched a guitar after 1983. Yet, he's way down at number 41. Years later, the magazine reissued their ranking and placed EVH in the top 10, a move that struck many hard rock fans as grudging at best. Mr. Ramone was moved down to the number 28 slot, but still ahead of metal performers like Randy Rhoads, Dimebag Darrell, and Slash.

The Ramones, of course, are the darlings of the New York intelligentsia and hipsters, so it comes as no surprise when the *Rolling Stone* staff gushes that Johnny Ramone's "elementary attack was part of the essential simplicity—matching last

names, two-minute tunes, a strict uniform of black leather and ripped denim—with which the kings of Queens ruled punk rock from the mid-1970s until they called it quits in 1996."

Notice the code words: elementary, essential, simplicity. The band couldn't play for shit and for some reason the critics dredged out their thesauruses to find ways of justifying their poor musicianship. It's interesting to compare the Ramones, beloved by New York hipsters, with KISS, constantly derided and scorned by the dark-rimmed spectacle set.

The main criticism of the masked rockers was that they were too calculated, too focused on image and marketing. They all adopted stage names to hide their ethnic backgrounds. They developed defined stage costumes. And they played consciously basic tunes, designed to couple with their bombastic stage show, aimed at kids in the suburbs and in the Midwest. And for that, they are forever linked with a 1977 *Rolling Stone* write-up by Charles Taylor that compares their music to buffalo farts.

Meanwhile, the members of the acclaimed Ramones all adopted stage names. And not for the first time either. Joey Ramone originally went by the fuck-the-world moniker "Jeff Starship" in a previous incarnation. And the punk rockers made calculated and premeditated wardrobe choices.

"We'd still get dressed up to go out, to go see the New York Dolls, but now we're starting a band—now *what* do we do?" Johnny Ramone is quoted as saying in *I Slept with Joey Ramone* by Mickey Leigh with Legs McNeil. "An image like that is fine for New York and L.A., but it's gonna be so limited. I had on silver lamé pants and a leather jacket with leopard-print fur around the collar. How you gonna get people coming to shows like that? We wanted every kid in Middle America to be able to identify. We realized we gotta get uniformed: jeans, T-shirts,

leather jackets, sneakers . . . We defined the image, and then we had to work out exactly what we were doing up there." KISS might have dressed up as cats and demons, but make no mistake about it, the uniform of the Ramones was just as strategic. Same goes for the flannel shirts, camo shorts, and goatees of the Seattle grunge bands, another movement that supposedly didn't care about image.

Two New York bands, two sets of name changes, two sets of strategic images, two bodies of consciously simple musical work: One is revered and applauded for their simplicity, the other reviled. To be fair, the Ramones didn't reach the product licensing excesses of KISS; there aren't any bomber-jacket and bowl-haircut coffins on the market. But at the same time, even the bombastic Gene Simmons didn't praise George W. Bush and try to make the political argument that "punk is right wing."

The point is that lists and critical acclaim and "who's the best" arguments are always deeply personal and subjective and inherently flawed. Find one list that praises a guitar player and there are two others that bitch about him. Even diehard metal fans such as author and pop culture critic Chuck Klosterman can be divided on the subject of what musicians are great and emotionally moving versus who sucks and is self-aggrandizing. In *Fargo Rock City*, Klosterman takes great pains to criticize the work of guitar heroes. "The instrumentals would play on and on, the pyrotechnic scales would climb higher and higher, and it gave you nothing but tinnitus," he wrote.

But his complaints are contradicted by his central thesis that music doesn't have to be accepted or applauded or acclaimed for it to be important. The sheer fact that it moves someone, anyone, makes it worthy. His benchmark is that metal "was certainly real to me and all my friends," he writes.

"And more importantly, it *did* say something. It said something about us."

Well, guitar heroes were important to me and my friends. I don't recall having a single conversation about who was the best singer (maybe who the coolest singer was, sure, but that focused on swagger and attitude), but lists of guitarists were constantly debated. No one ever said, "You've got to hear this keyboard solo," but I distinctly remember the time a guy named Patrick and I sat in his blue '64 Mustang as he kept playing and rewinding, playing and rewinding Randy Rhoads's guitar solo in "Suicide Solution" for us to hear over and over again. So while we can debate who deserves the guitar hero title, there's no doubt that the archetype was vitally important to a generation of listeners.

And they remain important to me today. I was thrilled at the prospect of meeting the guitar players I listened to as a kid. These were musicians who occupied a strange place of unknown fame. To the *Entertainment Tonight* viewers around the world obsessed with Miley Cyrus and the Jonas Brothers, these guitar players were total nobodies. But to their subculture of fans, they remained important, vital, and impressive. Oz Fox of Stryper was a perfect example of this. Ignored by the guitar press and unknown to the mainstream, a lot of people would debate the decision to grant him guitar god status. But I had once upon a time imagined myself playing the licks off *Soldiers Under Command*, so therefore he fit my method of categorization—which meant he was worth meeting.

A WEB SEARCH brought a certain Southern California music store and its instructor to my attention. After several years of living together, Lara and I were finally getting

married. My natural tendency to hesitate and hold back had delayed things long enough. Instead of dissolving a Vegas weekend in booze, bros, and strippers for my bachelor party, I sunk the equivalent cash into a solitary trip to Hollywood, a nice hotel on the Strip, and a walking tour of Mötley Crüe landmarks like their shared apartment and Cherokee Studios where they recorded *Shout at the Devil*. I also planned to get a guitar lesson while I was in the area.

Groovin' on Music was a small guitar shop that occupied the first floor of a building in Pasadena, California. The glass-front edifice was set off the road, with a small parking lot in front. A huge billboard for a car dealership towered over the lot.

I carried my guitar into the store and a middle-aged man said hello and offered me a seat on a purple couch. When it was my turn, Oz Fox from Stryper led me into a small, pristine practice room with equipment neatly stacked in the corners. At the time, I had seen that the band was on hiatus and that the guitar player was offering one-on-one lessons. And while I wasn't as obsessed with this group as I was with some other bands, it was still exciting to be sitting down so close to a guitar player I had listened to for years. I explained to him that I was basically a complete beginner and to treat me like a six-year-old.

"I appreciate your patience," I said. "It's gotta be boring to spend an hour going over something so simple and basic."

"Actually, this is a nice change of pace," he said as he shuffled papers. "Normally, I get beginners who come in here and expect to play Van Halen solos right off the bat. It's great that you're realistic about starting out properly."

He reached into a tabbed folder and withdrew a piece of paper. It had tablature lines on it like Doug's, but it was already

marked with clear typewritten notes for scales. He then hit a button on a small recorder.

"I like to record lessons. That way you've got some reference later on, when you get home," he said.

Those tapes were a great testament to the sheer speed and dexterity that guitar heroes possess. Fox would slowly pick through a given scale or arpeggio so I could see how it was done. He would pause between each note, look at me to see that I was following, and then move forward with the exercise. Then I would try it, mangling the rhythm and misfretting most of the notes.

With an elementary schoolteacher's background, Doug was eternally positive. If you walked in, dragged a rusty nail across your guitar, and then stabbed him in the leg, he would smile and say, "Good job. I can tell you've been working on that."

Fox, on the other hand, was more demanding. He was polite and respectful, but it was clear he wasn't going to let mistakes or sloppiness slide during his lesson.

"No, your ring finger goes here," he said as he reached over, grabbed my digit, and stretched it out to the tenth fret. He constantly told me to stop moving my hand during a particular scale. The hand, as a whole, was supposed to remain stationary on the neck. Your fingers were supposed to stretch out to reach the most extreme widths of the scale, but moving the entire hand was wasted motion.

After I had squawked out a few attempts at a scale, he would once more step through it slowly, with a pause between each note. And a gleam would come in his eye. A gleam that I had experienced as a child, even though I was no sucker for romantic clichés.

My father's racehorse farm was a small operation, with no employees for the most part. Occasionally we would hire part-time help but generally it was just my dad with some chores for my brother and me. Forget the romantic images of the sport of kings. Put away your *Seabiscuit* and *Black Beauty* references and pretty Kentucky Derby hats. The real horse business is physically demanding, financially draining, and heartbreaking.

"You can do whatever you want," Dad once told me. "Be a drug dealer or rob liquor stores, if you want. But if you go into the horse business, I'll kill you."

He needn't have worried. I had shoveled enough steaming piles of green horseshit to scoff at sentimental notions of the creatures. Yet, romantics are right in the assertion that thoroughbreds are born to run. You can sense it when they come to the fence for feed. You see their muscles ripple, their nostrils flare, and their eyes dart at each other. They stand at the fence waiting for you because they *have* to, because they must eat, but it's a chore they'd just as happily do without. They're just aching to run, to be away, to be turned loose so they can dash to the other side of the field or the farm or the other side of the planet if they could.

And that was the gleam I saw in Oz Fox's eye when he plodded through scales for me. After a few slow marches, it would be too much for him, and he would blaze off a run so fast that his pick strokes were like pistons in a Ferrari. He would squint and look at me, or sometimes open his eyes wide, so they bulged out of his face, and scream up and down the neck. No doubt that part of his show was for my benefit, to indulge the fan. But there's also no doubt in my mind that he did the same thing every day, by himself, locked away with the instrument and the speed of the great.

AT FIRST, MY lessons with Doug didn't seem to yield much improvement in my performance. I would pull out my guitar, plug in, and stagger through the exercises. Someone like Oz Fox or even Doug could proceed through movements with a smooth *duh-duh-dah-dah-ding* where notes melded quickly into one another to create a cohesive sound. With me, it was more *duh*-wait two seconds-*duh*-wait two more seconds-*dah-plink* from a misfretted *dah*-wait three seconds-*ding*, and shake sore hands out from the torture. Those guys could blast out rapid-fire arpeggios or scales like a high-tech machine gun. Me? I performed more like a rusty muzzleloader from the Civil War.

As I waited for my turn before each lesson, nerves churning my stomach, I listened to Doug's other students as they worked with him. I was always very cognizant of the thin walls in the practice room and of the kids and parents and salesmen roaming around outside while I mutilated the most basic blues progressions. I tried to hide as much as possible by keeping the amplifier turned down as low as it would go, so you heard both the physical plinking of the strings on my guitar as well as the sound that came out of the speakers.

"Next week, why don't you bring in a tune that you'd like to play?" Doug asked one evening as I snapped shut my guitar case. "We'll see if we can figure out a way for you to get through it," he continued. "That's more fun for you as a student, instead of sitting around doing scales and memorizing chords all the time."

My mind immediately went to the acoustic ballad "Forever" by KISS. It wasn't one of their trademark songs with the Spaceman Ace Frehley rocking the guitar and setting off smoke

bombs. But it was pretty and seemed straightforward and I had a meeting with Bruce Kulick scheduled for the following week. I hadn't been able to reach him after that first e-mail, but he was now performing with classic rock act Grand Funk Railroad in Evansville, Indiana, on a Saturday, followed by a KISS expo the next day. It seemed a perfect opportunity to say hello to the guitarist. I spoke to the Grand Funk publicist who thought my idea of interviewing Kulick and getting a lesson from him was a great idea. So his era of the KISS catalog was on my mind.

I mentioned the tune "Forever" and it started a discussion about metal songs from the eighties. At some point, Doug referenced Ratt and I said that Warren DeMartini was a favorite guitarist of mine.

As I walked out of the rehearsal space, there was a boy who looked to be about ten years old wearing a red Ohio State Buckeye sweatshirt skillfully plucking out a Cat Stevens tune on an acoustic guitar.

"Ratt?" he said. "I got a perfect score on 'Round and Round' on Guitar Hero." He dropped his head and went back to his chords.

LIKE THE WAY Mark McGwire, Sammy Sosa, and other acne-backed monsters are credited with resurrecting baseball after the work stoppage of 1994, the Guitar Hero and Rock Band video game franchises were a superhuman, turbo-charged steroid injection into the exposure of eighties metal bands and the musicians who strummed those power chords. Some of the guys who I admired had long ago been exiled to "where are they now" status by radio and music television but the video games brought new followers. "A new generation is discovering

the virtues of teased hair and flashy guitar solos," Brian Mans-field wrote in *USA Today*.

Erik Turner of Warrant was quoted in interviews stating that children brought their video game controllers for him to sign. Swedish guitar legend Yngwie Malmsteen, who was featured in the Xbox 360 version of the video game, recounted that a small child, eight or nine years old, approached him in an airport. The boy asked if Malmsteen and his long-haired colleagues were rockers in a band and then said that's what he wanted to do with his life.

"This was so cool because a few years ago that wouldn't be happening," Malmsteen commented on the interaction. "Plus, I see in the audience when I play now, every night, there's very, very young kids. This is a great thing."

As a result of that increased attention, more and more axe slingers and bands actively courted the Guitar Hero market. Aerosmith, Metallica, and Van Halen all had dedicated versions of the game. Smaller bands proudly issued press releases when one of their tunes was selected for inclusion. And more musicians began making their music available for digital download through the gaming systems. When Mötley Crüe released the first single off their 2008 *Saints of Los Angeles* album, it sold almost five times more copies on Xbox than it did on iTunes in the first week.

The popularity of the games is a testament to the overwhelming ubiquity of the instrument in our culture. Until the 1940s, the guitar was considered an accompanying instrument, relegated to the back corners of the bandstand. As inventors such as Les Paul, Leo Fender, Adolph Rickenbacker, and others experimented with electrifying the instrument for more

volume and tonal abilities, the guitar demanded a more and more prominent role on stages across the nation.

Guitar technology improved and production techniques were mastered at a time when rock and roll invaded homes and radios everywhere. In a confluence of cultural shifts, technological advances, and nationwide prosperity, the instrument became practically universal in the fifties and sixties. Once an afterthought, the guitar was now the star. And that inspired millions of people.

"Learning to play an electric guitar has become a rite of passage for thousands of teenage boys," writes Andre Millard, professor of history and director of American Studies at the University of Alabama at Birmingham, in *The Electric Guitar: A History of an American Icon.* "Playing in a successful rock band was one of those universal dreams of the baby boom generation." In spite of the rise of hip-hop, techno, sampling, and other forms of electronic music, the guitar still dominated the musical landscape.

Indeed, the guitar is *the* default sound of contemporary popular music. There's a reason ambitious software designers didn't create Drum Deity or Keyboard King. When we think of music, we think of guitar. I was starting out on the instrument at a much later stage in life than most. But my struggles with an F chord were the same that millions of others had faced for years. And with Bruce Kulick, I would encounter someone who, through decades of hard work, had mastered those same chords I was just learning.

4

A ROCKING TOUR OF EVANSVILLE GUITAR STORES

I idolized Bruce Kulick during his tenure with the non-makeup era of KISS in the eighties and early nineties. The band's genealogy of guitarists was complicated by the time he joined. Original member Ace Frehley was replaced by the troubled Vinnie Vincent in 1983. In band videos, marketing maestro, bassist, and group coleader Gene Simmons later described Vincent as, "the most self-destructive person I've ever met. This guy would hang himself as someone is offering him the keys to the kingdom." He was subsequently let go "to contemplate his mistakes," according to the legendary bass player in a video interview.

Mark St. John (real name Mark Leslie Norton) was hired to replace Vincent and record the 1984 *Animalize* album. The single "Heaven's on Fire" charted in numerous countries and got more airplay than the band had enjoyed in years. It was so popular that it temporarily replaced Prince's "When Doves Cry" in

the tape deck on the bus home from my junior high school track meets, a huge triumph for a long-suffering KISS fan like me.

Adding to the complicated guitar history of the band was an egalitarian approach to studio work. Even notorious control freak Simmons allowed other musicians to play his parts on certain tracks if they were better suited for the tune. So a host of uncredited guitar players performed on KISS records over the years, such as Steve Farris (who later came to fame in the pop synth band Mr. Mister) and the rock-and-roll hoochie koo Rick Derringer. Simmons, who produced Van Halen's first demo tape and helped them get a record deal, even claimed Eddie Van Halen secretly recorded solos for a couple of KISS songs.

Another uncredited guitar player, Bob Kulick spent years on the periphery of KISS after originally auditioning for the band as it was forming in 1972. Bob had always lobbied them to hire his younger brother, Bruce.

Shortly before KISS left for a European tour in 1984, current axe slinger St. John's joints were attacked by a rare form of arthritis called Reiter's syndrome and he couldn't perform.

So, pressed for time and desperate for a guitarist, the rockers relented and finally asked Bruce Kulick to take over for the ailing St. John.

Kulick was a talented player and rocked an impressive array of Jackson and ESP guitars. In 1985, the video for "Tears Are Falling" was a staple on MTV. I monitored the television screen with the vigilance of a nervous air traffic controller in a blizzard. In the clip, Paul Stanley plays a bright-red B.C. Rich Iron Bird, a model so jagged and sharply angled that it would seem more at home in the murderous grip of a goblin than a preening rock star. Kulick plays a purple-sparkle Charvel with black pinstripes starting wide and then converging at the neck,

like the lines of a highway meeting in the distance. The band rocks on a soundstage decorated like a jungle in front of a stylized volcano while sepia-tone scenes of a beautiful blond are intercut with the performance footage. For the solo, the scene changes to Kulick in the jungle during a driving rainstorm, playing with his left hand over the neck instead of the normal position.

In hindsight, the KISS videos of this era have not aged well for Simmons. As glam metal ruled the charts, he dressed in high heels and long flashy coats with padded shoulders that seemed like a mixture of Linda Evans from *Dynasty* and Liberace. He has since said of that period, "For years, I looked like a drag queen. I looked like Phyllis Diller's cousin or something. Wearing Joan Crawford kind of *Mommie Dearest* clothing with bouffant hairdos that went way up here. I looked like something I'd fucked the night before." But back in the summer of '85, no matter how many times that video appeared each day, I *had* to see it.

In 1996, after eleven years of recording and touring with KISS, Kulick was sidelined when all four original members of KISS reunited and put the makeup back on. The idea, or at least the impression that fans had, was that the reunion tour was a one-off thing and Kulick and drummer Eric Singer would eventually return to KISS. However, the tour allowed older fans to relive their seventies memories and introduced younger audiences to the scale of spectacle that a rock concert could be. The reunited, re–made up, rebooted KISS raked in $43.6 million, making it the top money-earning tour of the year according to *USA Today*. Kulick didn't wait around. Instead he took his guitar elsewhere, playing with Grand Funk Railroad as well as doing solo performances.

"On Saturday morning, call him at eleven AM to confirm an appointment at two or three later that afternoon," the Grand Funk publicist had told me. I drove into Evansville, Indiana, late on Friday night, slept in on Saturday morning, and called the guitarist.

"I'll do the interview, but I'm not going to sit there and show you chords," he grumbled over the phone. "That's just a dumb idea." He had just returned from a gig teaching at the high-end Rock 'n' Roll Fantasy Camp and media coverage depicted him as a patient, conscientious teacher. But he wasn't having it.

"Get here at noon. We can talk for just a few minutes then," he said. He was far from rude, but far from inviting either. At this point, it was about 11:15 and I hadn't showered, shaved, or gotten in any way ready to meet someone whose poster hung on my wall as a kid.

After realizing I left my toothbrush and toothpaste at home, I purchased a pack of Tic Tacs at the front desk to mask my foul breath, tossed a handful in my mouth like a spoiled debutante bent on an overdose, got directions to Kulick's hotel, and dashed out the hotel parking lot.

HE WALKED INTO the hotel conference room carrying a guitar case that had been left for him at the front desk. A Washburn retailer had sent Kulick a guitar with a light-blue finish that showed the grain of the wood to examine. Despite their reduced status in mainstream pop culture, guitar heroes are still big business for instrument manufacturers. ESP, Ibanez, Jackson, Charvel, and other companies currently feature expensive signature guitars from musicians most associated with the eighties metal scene. An ESP GL20 anniversary model

George Lynch Kamikaze guitar will set you back $8,000 and you'll need $3,000 just to get started with a Warren DeMartini Bomber made by Charvel or a Zakk Wylde Gibson model. Carefully crafted reproductions of the iconic instruments of the true gods fetched exorbitant prices. Gibson's reproduction of Jimmy Page's Les Paul started at $30,000 while the Fender re-creation of Eddie Van Halen's red-and-white-striped Frankenstein guitar was $25,000. With customers willing to pay that kind of money for anything associated with their favorite musicians, the industry was eager to kick in a few freebies when there might be some promotional benefit.

Kulick sat at the head of the conference table and my mind flashed between the man seated in front of me and the much younger version that I had seen in the 1992 KISS home video *X-treme Close Up*.

Back then, he was dressed entirely in black, with leather pants, what appeared to be a Jackson Guitars T-shirt, and a black vest. His face was full and unwrinkled. Permed, shiny, long black hair almost completely filled the screen. Now his face was more lined, more haggard. While still long, his hair now seemed to be slightly lighter in color and wiry and frizzy. With a silver hoop in his left ear, he wore jeans, a T-shirt, and a camouflage cap. A squared-off goatee framed his mouth.

He sat down and glanced at my wrist. "You should talk to Eric," he said.

On tour, KISS drummer Eric Singer scoured local jewelry shops and watch stores the way a junkie seeks a fix. Over the years, he acquired hundreds of high-end wristwatches. His enthusiasm and knowledge of timepieces infected most people around him. While Kulick didn't catch the watch bug, he knew enough to recognize the Breitling that I wore.

"Thanks, it was a gift from my wife," I said. Lara always kindly indulged my passions for guitars and watches, silently tolerating them cluttering up our home, and patiently listening to me discuss this obscure solo or that handmade watch movement.

Collectors of any sort revel in the fine craftsmanship, the details, the tiny differences from one item to another. Musicians sometimes refer to GAS, which stands for guitar (or gear) acquisition syndrome. It's what leads even nonpros to pile up massive arsenals of instruments. And for someone like Kulick, who can justify equipment purchases as part of his profession, the appreciation and acquisition bug can be intoxicating.

"The holding, the admiring of the instrument, the fact there are so many different styles and they all create different tones," he said as he described selecting guitars for recording. "There might be this one guitar part where I will need that Fender Telecaster sound, so I have this Tele that sounds great. And then I want something a little different so I better bring the B.C. Rich and, you know, what about that Schecter with the three pickups that I just got? So I am constantly looking at the colors to paint with, so to speak, and each one of these instruments are that. But the enthusiasm is no different than that time when I was in Queens, holding my first guitar."

Guitar tones are all different. When you think of the jangle of a song by the Birds or early R.E.M., you're hearing a Rickenbacker. The heavy crunch of Led Zeppelin or Guns N' Roses comes from a Gibson Les Paul. The thin, shimmering leads of a David Gilmour solo in a Pink Floyd track are the result of a Fender Stratocaster.

In addition to tonal differences, guitars act as talismans for

the musicians. Their look and feel can affect the guitar player's mood and therefore suit certain songs better than others.

Sound, body shapes, cosmetic details all combine to create the palette of guitars. Every musician has a favorite instrument and most have a story of one that got away. For example, when I asked Kulick about that purple Charvel that was in the "Tears Are Falling" video, he said it was stolen at a show in Philadelphia.

Born in 1953, Kulick's family originally lived in Brooklyn and then moved to Queens, where he shared a bedroom with Bob. His brother introduced him to the guitar and the younger Kulick started strumming chords on an old acoustic model.

His mother worked part-time as a secretary and his father had a government gig in quality control for aircraft and astronaut systems. "I did not really understand my father's work until one time when I was old enough and I actually drove to one of the research and development labs out on Long Island where he was the quality control guy and I was very impressed actually," he said.

Over the years, Bruce Kulick seemed to always be working. Even after KISS, he played on records for different artists, participated in different bands, and generally stayed busy. He seemed to understand that although music may be an art, having a career as a musician is a business and required perseverance, hard work, and determination. And in an industry defined by excess sex, drugs, money, firearms, conflicts, alcohol, trashed hotel rooms, and devil worship, Kulick's history was squeaky clean. He had seemingly emerged from the eighties with his dignity, and his bank account, intact.

"I think Dad's dedication in getting up every day at five AM

and being on the road by six and coming back by six gave me a very strong work ethic of my own," Kulick said. "You know, everybody usually takes the path of least resistance, but to be successful at anything, you do have to put your time in and be disciplined."

That discipline paid off when the young Kulick finally mastered Edgar Winter's riff in "Frankenstein."

"I used to listen to that when I first heard it on the radio and I said, 'That is the most incredible riff in the world and I will never be able to play it,'" he said. "When I conquered it, obviously, it wasn't as hard as I thought. I was never the shredder sweep picker, but neither is Eric Clapton or Jeff Beck, so that is why I was like, 'Okay, I don't have to be Steve Vai even though he's like a magician on the guitar.' But complicated riffs, I could figure out. I played in a band that would do 'Sir Duke' by Stevie Wonder and it was like, okay that's an interesting riff. I would have to figure that out. And I was really proud of that, that I could do those things and I did it by ear, too. I wasn't reading it off the chart."

At one point in Kulick's career as a musician, he was even in a rock group called Blackjack that featured future soul crooner Michael Bolton. Known for his brand of white soul music, his incredible mop of flowing locks, and his relationship with television star Nicollette Sheridan, the singer would eventually reappear in the KISS story when he collected a co-writing credit for the 1990 single "Forever" that peaked at number 8 on the charts.

When he joined KISS, Kulick was asked to bridge different eras of musical styling. The seventies era of KISS was typified by straight-ahead rock and roll. But the guitar hero pyrotechnics of the eighties definitely captured the band's attention.

"The first tapes they asked me to learn were live tapes of them just prior to me joining, so there was some stuff from 1983 with Vinnie Vincent that was really atrocious because the playing had no regard to the song," Kulick said. "Vinnie is a great player, too. He is a very talented guitarist. So why they let him get away with that, I don't know. But they did tell me, 'We want you to have your own style, but you've got to be closer to what the classics had. We want you to play with all the tricks and all the new kind of techniques and be as competitive as what is out there, but keep your feet in the classic stuff.' I'm not going to play like Eddie Van Halen in 'Deuce,' you know, so I think I had a good balance of how to approach that."

After all these years, to this day, a guitar was just a normal part of Kulick's minute-by-minute life. He claimed to be unable to watch television without a guitar in his hand. When his gear was being shipped to the next venue, the axe slinger sought out opportunities to simply get his hands on an instrument.

"There are many times when I can't have my guitar because I am traveling and the guitar is in the back line and I will see it when I get there," he said. "But I can feel my hands just going"—he curled his left hand—"like I want my hand around a guitar. Which is why when I'm traveling, I will ask if I can find some transportation to just get me to a guitar store. I kind of make it work by saying, 'Let's go to a guitar store.' But at home, there are guitars everywhere and it's wonderful!"

As we finished our chat, Kulick stressed the importance of hard work and determination. It was nothing terribly novel, but still something I used to reinforce my resolve to see this crazy guitar hero quest through.

I said I would be at the Grand Funk Railroad performance later that night. I thought that our time together was at an end.

He smiled.

"Do you have a car here?" he asked.

I OPENED THE trunk so he could drop his stuff in there.

"Why are you carrying that thing?" Kulick asked. He referred to the black-and-gray Line 6 amplifier. After our pessimistic morning phone call, I had left my guitar in the hotel room but I hadn't taken the time to remove the amp.

"Well, the publicist had said we would do the lesson thing, so I wanted to bring all the stuff—"

"Yeah, sorry about that," he interrupted. "I was a little harsh on the phone. But we sort of bonded over guitars I guess. We can play around at the store."

In a nearby Guitar Center, I asked Kulick what to look for when purchasing a guitar. Instrument choice is an extremely intimate decision and many musicians claim that even guitars of the exact same model, same wood, and same production run will sound totally different.

"Since I can't really play that much, how would I evaluate an instrument?" I asked. He explained about checking how it feels, how to examine the frets, and how certain guitars just seem to get it all right.

"Like, see that Les Paul?" He pointed to a sunburst model hanging on the wall. "I hate it when they do the burst like that. That just looks like crap. But the one next to it is beautiful."

At first, it was hard to tell the difference but I finally spotted the flaw. Guitars with a burst finish generally start out dark around the edges and then gradually fade into a lighter color toward the middle of the instrument. This treatment

highlights the grain of the wood and is a classic style favored by guitar icons over the decades. If you picture Jimmy Page from Led Zeppelin, you're probably also seeing his 1959 Les Paul with a sunburst finish. Texas blues master Stevie Ray Vaughan's trademark "Number One" axe was a 1959 sunburst Fender Stratocaster with a bit of a darker finish.

The instrument Kulick criticized didn't fade into the lighter color. It was an abrupt transition, almost a solid red straight into a light yellow, as if it had been marked off with painter's tape. The cosmetic treatment he preferred gracefully faded from dark to light.

He picked up a white Stratocaster and started pulling off random licks, but the instrument wasn't in tune. After breaking a string, the musician and I retreated into the heat of the parking lot. Tall and slender, he folded himself into my two-door coupe. There was another guitar store he wanted to visit but when we passed a Best Buy, he asked to stop.

"Have you seen the new volume of *KISSology*?" he asked in reference to a recently released three-disc DVD set with concert and music video footage. "They're going to mail some copies to my house, but there's a special version only available at Best Buy that has bonus footage from a concert at the Ritz in New York."

We found a large display of the KISS DVDs and each picked up a copy. At the checkout line, he went first. The freckle-faced blond checkout girl, who probably went to the local school in Evansville, probably was a junior varsity cheerleader, probably listened to Gwen Stefani and Kanye West, and probably wanted out of this town, didn't realize she was selling a DVD to someone who actually starred on that DVD.

Kulick put the receipt in his bag and patiently waited for me to complete my purchase.

I TRIED TO be nonchalant, but the fact is that I just couldn't stop myself from grinning like an idiot. At our second guitar store, an open and airy independent shop called the Musician's Den, Kulick plugged in. And whenever he played a recognizable riff or lick, I just grinned. I tried to control myself since smiling seemed too fan-like and I didn't want to be unprofessional, but I couldn't help it.

A salesman in his midtwenties strolled over as Kulick picked the intro to "Domino," a song off KISS's 1992 record *Revenge*. "Hey, that's pretty good," he said. "I know that riff from somewhere. Who wrote that?"

Kulick smiled and said, "I did."

The store featured a lounge area with recliners and we leaned back and relaxed as Kulick tried out a Morgan Monroe acoustic. It was a simple, inexpensive guitar, with a spruce top and a dark finish that made it look like an antique from the thirties. He started cycling through a random selection of riffs.

"One of my big thrills is watching somebody show me what they think is the right way to perform the tunes from my solo records and they play it," he said. "It's so interesting to see how incredibly personal the guitar is, not only in your touch and how you hold the pick, but there are so many positions that could be repeated. A piano basically has your octaves and it's all laid out right there. The guitar isn't like that and those voicings that you use are *your* choices so you can play the same chord in many different places, with different fingers. To see

someone else interpret it and then when I show it to them, they are like, 'Really?' I can hear right away that—even if they had the right positions—they are not necessarily going to sound like me. That is the beauty of a guitar as well. No matter how much manufacturers want to sell you their pickups and their amps and their guitars, the tone ultimately will come from your hands."

"There's a quiet pinging sound that happens twice in the solo to 'Forever,'" I said. "How do you do that?"

"Do you mean the harmonics?"

"I'm not sure. It's just a quick ding, one is higher pitched than the other."

He played the solo note for note, perfectly rendered from the track. He made the sound I was referring to. "That's just a harmonic," he said. He explained that harmonics occur at the seventh, twelfth, and nineteenth frets. Normally, to play a note on guitar, you hold down the string between the frets. But to get that delicate harmonic ping in "Forever," you touch the fret itself, ever so lightly, and then release as you pick the note. It pings off like the quiet ring of a wineglass.

After leaving the store, Kulick wanted to get something to eat before taking a nap to rest for the evening's gig. So we stopped at a Cracker Barrel and got a late lunch/early dinner. He ordered a meat and two vegetables, with iced tea. There was something in the way Kulick referred to the food and the restaurant that made me believe he felt Evansville, Indiana, was part of the South.

When I was a kid, I must have eaten at every fucking Cracker Barrel in that South—or at least those that lined I-75. While my family lived in Kentucky, our extended clan was in southern Georgia and Florida. Several times a year, we loaded up the

car and hauled down the highway to visit them and my father always stopped at the Cracker Barrel. We were such zealots for the restaurant that my family is probably single-handedly responsible for the chain's expansion northward.

As Kulick and I ate, I thought about all those childhood stops at Cracker Barrels when my ears would be still ringing from ridiculously loud KISS songs on my cheap Walkman cassette player. In those days, I imagined the band always wore leather and crazy stage clothes and only dined at fine restaurants with models seated around the table and a few crammed under the tablecloth. After all those years, here was the guitar player, in jeans and a T-shirt, cutting into his pot roast while I munched on a burger.

After our meal, I dropped Kulick off at his hotel and said I'd see him at the gig, figuring I would just get into the crowd and try to make my way up front to the stage. I hoped to take a few photos of the performance.

"Come back here at six," he said. "You can ride over with the band."

THE GRAND FUNK Railroad gig was at the Discovery Lodge at Burdette Park, a campground out in the countryside. The concert was a charity event put on by the Reitz High School class of '75. It was open to the public and proceeds from ticket sales funded a local scholarship.

Our van pulled into the campground and deposited us at a wooden A-frame cabin.

"You guys can get dressed and ready here," said the driver. "They'll come get you when it's time and take you to the lodge."

Inside the cabin, there was a large den with a stone fireplace

and a small kitchen. There were bedrooms and a bathroom down the hall, and an open loft with another bed upstairs. I chatted with singer Max Carl as the others got ready. He was already dressed in his stage outfit of black pants with silver coin-like discs down the legs, cowboy boots, and a black Western shirt with red flowers embroidered on it and pearl snap buttons.

Carl actually cost me fifty bucks. My knowledge of music trivia is legendary among my friends. I struggle to complete any math that is more complex than two plus two, but I can tell you who engineered Dokken's 1982 demo. In the car one day, I argued with my wife about a tune on the radio.

"I love this song," Lara said as she turned it up. "This is the only 38 Special song I ever liked." The tune was a soft ballad, with barely any guitars in it, called "Second Chance."

"That is not 38 Special," I stated confidently.

"It is! I had a cassingle of this in high school." Weird creatures, cassingles were cassettes designed to fulfill the role of 45 record singles during the decline of vinyl in the eighties.

I didn't believe her and continued the argument. She asked if I wanted to wager on the song.

"You want to bet *me*?" I taunted.

We settled on fifty dollars and as soon as we got home, I looked the song up on the Internet. Sure, enough, it was 38 Special, written by former vocalist Max Carl.

A white van arrived and took us to the venue for the performance. It really was a lodge, in every sense of the word. Standing on a hill in front of a small pond, the large timber building had a concrete floor, vaulted ceiling, and a log-cabin-like design. It seemed more appropriate to house a Boy Scouts gathering than a rock concert. The venue's website said capacity was 650 people and locals expected about 450 to 500 would

turn out for the show. We unloaded and walked in a back door by the stage and into a small room that had a sink, some cupboards, a beige couch, and some metal folding chairs. A box of baby wipes sat on the counter by the sink.

Just as the band was ready to go on, a sound guy came in and said the PA system wasn't working. We sat back down and Kulick looked at me and joked. "You're getting to see the real backstage experience," he said. "A real Spinal Tap moment."

At one point, the band discussed abandoning the PA system and turning their monitors toward the crowd. But after about twenty minutes, the problem was corrected and Grand Funk Railroad took the stage.

I walked out into the audience milling about inside the lodge, proudly displaying the all-access pass hanging around my neck. The stage was set up in front of a massive stone fireplace and Kulick occupied the right side. He wore a black shirt, unbuttoned to show a T-shirt underneath, and a black bandanna over his head. Even though I didn't know many of the songs—only their biggest hits "We're an American Band" and "Some Kind of Wonderful"—he performed well and the crowd loved him. When he first joined KISS, he was nicknamed "Bruce the Spruce" because of his immobile, treelike tendencies. But he had learned well from the master showmen Gene Simmons and Paul Stanley and knew how to work a crowd with a series of winks, nods, and smiles, like he was greeting each audience member from the stage. During the course of the night, he switched from a cream-colored Telecaster to a sunburst Les Paul to a black ESP Viper.

Throughout the day, I had begun to see Kulick as a friend, just a regular guy. But onstage he reminded me why I had loved his guitar playing over the years. He was inventive without

being outlandish. He was respectful of the song's original recording while adding his own touches here and there. The crowd hung on every note and cheered every solo. At one point, I stepped between the amps on the side of the stage to take a photo and he caught my eye and smiled.

After the show, we piled back into the van parked behind the lodge. A group of fans followed us out and the band signed a few autographs through the open windows of the vehicle. Just as we started to pull away, a pretty, middle-aged brunette who had probably been the most popular girl in school in 1975 stuck her head in the window and asked, "Are you guys going out anywhere? Do you want to party?"

The guys said they were just going to get some sleep and she sighed disappointedly and walked away.

Back at the band's hotel at the end of the night, I said my good-byes to Max, set up a time to meet Kulick at the KISS Expo the next day, and returned to my own room. I practiced harmonics on my guitar, pinging off the delicate sounds late into the night. Then, I watched the *KISSology* DVD until I fell asleep.

THE KISS EXPO was in a ballroom at the Marriott where I was staying. I walked in as Kulick was setting up his table. He was selling CDs, DVDs, signed photographs, and other memorabilia.

In the early nineties, KISS hosted official conventions around the country. These were expensive events with official relics such as the *Love Gun*–era outfits and instruments. Since then, KISS Expos still appear around the country but they are smaller affairs, more like a band-associated swap meet. Some

of them attract hundreds of fans and have wild entertainment, such as the time Kulick was interviewed at a New Jersey expo by a red-faced, hooded character named Maul Stanley who combined the Darth Maul assassin from *Star Wars* with KISS singer Paul Stanley.

The Evansville event had been arranged on short notice and was sparsely attended. Vendors hawked T-shirts, old magazines, a few original KISS dolls from the seventies, guitar picks, and other junk. One table had nuts and bolts individually packaged in small plastic Baggies. It looked like you wrapped up an aisle from a hardware store, but it was actually pieces of the late Eric Carr's drum set. I had gone by the ATM earlier that morning in anticipation of finding some cool piece of history I couldn't live without. But this was pretty much all flea market cast-off shit and quality-control rejects from a T-shirt factory in Bangladesh.

A heavyset guy carrying a handmade diorama of a KISS stage came up to Kulick's table. He wore a red Justice League of America T-shirt and an Orange County Choppers hat. McFarlane Toys had produced detailed figurines of KISS and the fan had strategically placed them on his stage. He set the diorama on the floor next to Kulick's table and plugged it in so that tiny Christmas lights in the stage set lit up. It was a big hit with the small group of fans gathered around—until a guy in full Gene Simmons costume almost stepped on the diorama and the owner scampered off with it.

Several people brought guitars for Kulick to autograph. There was a Kramer from the eighties, a black Silvertone Strat, something called a Bridgecraft, and a guitar that looked like an old Mosrite from the fifties.

Some of these instruments were clearly pieces of shit. Even

from a distance I could see rust on the frets, cracks in the finish, and a neck so warped that it looked like a wrung-out wet washcloth. But each time someone presented an instrument to Kulick, he lifted it up and examined it. For a brief moment, he would be alone with the instrument, inspecting the neck, checking the action, tuning it. Bruce Kulick had been playing guitar for almost forty years. He owned over a hundred instruments at the time and had handled thousands throughout his career. Yet he still seemed to experience rapture every time he touched a new guitar.

The fans mingled in and out. Some were obviously excited and talked to anyone. They jumped from table to table chatting with the vendors and other fans. Others loitered around Kulick's place, never straying far from the star.

A bearded guy with a blond ponytail in a black KISS T-shirt, a Dale Earnhardt hat, and a leather cuff watch asked Bruce to sign a poster. A golden Star of David hung from a necklace proudly positioned over his T-shirt. Throughout our time in Evansville, Kulick seemed a little out of place. He grew up in New York City and had lived in Los Angeles for years and maybe he wasn't quite sure how to handle this middle part of the country. He brightened up when he saw the guy's jewelry selection.

"Are you a member of the tribe?" Kulick asked the fan.

"Huh?" the dude questioned.

"Your necklace," Kulick responded as he pointed at the guy's neck. "That's the Star of David. Are you Jewish?"

"Ah, no," the guy said. "I just wear it 'cause I like the way it looks."

Kulick sighed. He signed the poster and the guy moved off.

At one point in the day, a fan mentioned the *KISSology*

DVD and I'll admit a certain excitement as Kulick said, "Me and a friend were at Best Buy yesterday and bought a copy."

KISS Expos generally feature bands, often with tribute acts in full makeup mimicking their heroes. An outfit called the Steve Sizemore Group played a few KISS covers and one or two original tunes. Led by the titular slender blond bass player, the band had performed at several KISS expos and served as Kulick's band in the past. They played throughout the Midwest and even appeared at former KISS guitarist Ace Frehley's fifty-first birthday party. They were a perfectly serviceable band, playing melodic hard rock in a completely competent and professional manner. You couldn't complain about them—until Kulick stepped onto their stage and picked up a guitar.

As soon as Kulick plugged in, it was clear exactly who the rock star was. He was playing a borrowed instrument through the Steve Sizemore Group's amplifiers. And yet even his warm-up exercises sounded better, more in command, more professional.

In the last forty-eight hours, my initial awe of the man had faded. But in the final session at the KISS Expo, he showed why he's a guitar hero. He led the band through several KISS tunes and some of his own solo material. Even though they had performed with him in the past, they seemed nervous, unable to make eye contact with him. Kulick barked, "We're not playing it that fucking fast!" when they screwed up the beginning of "Love, I Don't Need It."

He demonstrated crunching rhythms, soaring leads, and intricate licks. He sounded better than everyone else and performed better than everyone else.

After the performance, the expo wound down. I helped

Kulick pack up his stuff. I asked him to sign a guitar strap I brought.

"What's a tip you can give me, a complete beginner, on the guitar?" I asked.

"This sounds like something your parents would tell you," he said. "But walk, don't run. It just seems like everybody wants to jump in full speed ahead and they don't understand a basic chord like a power chord. You should not be playing lead first. I have seen people getting around on the guitar and you are like, 'Let me see your D chord,' and they're, 'Well, what's that?' That doesn't make any sense to me." My problem had been that I didn't sit there and musically put one foot in front of another in order to "walk" on the guitar. I wanted to sprint right away.

We exchanged e-mail addresses and promised to stay in touch, a new contact that I would have thought impossible during my teenage years.

The summer sun was setting over the countryside outside of Evansville as I started my drive home. My guitar was in the backseat, the amplifier in the trunk. I called my father and told him I'd spent the weekend with a former member of KISS.

"I hope it was better than that goddamn racket I took you to," he said. As a child at that first KISS concert, I watched the corners of the stages, looking for wires, for trap doors, for trusses, for triggers. I wanted to know how Gene Simmons blew fire and Eric Carr's drum set shot cannonballs. I wanted to know the tricks and the secrets to the special effects.

But after my weekend with Bruce Kulick, I understood that there was no trick, no easy explanation to being a guitar hero— just a lot of work and dedication.

5

THE GUITAR HERO CONSTELLATION AND PLANS FOR A PILGRIMAGE

I was going to have to get more organized if I really wanted to meet my guitar heroes and learn about the instrument and life from them. The smattering of interactions I had was fun, but I wanted more substance. Lonn Friend, who edited *RIP* magazine and appeared on *Headbangers Ball* in the eighties got to hear a demo tape of "November Rain" in a car stereo while Guns N' Roses was still working on the tune and he was honored to carry Jimmy Page's guitar into a venue. Neil Strauss was asked by Dave Navarro, "Do you know what to do when someone shoots up too much?"

In my case, I had simply shared some Cracker Barrel cuisine, gotten a lesson and some practice tapes, and stolen a few words after lurking in a local bar. I wanted more out of my experiences with the musicians. I knew I needed a plan. I needed to get organized.

As a kid, I had two other obsessions in addition to the guitar. I played Dungeons & Dragons constantly and I stockpiled comic books like an end-of-days survivalist stores cans of beans and cartons of ammo. My brother and I bastardized D&D because we misinterpreted (or ignored) the rules and created characters that were ridiculously powerful. My personal favorite was a long-haired blond cleric who wielded a mace in battle and could pulverize the most dangerous dragon by simply blinking his eyes. As a pretty literate kid, my D&D fascination was buttressed by Greek mythology mixed with Tolkien and C. S. Lewis books.

I also read comic books compulsively, or at least as much as geography and finances would allow. In small-town Kentucky, we didn't have cool comic-book shops that offered the esoteric and the independent for sale. I was stuck with the meager Marvel and DC offerings at the grocery store. But I always loved their special edition encyclopedias that recorded every character in the universe, along with a brief synopsis of origin, superpowers, alter ego, genealogy, and so forth.

With those templates of mythology in the back of my head, I took out a piece of paper and sketched a constellation of guitar gods, as I might categorize them. The designations were a combination of my own personal opinion of the musician mixed with a general idea of where non-guitar geeks might place them. As much as I might complain about a culture that heaps such fame and riches on Justin Bieber or Britney Spears, I couldn't pretend that music exists in a vacuum. Only a truly deluded fanatic would put Chris Impellitteri or Akira Takasaki at the top of any guitar heap given that 99 percent of the world's population had never heard of them.

First, there were the true Titans: Jimmy Page, Jeff Beck, and Eric Clapton. They were from a previous era, sort of an

amplified version of Cronus and Hyperion that ascended to greatness before the time my own guitar obsession began. In spite of the fact that Clapton had married a local woman and was periodically seen around town, he and Page seemed impossible to reach, existing in a mist of mythology and legends.

If those guys were the Titans, then the current Mount Olympus was occupied by Eddie Van Halen and Slash, both rockers who made their names in the eighties but retained a level of renown and fame. In recent years, Van Halen had been in and out of rehab, he battled cancer, and he sparred with his lead singers repeatedly. Although far from being a Salinger-style recluse, he didn't give many interviews or make many appearances. Slash, on the other hand, was everywhere. His top-hatted image appeared on Guitar Hero video games, he performed with pop stars such as Fergie from the Black Eyed Peas, he served as a guest adviser on *American Idol*, and he wrote a bestselling memoir. It had been, amazingly, more than twenty years since Slash and the rest of his Guns N' Roses bandmates released the seminal *Appetite for Destruction* record, yet he was as well-known now as ever.

Still on Mount Olympus, but maybe slightly lesser gods, were Mick Mars of Mötley Crüe and Zakk Wylde of Black Label Society. After many years out of the spotlight consumed with physical pain and exotic maladies, Mars joined his bandmates on a highly successful reunion tour in 2005 and then launched Crüefest, a traveling festival of hard rock and heavy metal acts. Wylde maintained an active schedule juggling guitar duties for Ozzy Osbourne and his own band, Black Label Society, as well as writing music for ESPN and other activities. Known for his berserker image and lifestyle, Wylde was a fixture in the guitar magazines, frequently dispensing quotes such as "I don't brush

my teeth, I don't shower, I don't wipe my ass, but this is what chicks actually want." These guys were huge icons of the instrument, but I wasn't as drawn to them. Their stories were well-known, their fame and fortunes intact. I was more interested in the lesser members of the guitar hero constellation, many of whom labored under difficult circumstances, financial hardships, and disregard from the general public. While Kobe Bryant's work ethic is certainly to be admired, it's not hard to understand why he keeps doing it, not when he has a helicopter take him to every single home Lakers game instead of sitting in traffic. But for someone hooping overseas or in the developmental league, riding un-air-conditioned buses for hours on end, someone who just refuses to give up, what's really in it for them? Those are the guys who are truly going "all-in."

I drew an offshoot from the Olympians called the Virtuosos, a genus of guitar players who were still considered deities, but in a slightly different manner. I placed Steve Vai and Joe Satriani in this category. Although they had both performed with popular bands such as Whitesnake and Deep Purple, they were characterized by largely instrumental music that pushed the boundaries of what human beings can accomplish on the guitar. More recently, a guy my own age named John 5 had entered this realm with instrumental records that mixed chicken-pickin' bluegrass techniques with heavy metal crunch and serial killer references. His music bolstered his solo endeavors with steady gigs accompanying rockers like Marilyn Manson and Rob Zombie.

Below was the category for Heroes. These were mortal men who accomplished extraordinary feats of musicianship or success in the business. Or, were just guys that I imagined swapping places with while I flipped burgers at a concession

stand in an amusement park. Some of them held a level of fame within the context of their genre and fan base, but were largely unknown by pop culture as a whole. I filed musicians such as Warren DeMartini of Ratt, K. K. Downing and Glenn Tipton of Judas Priest, Brad Gillis of Night Ranger, George Lynch of Dokken, and others in this slot.

On a completely different sheet of paper, I wrote "The Elder" across the top. This unique genealogy was dedicated entirely to KISS axe slingers. At this point, the Greek mythology template went out the window, because some academics refer to the Titans as "elder gods." But those ivory-tower, tweed-jacket-clad folks probably aren't aware of a foolhardy recording widely regarded as one of the biggest failures in the history of hard rock.

In the late seventies, KISS was in a commercial funk with album and ticket sales declining. The group decided to partner with producer Bob Ezrin on their next album. Ezrin had helmed the controls for the group's wildly successful 1976 release *Destroyer* and the band had been promising a return to hard-rocking roots, so hard-core fans were optimistic. But the dope-addled producer (who had also overseen Pink Floyd's *The Wall*) read a Gene Simmons–devised plot for a fantasy story about a race of immortal creatures involving the line "when the earth was young they were already old" and decided that the masked rockers needed to record a concept album. The idea was that a serious affair evoking Arthurian legend with appearances from the American Symphony Orchestra and St. Robert's Choir would impress the critics and establish the band's artistic bona fides.

The strategy was controversial within the KISS camp and signaled the beginning of the end for Ace Frehley. He recorded

his parts in his home studio in upstate New York and shipped the tapes to the rest of the band, who were working in Toronto. Those parts that he didn't mail in, session players recorded.

The result was an album called *Music from "The Elder,"* which was released in late 1981. It was, by far, the biggest flop of the band's career, becoming their first record to fail to reach the recording industry's gold status designating 500,000 copies sold.

As a nine-year-old, I thought the record was okay. It did seem out of place in the band's canon. I couldn't figure out why there were quotes in the title, and I immediately thought that the Gene Simmons–penned track "Mr. Blackwell" (based on a repetitive and dull bass line, featuring lyrics that seemed reminiscent of Boris Karloff's ode to the Grinch) might very well be the worst song in recorded music history. But on the plus side, the album featured a cool gatefold package with photos of a big table and candelabra that was straight out of the Rivendell Furniture Collection by Elrond. There was a spoken-word bit that referenced a character named Morpheus and alluded to champions and being worthy of a fellowship. It seemed sufficiently Tolkienesque to pass my muster at the time.

In spite of the album's failure, the idea of the ancient race of powerful beings continued to factor in to the KISS universe. By that point, they had already established the premise of the band members possessing superpowers in comic books and television movies. Becoming immortal was just the next step. Into the nineties, there were KISS graphic novels and comics and even video games featuring the Elder concept.

So it made perfect sense to label a separate sheet of paper The Elder as I completed my guitarist categorization. Under that heading, I listed the numerous axe slingers that had been

members of the band: Ace Frehley, Vinnie Vincent, Mark St. John, Bruce Kulick, and Tommy Thayer.

Now that my universe was fully documented, I just had to find a way to reach the various gods, heroes, and elders.

"WHAT IS THAT?" Lara asked as she walked into my office. According to the real estate agent it's a third bedroom, but we use it as an office, which really means it has a desk, some bookshelves, and a shitload of my clutter.

"A schedule," I replied. I had purchased four two-month dry-erase calendars and plastered them to the wall. I then spent an entire afternoon clicking on band websites and checking tour itineraries. I ignored international dates, but any concerts within the continental United States were recorded on the schedule. Some days were jam-packed. One October Sunday featured Oz Fox in Chicago, Bruce Kulick in Berlin, Connecticut, Yngwie Malmsteen in Clearwater, and Kirk Hammett in Atlanta. Other times, whole weeks were empty.

"And just how many of these concerts do you think you're going to attend?" she asked.

"I'm not sure," I said. "But this should help me find potential places to meet the musicians."

"Or, potential cities to get arrested. This looks like a scene from *Law & Order*, after the cops kick in the stalker's door."

Oblivious to her practical objections, I turned back to my computer. I checked each guitar player's website, looking for a Contact Us section. Some listed their publicist, others had a webmaster, some included what appeared to be a direct line, and some had no means of communication at all. Then I looked at the record companies that released each rocker's work. I made

a note of all those corporate contacts as well. Finally, I checked out which guitars each axe slinger promoted and I jotted down the manufacturer's contact information.

When I was finished, I was startled to find it was 4:00 AM. I had spent the last six hours diving through websites, parent companies, management firms, news reports, marriage records, and even some LexisNexis property assessments trying to compile a list of contact points for each musician. I had accumulated about a hundred e-mail addresses, including some girlfriends, a few roadies, and even an ex-stripper who now worked at a church: anyone I thought could help connect the dots.

As the sun started to rise, I unleashed a barrage of e-mails, requesting interviews with the guitar players. It wasn't a massive spam exercise, like some kid in Prague trying to convince millions of suckers that he's a wealthy Nigerian princess. No, these were carefully crafted missives, tailored to each recipient.

Now I just had to wait for the responses to come flowing in. I figured some of the most famous guys might be a challenge. Slash wasn't hurting for publicity so I could see where his folks might not fawn over my request. But some of these other guys, diminished guitar heroes playing to a couple of hundred people a night? Surely they would leap at the chance.

I took a shower and pressed ice cubes on my eyes in an attempt to reduce the swelling and redness. I put on a tie and headed off to work, where I promptly sat at my desk like a zombie and did nothing, desperately fighting off the urge to take a nap, while counting down the minutes until I could go home and check my e-mail.

THAT EVENING, MY inbox had not exactly been inundated with guitar players clamoring, "Yes! Yes! I'd love to meet you and share all my deepest, darkest secrets." In fact, I actually received zero responses to my queries.

Over the coming days and weeks, a few notes trickled in. One challenge, I learned, was that publicists do not always partner with a musician permanently. Instead, they work for a given period of time to promote an album or a tour and then they move on. So the obscure publicity contacts that I dredged up from some two-year-old gossip page might no longer be relevant.

For example, in trying to reach Slash, I started with influential music publicist Bryn Bridenthal, who had run campaigns over the years for Mötley Crüe, the Eagles, Queen, Duran Duran, Guns N' Roses, Aerosmith, and many more. She informed me that Slash was now working with a company called Mitch Schneider Organization (MSOPR) and was courteous enough to bring those folks in on our discussion. Kristine Ashton-Magnuson at MSOPR then pointed out that her firm was in between projects with the top-hatted rocker and that I should check with his manager, Jeff Varner, at the Collective. Once there, I always got a prompt, professional response, but nothing that yielded an interview with Slash. I wasn't terribly surprised.

In *Rock and Roll Will Save Your Life*, Steve Almond writes that protective publicists "seem to have a sixth sense when it comes to Drooling Fanatics posing as music journalists." He is absolutely, 100 percent correct. I learned that publicists don't

just publicize but they also protect. They serve as gatekeepers in prioritizing requests so the musician's time is focused on the biggest and best outlets.

Also, the short-term nature of the publicist gig proved to be another obstacle in my quest. I was offering the flacks some nebulous publication for the interview, at some undefined point in the future.

"They don't give a fuck for something that won't appear for six months, if ever," my roadie pal Henry told me. "They'll be fired by then. They need immediate results to justify their miserable existence."

So I found a small website that agreed to take my interviews if and when I secured them. Having a guitar-related URL in my pitch helped improve the discussions slightly—but only slightly since the website stopped posting new content almost immediately after our agreement. And even when there was a response, I was often passed between the manager, publicist, record company contact, guitar tech, dental hygienist, hair stylist, mortgage broker, and anyone else even remotely connected to the guitarist, including the smooth-talking Ferrari salesman in Malibu and favorite waitress at the Rainbow Bar and Grill.

Nonetheless, I did manage to fool some people and get some interviews lined up. I was excited to share my schedule with Biggs, but he wasn't impressed.

"You sound like a groupie. You realize that, don't you?" he said while we sat at the Blue Danube on High Street. He had grown up in Columbus and returned periodically to visit family. The 'Dube was a cherished but grimy spot from his childhood, a place that served minors along with a mean mac and cheese. The ceiling was covered by painted tiles depicting

everything from hippie tie-dyes to portraits of Hank Williams. The floor was covered by some sticky substance from God only knows where.

"Except groupies have something to offer the musicians," he said as he set down a beer bottle. "A reason for taking up space backstage. You're like a groupie without tits."

"I am offering them respect," I said as I pounded the table for mock effect. "Sure, they can get on some cable music channel and be humiliated with a 'One Hit Wonder' profile. But I'm not going to make fun of them."

"They'll move more records with some embarrassing two-minute spot on VH1 than anything you have. They may not like it, but it'll pay a month's child support. You're dealing with has-beens and never-wases. They don't care if a network or if *Rolling Stone* rags on them." Biggs's musical tastes ran to the folkies mixed with a smattering of techno. He could actually play the guitar, but preferred a cheap Harmony hollow-body instrument as opposed to the axes I adored. From time to time, he had offered to show me a few things on the instrument, but we never seemed to actually follow through on those opportunities.

I didn't win the debate, but I finally wore Biggs down with my sheer tenacity and a refusal to acknowledge the whole idea was ridiculous.

"Well, shit. People devote a summer to run around in a van chasing Phish, so I guess this isn't any different," Biggs finally admitted. "Where do you start? Are you coming to New York?"

"Nah," I said, smiling.

"Los Angeles, then?"

"Nope. Oklahoma."

"What the hell is in Oklahoma?" Biggs asked.

A MIDWESTERN METAL
ESCAPE

As I fought to stave off heatstroke and remain lucid, the rock star stood in front of me, perfectly composed. He wore boots, stylish jeans, a black military-inspired shirt, and a pair of aviator sunglasses. His hair was perfectly coiffed and he didn't seem at all bothered by the sweltering conditions. He was most known for being a vocalist and bass player, not a guitarist, but I wanted to get his take on the guitar hero phenomenon.

My vision blurred and I struggled to stand straight, as the canvas tent seemed to whirl around me. We were in the closed end and absolutely not one molecule of air was moving. I felt clammy and a chill ran across the back of my neck. The heat index was 120 degrees. Passing out would be humiliating but it wouldn't be the first time medics had been called to help some barbecued soul that day.

I asked a question and the sweat that flowed down my face flew off my lips, hitting him. He didn't seem to notice—or pretended not to.

"You just do it because you can't not do it," Kip Winger calmly said as he explained why musicians stick with their craft in spite of dwindling audiences and reduced record sales. "You feel tortured by not doing it. Plain and simple, man," he said.

Winger knew about torture. After performing with Alice Cooper in the mideighties, he launched his own eponymous group, scored two platinum records, and had a few massively successful singles. But a running joke on the *Beavis and Butt Head* television show, along with an appearance in *Playgirl*, reduced the band to such a punch line that denim-clad rockers in muscle cars joined forces with intellectual music critics in Greenwich Village to criticize Winger. I always kind of liked the band and enjoyed the infectious riff of their biggest single. Since the eighties, Winger focused on what his website called "music without limits." His orchestral works were performed by the Tucson Symphony Orchestra, and the San Francisco Ballet had plans to feature his music.

Desperate for some air, I dashed out of the tent when we were finished, hoping I could make it to the pathetically air-conditioned VIP food area before I collapsed. Winger stood motionless like a lizard, waiting for the next hapless journalist to stumble in while I tripped on an iron stake that held down the tent's guylines.

The VIP section was only slightly cooler than out in the sun. In the corners of the massive tent, portable air conditioner units wheezed out currents that felt like warm bathwater. Industrial-size boxed fans were stationed in front of the air conditioners in an attempt to disperse the air. Sunburned concertgoers sank into sagging plastic chairs in front of the fans, screaming to chat with each other over the noise, their hair blowing in the breeze. This VIP area cost a couple of

hundred extra bucks, but it wasn't a swanky respite for high rollers. With so many deflated, sweaty folks scattered around, it looked more like a hastily thrown together FEMA setup for catastrophe refugees.

Frantically trying to lower my body temperature, I dipped a blue bandanna I had been using to clean my camera in an ice bucket and wrapped it around my neck. Then I collapsed into a folding metal chair and put my head on the table as I felt that falling sensation that comes before you pass out.

As I lost consciousness for a second, all I could think of was that I had spit on Winger, the guy who had a hit single in 1988 proclaiming lust for a seventeen-year-old girl—and that I hoped I would recover in time to interview a guy who rocked a completely serious and straight-faced tune called "To Hell with the Devil."

ROCKLAHOMA WAS A music festival dedicated, largely, to glam metal bands of the eighties. Located in Pryor, Oklahoma, about fifty miles east of Tulsa, the inaugural event in 2007 welcomed a reported hundred thousand fans pouring in to a remote field. Internet reports were full of naked chicks in the campgrounds, reunited eighties legends performing songs unheard for decades, and leather-clad rockers drinking with sweaty fans—an altogether unholy congregation devoted to metal.

So my expectations were high for the festival and I was eager to spend a Friday and Saturday at the show. But I was unprepared for the pure, unadulterated fucking heat of the Oklahoma—sorry, *Rock*lahoma—weekend.

I grew up in a Kentucky farmhouse with no air-conditioning. My Mississippi apartment in college had only a weak window

unit that constantly froze up. I spent a summer rolling out pink insulation in new-home construction and another one trudging behind a foul-smelling tractor throwing seventy-five-pound hay bales onto a wagon. I lived in Hawaii for two years and spent hours on the beach and hiking the Na Pali Coast. And, still, I've never encountered the hellish level of torture that greeted me in rural Oklahoma.

My skin tingled like it was getting sunburned—even in the shade—just from the sheer ambient air temperature. Stick your arm into the oven to retrieve a pair of baked potatoes that have been cooking away at 450 degrees for three hours. That's what it felt like.

The grass crunched under my feet as I dashed into the shade of the Holiday Inn Express portico. Other fans streamed in and out of the hotel as the facility's sound system played Judas Priest's 1986 single "Turbo Lover" instead of the usual lobby Muzak. Based on people's cleanliness, you could tell if they were returning from the concert grounds or just departing for the day.

I looked over my shoulder and a sunburned dude with a mullet and a tattoo of the cover to KISS's *Rock and Roll Over* album on his shoulder staggered through the lobby toting a filthy cooler covered in Pabst stickers.

"Stay cool out there, bud," he said. After a quick shower and a change, I felt infinitely better than when I passed out in the VIP tent and when I spit on Kip Winger, but now I was nervous about my upcoming interviews that weekend. I had one confirmed chat and another I hoped to score.

"It's a hall pass for life," Winger had told me. "It's like 'get out of jail free' for life. You're good. Everyone is looking for an escape and the guitar hero is an escape."

Over the years, that had certainly been true for me. Imaginary concert halls formed my equivalent of a guided meditation cave, the walls ringing with guitar chords and amplifier feedback. Tyler Durden's power animal might have been a nut job named Marla but mine was an image of leather-clad rockers clutching customized instruments. In high school, I donned headphones and retreated into the music whenever I was stressed about my nervousness around girls. I cranked the volume knob as far as it would go and imagined myself in Ratt, Bon Jovi, Def Leppard, or other bands, confidently gazing down at legions of groupies while ripping a solo.

More recently, I found myself laying in bed each night listening to music and visualizing myself confidently strumming a cool Charvel or Jackson axe in front of massive amplifiers to escape frighteningly escalating fertility treatments and my ever-present concern about going all-in.

"I just don't see what the difference is," my wife Lara argued.

"There's a helluva distance between 'trying' with a capital *t* and 'trying' with a little *t*," I said.

Lara was a determined PhD from Johns Hopkins with a burgeoning career as a public health researcher. She was a consummate planner, so it wasn't a surprise when she expressed concern over the amount of time it was taking us to have children. She suggested seeing a fertility specialist but I balked at what seemed—to me—a huge step.

"Once you get doctors involved, there's all this pressure," I said. "It consumes your life. I'm not ready for that. Plus, I've heard it's obscenely expensive. Let's just keep 'not preventing' instead of 'trying' with a capital *t*."

"Your concerts and guitar trips are also expensive," she said. "You don't have a problem with that." I didn't have a response

and managed to change the subject. I grabbed my iPod and promptly lost myself in Steve Vai's instrumental tune "Whispering a Prayer." Intellectually, I knew that musicians had just as many problems as so-called normal people. But in the sphere of my imagination, sheltered from the outside world by noise-canceling headphones, periodically replaced by the fantasy guitar hero identity I crafted for myself, everything seemed flawless and untroubled.

I had escaped the office, escaped the discussions about children, cashed in some vacation time, and now found myself baking in an empty field in Oklahoma. And that's how I ended up sitting across from a pious guitar god who signs autographs with the tagline "J. C. rocks!" and his wife who founded an organization called Hookers for Jesus.

INSIDE THE LOBBY of the Hard Rock Hotel in Tulsa, it looked like *Headbangers Ball* invaded an old lady's beauty parlor. Elderly women in pantsuits and orthopedic shoes shuffled around while mascaraed rockers with chunky wallet chains and biker boots strode by.

A heavyset woman approached a slender, long-haired dude slumped on a chair across from me and asked, "Are you the Night Ranger? I'm supposed to pick him up."

The two main guys from Anvil walked through the lobby. The Canadian band had recently achieved some level of renown after a touching and poignant documentary showed how they refused to give up the rock even after decades of failure. Steve "Lipps" Kudlow, the lead singer and guitar player, got clocked by an older lady pushing a luggage rack with a funeral arrangement on it. Autograph's 1985 tune "Turn Up The Radio" played

on the house sound system as slot machine chimes punctuated the beat and a few geezers with VFW hats yelled at their pals.

My interview subject was Oz Fox, guitarist for the Christian metal band Stryper, and the guy who had given me a single music lesson in Pasadena. He sat down on the couch and clearly didn't remember me. Next to him on the couch was his new wife, an attractive woman named Annie Lobert. The couple had received a lot of media attention when they broadcast their wedding ceremony on the Internet. Their unusual—and opposing—backstories made for intriguing media reports.

Born Richard Martinez, the young boy's parents had split up, so his musical exposure was divided. Mom was into pop, rock, and country while Dad grooved to jazz and urban music. One of the young Martinez's earliest musical loves was Buck Owens and His Buckeroos. The band had a 1966 record called *Open Up Your Heart* that featured chicken pickin' performed by the early rock and country legend James Burton, and it transfixed Martinez for hours on end. An aunt purchased a small-scale acoustic guitar for the boy and older uncles introduced him to Cream and Jimi Hendrix. His musical interest ultimately moved to Santana, Led Zeppelin, Black Sabbath, KISS, and UFO. By the time he was seventeen or eighteen, Martinez was leveraging his Sabbath obsession by mimicking Ozzy Osbourne's distinctive voice. The young man from Southern California proved so adept with that famously drug-damaged British vocal styling that his friends began calling him "Oz." Although he might be able to impersonate the Prince of Darkness vocally, the guitar was ever present.

"I wouldn't go out anywhere," Fox said. "I would sit in my room and practice and go over riffs and stuff and I would do that until three or four in the morning. Then, I would fall

asleep with my guitar on my lap and I'd wake up and it would be like noon. I'd be like, 'Oh man, I gotta get to school!' And school was already half over. So I would make it to vocal jazz ensemble class where I used to sing in a choir. And then I didn't want to go to the last period so I would split. Take off, go home, and get back on my guitar."

The budding musician established an early musical goal when his clock radio went off and the DJ introduced Van Halen's supercharged version of the Kinks classic "You Really Got Me."

"I went down and bought the album that day and sat there listening to Ed [Van Halen] playing everything, just going, 'Wow!'" Fox said. "So that was one of my goals, just to learn as many Van Halen songs note for note as possible. So I got through 'Runnin' with the Devil,' which was easy compared to all the other ones. I went through a handful of songs and just learned them all note for note. That's when I used to go jam with my friends and Robert and Michael Sweet were amazed by that—that I had Van Halen down."

Those friendly jam sessions with Robert and Michael Sweet led to a band called Roxx Regime. The friends eventually rechristened the group Stryper. The band's stage presence and branding came from the Bible verse Isaiah 53:5. It states, "But he was wounded for our transgressions, he was bruised for our iniquities: the chastisement of our peace was upon him; and by his stripes we are healed." Using that line as inspiration, the band assumed a bumblebee motif, and deconstructed their name to say it stood for "Salvation Through Redemption Yielding Peace, Encouragement, and Righteousness." The new unit hit the studio and started releasing Christian-themed metal records with their 1984 debut *The Yellow and Black Attack!*

While every other band of the era distributed pussy passes to hotties in the crowd, Stryper handed out Bibles to the audience during their shows. Their biggest hit was a syrupy power ballad entitled "Honestly," but their records and live shows were surprisingly heavy, with speedy guitar licks traded off by Michael Sweet and Oz Fox. During the eighties, Fox had a cumulus cloud of black hair, teased and bouffanted to the ceiling. But now he wore his curly locks more closely trimmed and sported a narrow soul patch running from his bottom lip to his chin.

Annie Lobert sat next to him. She had been a prostitute for sixteen years in Hawaii, Minneapolis, and Las Vegas. After leaving the sex industry, Lobert founded Hookers for Jesus, a faith-based organization" that focuses on helping people "escape and recover from the harmful effects of human sex trafficking and prostitution." The organization was leading a transitional home for women being rescued from human sex trafficking called the Destiny Center. Published reports said Lobert now walked the streets of Las Vegas handing out Bibles and administering to prostitutes. She was petite, with shoulder-length hair dyed blond on top and black underneath. During my chat with Fox, she occasionally nodded in agreement with his references to passion and dedication and rewards.

"I still play in bars for twenty people that I get sixty-five to seventy-five bucks a night to play because it's my passion," Fox said. "I just love doing it. It's what I like to do and I feel good doing it and I feel like I'm accomplishing something by doing that. Whether it's ten people in a bar or twenty thousand people at a concert, it really makes no difference to me because I'm playing."

Fox still devoted significant amounts of time to practicing, sitting down each day with an established regimen of exercises

and techniques to polish. And he maintained his usual reper-
toire of leads and licks for whenever they might be useful.

"I have a handful of licks I really like," he said. "I've got
some mixolydian stuff that I do. I do my own whammy de-
scending mixolydian thing. I've got a couple of pentatonics that
I do that are just kind of similar. I would use them all the time,
familiar licks that I just whip out because I know how to do
them really fast. But, what I'm doing is just striving to get to
the next level of playing every time."

That striving aspect, the desire to get better, to improve,
and to learn new things was a hallmark of the guitar hero. Even
though the crowds might expect to hear the same classic tunes
over and over again, the musicians by themselves never seemed
to stop pushing.

"You get a certain amount of dignity from being a great
player," he said. "And if you can pull something off that's really
amazing and you practice that hard enough, then people start
going, 'Wow, dude! That's amazing.' There's something that
comes from that. You get a self-gratification."

I tried to think of a time—*any* time—in my life when I've
done anything amazing. I was a decent student but never the
valedictorian. I played a fair bit of sports but didn't get any
MVP trophies or mash letters from college coaches. During a
study date turned grope session in college, I think a brunette
coed breathlessly said I was amazing as she stood up, leaned
against the desk, and pulled my head under her sundress. But
realistically speaking, it was probably her boredom with Ref-
ormation Drama that led to the exclamation more than any
spine-tingling performance on my part. Like mine, most lives
are filled with a sort of mundane, unremarkable level of skill
and success. Yet, guitar heroes get onstage every night and do

things the audience can only dream of. While the rest of us waver and debate and hesitate, these guys pour everything into their instrument with no reservations—a lack of reserve that I needed to learn.

AFTER FINISHING UP with Fox at the Hard Rock, I headed back to the concert grounds in my rented Pontiac to catch Ratt's press conference. They were one of my favorite bands from the eighties and I lived on their second full-length album, *Invasion of Your Privacy*, almost exclusively in the late summer and early fall of 1985. I was thirteen years old and devoting my summers to sleeping late and watching MTV at my grandmother's house.

The band's debut album on a major record label was 1984's *Out of the Cellar*. The cover art featured vixen Tawny Kitaen in rags, crawling across bricks and peering into an open hatch that seems to indicate rock and volume and sleaze bursting out of the catacombs below. The debut single, "Round and Round," was promoted with a video featuring Milton Berle in drag. The famous comedian's nephew managed the band and he convinced the entertainment icon to appear in the clip about a stodgy dinner party that is invaded, figuratively and literally, by rodents.

Ratt was tough, like their pals in Mötley Crüe, because vocalist Stephen Pearcy seemed just mean enough to whip a straight razor from his boots while guitarist Robbin Crosby was a giant of a man who could simply pound hecklers into submission. Their music was of the gritty Hollywood streets. But there was also a melodic, more female-friendly aspect than some of the era's rougher-edged groups. The members of Ratt

were very much aware of this more accessible vein. Early flyers that the band posted along the Sunset Strip promoted their version of "fashion rock."

Guitarist Warren DeMartini wailed on an arsenal of custom Charvel guitars including one with a paint job featuring two crossed swords, another axe with a bronze-gray snakeskin motif, a white one emblazoned with French text that translated to "too fast to live, too young to die," and finally a black guitar with a white skull and red blood dripped over the body. Slender with brown hair, quiet, and private, DeMartini was nicknamed "Torch" allegedly because of his speed on the instrument. In some ways, he was a perfect counterpoint to his guitar partner, Crosby, a blond hulk who was infamous for his self-destructive behavior, even during a time period marked by hedonism.

In the early nineties, the band disintegrated amid bickering, addictions, and lawsuits. Various incarnations of the group popped up here and there with a sort of revolving door of original members and Hollywood hired guns, without Crosby. He had been diagnosed with HIV some years earlier that then progressed into full-blown AIDS. Tormented with drug addictions, kicked out of the band, and penniless, the guitarist had swollen up to a reported four hundred pounds. He lived, for a time, in a Hollywood Hills pad that served as a shooting gallery for addicts and parasites. Those same friends stole all his guitars, platinum records, and valuables when he was out of the house taping a television show about addiction.

In a 1999 video interview included in the VH1 program *Behind the Music*, Crosby wears his hair pulled back in a ponytail that made his face seem that much puffier. His speech was slow and slurred but he claimed to have few regrets. In 2002, Crosby died of a heroin overdose. His bandmate Pearcy said in

the media that "he was going to go down in flames; he wasn't gonna fade away. That ain't his style."

Completely ignored by the mainstream, unreported on the nightly news and in the showbiz rags, Crosby's death stuck with me. I was too young to comprehend John Lennon's passing and too old to get overly wrapped up in Kurt Cobain's suicide when those events happened. Crosby's death, on the other hand, was one of the first times I lost a musician that had been important to me. It just seemed so fucking *sad* because he died broke, humiliated, and lonely. Years later, on one of my first trips to Los Angeles, I tried to find the last-known addresses of the guitarist. I abandoned the quest because as I honed in on the neighborhood, it was just too depressing.

But now Ratt was, somewhat, back together. Original members Pearcy, DeMartini, and drummer Bobby Blotzer were joined by guitarist Carlos Cavazo (most famous for being in Quiet Riot during their eighties heyday) and Robbie Crane on bass. Rocklahoma was one of their first major appearances together with this lineup, and I was thrilled to catch their performance and the press conference that preceded it. But I was running late.

I've always been a pretty conservative driver. A neurotic streak of paranoia and an aversion to risk have kept me from speeding too much. In fact, throughout my life, they've kept me from doing much of anything risky or daring, which undoubtedly pleased my nervous parents but didn't allow me to generate the kinds of tales of rock star excess that fascinated me so much.

In the late nineties, during the Internet boom, my colleagues regularly came to work hungover or still drunk and full of tales from the night before.

One morning, we sat in the cubicles and rehashed the previous night's adventures at Carpool, a garage-themed bar on Fairfax Drive in Arlington, Virginia. The winner of the evening was Robbie, a midfielder on our corporate soccer team who left early with a slinky blond who he had just met a couple of Goldschläger shots earlier.

As the conversation finally turned from the bar escapades to whether we should go to Red Robin or Macaroni Grill for lunch, Robbie staggered in. Before anyone could inquire about his conquest, he cut them off.

"I don't want to talk about it," he grumbled. "I just want some aspirin. Who's holding?" He thrust his open palm in every face that lined the hallway.

Unable to tolerate our pointless banter but equally unable to concentrate on any manner of productive work, Robbie immersed himself in Solitaire on the computer. When we finally got the initiative together to leave for lunch, Robbie refused to join us.

"I left the girl at my place," he said. "I gotta run home."

"The 'girl'? You don't even know her name?" asked Monique.

"I probably did at some point. But I'll be damned if I can remember it now," Robbie continued. "She's still at my house. I told her I would pick her up at lunchtime and get her back to her car."

Everyone patted Robbie on the back for the noteworthy score, but I was mortified. It was not from any streak of morality on my part, but instead from sheer jealousy that I never had the balls to pull off such an evening. If I met a woman at a bar, didn't catch her name, took her to my pad, fucked her on the pool table in the den, and left her there in the morning to sleep it off while I went to work, then I would, undoubtedly, return at

lunchtime to an open door swinging in the wind. I would step inside my house and notice how my footsteps echoed since the place had been emptied out of every piece of furniture, technology, art, and clothing that I own. As I stood there inside the empty box of stolen dreams, my ears would thunder as police sirens bounced off the walls. A jarheaded cop would stride up to me, demand to know if my name was Scott McKenzie and was I at Carpool last night. I would stammer an affirmative answer. He would mention a young lady's name, tell me she was fifteen years old, and that she had filed a criminal report accusing me of rape. Oh, and then, at the penitentiary infirmary, I would discover that the young lady had been Typhoid Mary and I would be diagnosed with every STD imaginable. That was my luck. Robbie's luck was that he got to go home to a bit of hungover afternoon delight.

That kind of paranoia-induced imagination kept me from taking random women home at night, kept me from shoplifting, kept me from cheating on my taxes, and so many of the other risks that young men take. And it also regulated my automotive activities to only the maneuvers that were approved in my high school driver's education class.

But, goddammit, this was Ratt. Their song, "Dangerous But Worth The Risk" was the ringtone on my cell phone. And besides, highways in Oklahoma are like airport runways. Flat and straight, you can easily do a hundred without even noticing. Yet, I was torn between the need for speed and the fear of getting caught. I nervously pressed the car to about eighty-five and kept my eyes peeled for cops. I was too afraid to go much faster. But I did manage to keep looking down at my phone and hitting the Refresh button.

I had been playing e-mail tag with Jamie Talbot, the band's

manager all day long. I had hoped to interview DeMartini in the backstage area at the Rocklahoma grounds.

Talbot's e-mails stopped in the late afternoon and early evening with nothing resolved. Cursing because I hadn't passed a single policeman or state trooper on my nerve-wracking drive and my fears were unfounded, I pulled into the Rocklahoma parking lot and dashed to the media tent. I could see that the Ratt press chat was wrapping up. The band walked to awaiting golf carts and I spotted a tall man in shorts and a T-shirt. I ran over and asked if he was the manager.

"It's a really hectic weekend for the guys," he told me. "Let's catch up next week, maybe do something later in the tour." It dawned on me that my efforts amounted to nothing and I stood in the dusk and watched the convoy of golf carts and rockers pull away. I caught Ratt's show that Friday night and the band sounded great. But it was still from a distance, from a sort of remove, along with the other people who were simply fans and didn't get to interact with their favorite musicians.

I should have driven faster—an apt metaphor for so much of my life.

7

HITTING THE ROAD

Now that KISS has become accepted family entertainment (and as the shock value of video games, movies, and other entertainment has continued to push cultural boundaries), it's hard to remember that parents once feared the band. There were the urban legends and rumors that the group's name stood for "Knights in Satan's Service" and that Gene Simmons had a cow tongue surgically attached to his mouth. As recently as 1996, when I saw the band perform in Tupelo, Mississippi, conservative church groups protested what they laughably interpreted as an evil influence on the community.

As much I might have fantasized about crashing DeLoreans and banging groupies when I was a kid, the only thing KISS actually did influence me to do was develop an arguably overactive imagination. What critics fail to recognize is that ten-year-old boys aren't going to comprehend the political nuances of Bob Dylan. I was a highly literate kid and I didn't get the full meaning of Mr. Zimmerman asking senators and congressmen to heed the call. Lyrical sophistication and grand ideals don't get a child's attention. Blowing shit up does. Wearing demon

boots does. Pretending to be a superhero, belching fire, and flying across a stadium definitely does.

With each KISS record, the group altered their outfits. I awaited photos of the new costumes with the anticipation of a fashion blogger looking for the first Oscar de la Renta model to horse stomp down the runway. I microscopically cataloged each detail of every demon boot, every cape, every chain and ring.

With each tour, the band changed the stage set from post-apocalyptic ruins to a giant tank to a Statue of Liberty theme. There were new ramps, new effects, new explosions, new spotlights.

These visual details added to the experience of being a KISS fan—or at least an obsessive one like me. Art was not a strong suit, but I drew pictures of the band and placed them in character dossiers like the ones in the Marvel Comics encyclopedias.

Because of the way I stressed over those details, music was not just background noise while I pursued some other hobby like assembling models or racing toy trains. No way. I fucking *worked* at listening to KISS. I could easily lose five or six hours at a time with records and eight-track tapes. I would start trouble around the house for the express, strategic purpose of being sent to my room, because it meant several hours of uninterrupted music. It was a fully immersive experience that left me sweaty and exhausted. Frequently, that sweat was a result of lengthy and extensive marathon performances of not-quite-air guitar.

Not content to simply flail away at mere air, I developed extensive props to assist in my fantasy stage shows. I had the obligatory tennis racket as all kids do. But mine had a strap and its rounded shape made me think of a Les Paul. I also had another instrument fashioned out of a BB gun (yep, the very same

Christmas gift that resulted from the newspaper mix-up when I was seven) and stuck a sort of cardboard tube on the end. Depending on how I bent it, that cardboard thingy could be the headstock of my guitar or a silencer on a machine gun, based on whatever I was pretending at a given moment. My toy box was an amplifier where I could prop my foot during a particularly grueling solo or where I could sit down and strum during an easygoing tune like "Hard Luck Woman," KISS's take on Rod Stewart's "Maggie May"–era hits. A few science fiction and fantasy paperbacks scattered around served as guitar effects and wah-wah pedals. A section of a cane-pole fishing rod made for a great microphone stand.

In my bedroom, a green sculpted carpet covered about half of the hardwood floor. The carpeted portion marked the boundaries of my stage; the hardwood area was the audience. My twin bed was positioned parallel to the edge of the carpeting/stage but was farther back. So it was a higher level to the set, like when sections of the KISS stage would rise during "Black Diamond" and propel the musicians into the heights of the arena.

I would go through the entire *KISS Alive!* concert recording and then move immediately into the songs from the sequel, *KISS Alive II*. It wasn't unusual for these shenanigans to last for three and a half hours. Bruce Springsteen doesn't work as hard at a performance as I did when I was a ten-year-old pretending to hit every single solitary one of Ace Frehley's notes.

MY HIGHLY DEVELOPED imagination came in handy when I was trying to master the exercises my guitar teacher Doug had given me the previous few weeks. In my head, I sounded great and my fingers danced across the fret board with

the ease of a geek playing Half-Life on the computer. But in reality, I wasn't as accomplished. There were times when I thought playing guitar was the most difficult challenge in the world.

You can go into the driveway and sling a basketball in the general direction of a hoop, and occasionally you'll make a basket. You may not be able to bend it like Beckham or head butt it like Zidane, but you can kick a soccer ball to a friend. The most frustrating video game challenge can usually be licked after getting pummeled for an hour before you locate the secret hiding spot that allows you to take out the bad guys with a sniper rifle. With many hobbies, you can achieve small successes in a relatively short period of time.

However, I seemed to take weeks to even be able to play five-second segments of music. But I did find myself enjoying the labor. It was quite common to lose two hours just practicing scales. I would go through four or five slow attempts and then speed up my efforts. I would go faster and faster until things fell off the rails and lurched to a crash of misfretted strings, muted pick strokes, and general cacophony. At that point, I would simply start over, slowly plucking out each note of the scale and build again a house of cards of delicately balanced and precarious notes.

And I *was* seeing improvement of a sort. I wasn't blazing through ten-minute progressive rock opuses, but I was hitting the chords more cleanly, and my work on arpeggios was getting more fluid and smooth.

The solo to Twisted Sister's 1984 smash hit "We're Not Gonna Take It" involved barely more than one string, four frets, and just one or two fingers. Simply move one digit from the fourth fret to the fifth and then let go. I had that sounding very recognizable.

I could also get out the first dozen notes of Pink Floyd's stoner ballad "Wish You Were Here" in a fashion that was less horrific sounding than a garbage disposal loaded with rocks.

And when I couldn't produce anything pleasing, I concentrated on alien sounds and helicopter rotor patterns. The manufacturer Line 6 built their reputation on digitally modeling sounds of famous guitars throughout history. Instead of investing millions in vintage instruments, you just hit a button and suddenly have the tone of a '59 Les Paul or a '62 Strat. They also deciphered the effects settings for well-known songs so you could easily dial in the echo of U2's "I Will Follow" or the crunch of ZZ Top's "Tush." When a simple major scale became too repetitive, I would set the amplifier to Chopper Dan or Spaz Logic to make noises better suited to horror movies than a smooth guitar tone. Decades ago, such musical endeavors would have required hours of fiddling with dozens of effects pedals and amplifiers placed throughout the house. With modern technology, you can dial up any tone with the push of a button. It certainly made repetitive practice tasks much more enjoyable.

Making contact and securing a chat with the guitar players on my list were also yielding small successes but no home runs. I finally heard back from Slash's manager, who said to come back after I had more commitments from other musicians. Mick Mars's management at 10th Street Entertainment responded to probably one out of five queries and said they would check but I never heard back. Phone calls to their office were also directed to a voice mail for an employee that I began to suspect did not exist. I got an e-mail from someone who worked with John Sykes—a guitarist who had performed with Thin Lizzy, Blue Murder, and Whitesnake—with the axe slinger's phone number and instructions to call. But he never called me back.

I wasn't interested in the biggest names anyway. I wanted to learn from the guys in the trenches, the musicians further down on my guitar hero constellation, the guys who weren't given book deals and movie documentaries about their lives. They were the ones who truly lived the single-minded determination that fascinated me. They had an uncompromising, unavoidable drive in life that I wanted just a small portion of.

So I decided to do what the rockers do: I hit the road.

8

A SOGGY COUNTY FAIR

In high school, I had a date with one of the contestants for our local Miss Bourbon County Fair pageant. I waited for her to finish rehearsals outside the grandstand, next to a burgeoning summer fairground. I was shocked at the grotesque menagerie of guys constructing the rides. It was surprising that some of these mongrels could tie their own shoes, much less safely operate high-speed, high-altitude rides. Now, infield in rural Pennsylvania, I felt the same pang of dread as I approached the Clearfield County Fair.

I've never understood how people can ride the roller coasters and whirligigs at county fairs. It's one thing to put your life in the hands of the Walt Disney Company, where presumably they employ legions of safety inspectors and quality assurance engineers to exhaust massive budgets on permanently installed roller coasters. But it's another thing entirely to fly upside down on some temporary erector set in a muddy field.

Yet evidently the local residents did not share my concerns, as plenty of youngsters hurtled into the gloom of a rainy evening. During the brief moments when the rain stopped, a damp

fog hung in the air. I kept buying corn dogs, one after another, just to be able to sit under a concession stand's tent and dry out for a few moments.

Clearfield was about two and a half hours northeast of Pittsburgh. The county fair had been in existence for almost 150 years and attracted a surprising number of national bands to the grandstands. The week's worth of headliners this particular year included shock rocker Alice Cooper, *Dancing with the Stars* celeb Julianne Hough and musician Dierks Bentley, a tractor pull, *American Idol* winner Kelly Clarkson, and on the final evening, Ratt.

I HAD BEEN trying to reach Warren DeMartini of Ratt since Rocklahoma. I would get a few responses, then silence, then a few more. One employee would hand me off to another. They were nice enough; we just weren't getting anywhere. Finally, I ended up with a particular publicist at the record company. She seemed interested in an interview, but we could never finalize any details.

"How about at the Clearfield, Pennsylvania, date?" I asked via e-mail. Looking over the Ratt tour schedule, this appearance was only about five hours from my house. I figured I'd have a nice drive, see the show, and get my meeting with DeMartini. Rocklahoma was a big event, even though the final attendance had been poor. It was understandable that the band was swamped with obligations. But a county fair in rural Pennsylvania? I guessed they would be lounging around all day at the local coffee shop or something.

The publicist said that wasn't a good weekend, maybe we could do a phone interview the following week. But I wasn't

deterred. I figured I would go to the show and see if I could manufacture some sort of meeting. I e-mailed the publicist and said I'd love to chat whenever DeMartini had time in the coming days and weeks, but that my travel was already booked for Clearfield and that I would be in attendance, whether I had an interview or not.

"I'll just sit back and enjoy the show," I e-mailed. "Maybe talk to some fans."

Ticketmaster or other online ordering options don't exist for the Clearfield County Fair. You have to call the box office to place advance orders for tickets. The phone rang and rang and then finally a grandmotherly sounding lady picked up.

"You can just buy your tickets at the gate," she said. "You don't have to get them ahead of time."

"I'm coming in from out of town. I'd like to get it settled."

She sighed. "Well, okay, but there ain't going to be no problem with tickets."

I asked how many advance seats they had sold. She laughed and said the number was about two hundred.

"How many people does the venue hold?"

"Six thousand," she replied.

AT THE TICKET window the day of the show, an employee said that ticket sales were up to about fifteen hundred. I had purchased higher priced seats, closer to the stage. They were located in an infield area with folding metal chairs set up on the grass.

"You might want to sit in the grandstand," the lady said. "It's a bit farther away, but it's covered and will be dry."

Whoever booked the bands for the Clearfield County Fair

was creative. I had to give them that much. The warm-up act for Ratt was none other than a former member of the Ramones.

Marky Ramone wasn't the band's original drummer, but he is described as being the only living member of the longest-running lineup of the group. Real name Marc Steven Bell, he was christened "Marky" when he joined the Ramones in 1978. In the years after the band finally dissolved, Marky had recorded with different acts and also toured under his own banner. He also took a page from the Gene Simmons merchandising play-book by creating a line of clothing in partnership with Tommy Hilfiger and then releasing Marky Ramone's Brooklyn's Own Pasta Sauce, a pretty authentic sauce with a little bit of a kick. Like Paul Newman, he saw big money in foodstuffs.

A massive black banner hung from the lighting rig on the stage. It read MARKY RAMONE'S BLITZKRIEG and featured a nod to the New York band's iconic eagle seal logo. Behind it was an even bigger banner with Ratt's name in silver font with red outlines.

A linebacker-size security guard stood by the stage and I handed him a business card. I decided to play the working-stiff-getting-screwed-by-the-boss card.

"Hey man, my editor is all over me for this interview. I need to speak to the band. Can you help me out?"

"You on the list?" he asked as he spit on the mud at his feet.

"Nah, there was some kind of screwup. I don't know what happened."

"You'll have talk to the office. I can't do nothing with-out . . ."

We both looked up at the stage as the security guard let his sentence trail off, unfinished. Six young women in pastel-colored pageant gowns walked between the amplifiers and

scaffolding. They all wore sashes of different colors and two of the girls had tiaras. A voice came over the PA and instructed the crowd to welcome the new fair queen and her court, escorted by the previous year's winner, who was ending her reign.

The Clearfield County Fair queen rules stipulated that contestants must not enter any other fair queen competitions, must be of the female gender, must be single, never married, have had no children, and must agree to neither marry nor become pregnant during their year with the crown. And they must be willing to work around livestock, including but not limited to cattle, horses, sheep, swine, and poultry.

Standing in front of Marky Ramone's banner, the queen thanked the audience and the fair organizers, congratulated her court, and stressed her commitment to promoting an agricultural-based platform.

As the girls were leaving the stage, Marky Ramone's Blitzkrieg stood to the side. Marky was in the trademark jeans and black T-shirt, while his female bass player, Clare B, had a multicolored mohawk, tight shorts, and thigh-high socks. Once the pageant queens were clear, the group kicked off a buzz saw set. It was too loud to continue chatting with the security guard and he seemed unwilling, or unable, to help in any event. He just kept shaking his head no and pointing in the direction of the grandstand, where the front office was located.

By the time Ratt finally began their show with an intro tape of a revving engine before kicking off "Tell The World," the drizzle had turned into a downpour. I had one of those disposable ponchos so I was somewhat protected, although my shoes were so soaked that water shot out the seams every time I took a step.

DeMartini played his white Charvel with the French text

for most of the show, switching to an inverted version, a black body with white lettering. He wore a T-shirt with a pinstriped vest. His studded-leather belt was slid over so the buckle was closer to his hip than to the usual spot, a move made by many guitarists to protect the backs of their instruments.

On this tour, the band was performing 1984's *Out of the Cellar* record in its entirety. This had become a common ploy for legacy acts from the eighties. Originally, this strategy was just for concept albums such as when Queensrÿche played *Operation: Mindcrime*. In the case of a thematic piece of work, it made sense to do the whole thing. But more recently, bands had begun to commemorate major milestones by playing all the songs off one record. Judas Priest, W.A.S.P., and Mötley took their turns with the concept. And since it was the twenty-fifth anniversary of the Ratt 'n' rollers releasing their reputation-making record, they trotted out some seldom-performed songs from the disc.

It was basically the same show I had seen at Rocklahoma, but new guitarist Carlos Cavazo seemed more integrated in the group by this point. And drummer Bobby Blotzer brought out his son Michael to play drums on "You Think You're Tough" while he cheered from the sidelines, like any proud parent at a neighborhood soccer game, just with more volume.

The group plowed on in spite of the weather and sparse crowd. Singer Stephen Pearcy took a moment during "Lack of Communication" to congratulate the queen of the fair and her court as they walked by the security guards on the ground in front of the stage.

My crass pal Henry felt the fair queen and her court might be a way to get backstage. I had texted him throughout the day, describing the bounty of fried foods and meats served on a stick

at the fair. He might be the only person on the planet who had a more unhealthy diet than I did, so junk food was like porn to him. He also used emoticons and text messaging abbreviations more suited to a twelve-year-old.

"Didn't U say those chicks were going backstage? That's UR fucking chance 2nite," he wrote.

"They're high school girls, dude," I texted back.

"U don't have to hit on them, I'm not being fucking sleazy. Just talk. Make friends. Theyll B impressed with the bigtime writer. Won't kno better."

"My intentions won't matter. It will still look creepy and I'll still get arrested."

While I was firmly committed to my quest of learning from guitar heroes, I couldn't bring myself to enlist unsuspecting teenage girls. I enjoy locker-room humor and *Girls Gone Wild* as much as the next guy, but I never understood the rich musical history of hard rock paeans to jailbait. In the eighties, Bonham had a song called "Wait for You" that featured lyrics about how the girl was too young. Times were, admittedly, different in previous eras. An accepted part of rock-and-roll lore is that Lori Maddox was fourteen when she took up with Jimmy Page, and Jerry Lee Lewis went a junior high school class better when he married his thirteen-year-old cousin. But I couldn't do it, even though I was only after a backstage pass and nothing more.

It was still summer, but I cranked up the heat in the car, trying to dry out my shoes as I drove to the Holiday Inn after the concert. This trip had been a bust. If I had been the kid in *Almost Famous*, *Rolling Stone* would have fired me. In my room, I logged on to the Internet and checked my e-mail. Good news: a note from Stacey Blades, guitarist for L.A. Guns.

"Hell yeah, bud!" he wrote. "Love to have ya."

Smiling, I made a reservation to pick up a rental car at the Minneapolis–St. Paul airport. Then I checked driving directions from the Twin Cities to Algona, Iowa, while also looking up the tablature to a tune called "The Ballad of Jayne."

I sat in my Clearfield, Pennsylvania, motel room and started plucking out the opening notes to the song on the unamplified B.C. Rich guitar before catching a few hours of sleep.

GUNS, BLADES, A MECHANICAL BULL, AND SOME USEFUL CHORD TIPS

When I walked into Biff's Sports Bar & Grill in Spring Lake Park, Minnesota, the massive televisions around the venue showed soccer highlights and close-ups of Cristiano Ronaldo's ubiquitous step-over move. Fluorescent lights and beer company neon signs kept the joint brightly lit. It seemed an odd spot for an eighties metal band to play, but the big banner outside proudly welcomed L.A. Guns. The guy at the door said they had 515 people in the bar, with a maximum capacity of about 650.

L.A. Guns had a long and torturous history in the world of eighties metal. In some ways, the band is perhaps most well-known for the folks who *left* the group. In the early days, there was an incestuous mix of musicians gigging on the Strip. You might sing for my group tonight. I'll sit in for your band

tomorrow. It was a time of band-related bed hopping for Los Angeles musicians. In a move that changed the face of music history, segments of L.A. Guns joined forces with components of Hollywood Rose to form the iconic street urchin band that famously welcomed American teenagers to the jungle. According to rock journalist Stephen Davis, the first time the combined unit performed was March 26, 1985, and they promoted the gig with flyers that proclaimed, "L.A. Guns and Hollywood Rose presents the band Guns N' Roses."

While former bandmates Axl, Slash, and Izzy became the biggest band in the world, the remaining arsenal of L.A. Guns soldiered on. During the eighties, the group had hits with "Never Enough" and "It's Over Now." Their biggest single was "The Ballad of Jayne," which started out on the acoustic guitar before moving into electric territory. The band filmed a video of the song at a mansion that had reportedly once been owned by Imelda Marcos. That version of the band, the one that most people think of when they hear the tunes on the radio, consisted of Tracii Guns and Mick Cripps on guitar, Kelly Nickels on bass, Steve Riley on drums, and Phil Lewis on vocals.

By the late nineties and the early parts of the following decade, describing the genealogy of the Guns guys had become more complicated than unraveling the lineage of Henry VIII's various legitimate and bastard children.

No less than twenty-five musicians were part of the L.A. Guns family tree by the late 2000s. And to make matters more confusing, there were now *two* competing versions of the band, both using the same name.

In the early 2000s, founding guitar player Tracii Guns left his namesake group to form an outfit with Mötley Crüe bassist Nikki Sixx called the Brides of Destruction. The group also

featured a drummer named Scot Coogan, who performed with Ace Frehley and George Lynch on their solo endeavors. The band released a record and toured small clubs.

While Guns was gigging around with Sixx, his old bandmates wondered what they were supposed to do with their lives. They had to make a living somehow, so they pressed on under the L.A. Guns moniker. In 2003, Phil Lewis and Steve Riley hired Stacey Blades to take the guitar slot and they hit the road. With the exception of a few bass players rotating in and out, this version had been relatively stable over the years.

The Brides of Destruction didn't really go anywhere and the early wheels were being put into motion for a Mötley Crüe reunion that would eventually net a reported $125 million deal. So the Brides fell apart and Guns was left to resuscitate his own act, using the same band name as his former colleagues. He hired vocalist Paul Black, who sang on the first band demos in the eighties but had since been replaced by Marty Casey, who was a contestant on the reality show *Rock Star: INXS*. He was then replaced by Jizzy Pearl, who sang for Ratt during Stephen Pearcy's exile. When Pearl left, the mic was handed to a female singer named Dilana Robicheaux, a contestant on the second season of the *Rock Star* reality show. The story also circulated that his son Jeremy played bass for this version of the band. Problem was the bass player's real name was Jeremy Carson and he was no relation to the axe slinger.

So that was L.A. Guns—as complicated as the plot of *Lost*, just with bigger hair.

Tracii Guns claimed that as the bandleader and author of the group's trademark riffs, his version was the *true* L.A. Guns. Phil Lewis countered that his voice was what fans heard on the radio, so *his* version was most accurate to listener memories.

The end result was that audiences had to do quite a bit of digging prior to purchasing a ticket because, at first glance, you could never be sure which version you were going to see at a local bar.

All of this is to say that I wasn't surprised when a guy with a mustache and a Golden Gophers T-shirt at the urinal in Biff's Sports Bar & Grill yelled, "Tracii Guns is gonna rip up the stage tonight!" even though Stacey Blades was the only axe man in attendance.

I HAD MET Blades a couple of years earlier at his West Hollywood apartment, after a mutual friend introduced us. Graciously, he invited me to swing by his place to talk. Tall and slender, with long black hair, Blades kept his door open and stood in the hallway as he smoked a cigarette. He wore jeans and a wifebeater that showed off the flames-and-stars tattoo on his right shoulder. The apartment was covered with banners and posters from his group, mementos of past tours and appearances. A copy of Mötley Crüe's seminal rocker sleaze manual *The Dirt: Confessions of the World's Most Notorious Rock Band* sat on a shelf.

In his bedroom, a rack of guitars held six or seven instruments. In addition to a Les Paul and some B.C. Rich guitars, Blades had, at that time, collaborated with an upstart manufacturer called TTM operating out of Palm Desert, California. They were planning a Stacey Blades signature model and the current instrument he had in the apartment, called the Devastator, had a reverse headstock and a yellow, white, and black graphic.

Born in Canada in 1968, the guitar player was named Brian and given up for adoption. A week later, Peter and Shirley

Ingram took him in. His right leg was twisted to the left and doctors had to break the limb to reset it. This resulted in the young boy being fitted with braces to enable the leg to heal properly. Blades said that for the first three years of his life, he was in and out of the hospital.

The Ingrams were a piano-playing family that included a relative who evoked one of the flashier musicians of the sixties and seventies.

"My great-uncle was like Liberace," Blades said. "He had the big rings and the velvet suit. He was amazing. He would come over every Sunday and God he was so good." The family enrolled Blades in lessons and he did the piano recital thing for two years, but preferred to rock out instead. He convinced his mother to buy him a guitar, first an acoustic model and then he worked his way up to an Ibanez cherry sunburst Les Paul copy around the age of fourteen.

"I was like, 'That's it. This is what I'm doing.' I would just stand in front of the mirror with my guitar and envision the lights on me and stuff like that. My buddy used to make these light gels. He had track lighting down in his room and he'd make the gels and I'd go over there. We'd put all the lights up and crank up live Ozzy and pretend we were just rocking them out."

Convinced of a destiny of rock stardom, the young guitar player was not certain that Brian Ingram was the most attention-grabbing name. Elementary school classmates had bestowed the nickname "Blades" years earlier. So that was a well-worn label. He adored Cheech and Chong's movie *Up in Smoke* and thought Stacey Keach was hilarious in the role of the fanatical Sergeant Stedenko. So he assumed the actor's first name as part of his *nom de théâtre*.

Years later, with the two rival versions of L.A. Guns dueling

it out on the highways of America while their fans argued on the forums of the information superhighway, detractors thought Blades's appellation was a deliberate play on their favorite guitarist's name.

Tracii Guns: Stacey Blades

Take an androgynous *y* name, add a weapon, and there you go. Maybe you could form an entire band with musicians called Darcy Shanks, Mikey Grenades, and Ashley Bayonets.

Blades's name came from his high school years, long before he ever thought about joining L.A. Guns. However, he was certainly a fan of the band in those days. When he first got a copy of the group's eponymous debut, he thought the band "was everything I wanted to be."

In his late teens and early twenties, Blades lived in Toronto, performed with a series of local metal bands, and worked day jobs at places like the Labatt's brewery and a customs broker where he ran around town dropping off documents. He saw an ad in *Metal Edge* magazine about Roxx Gang holding auditions for a new guitar player.

The group had originally formed in Florida and released a debut album called *Things You've Never Done Before*. They were a fairly obscure band, even for a metal geek like me. I was aware of the name, saw them in a few magazines, and mainly noticed the band because they were produced by Beau Hill, a longtime industry veteran who worked with Ratt. After band infighting and record company problems, the main lineup of Roxx Gang disintegrated and a revolving door of musicians ensued, creating an opportunity for an enterprising young axe slinger from Canada to enter the picture.

Blades dashed off a press kit and, a few days later, was invited to Tampa to jam with the band. Besieged by a vicious flu

and crashing in a shithole motel, he practiced the Roxx Gang tunes around the clock, crushed the audition, and got the gig. It was a major career break for Blades, but also one that established a pattern of joining existing bands, as opposed to creating something from scratch.

But the midnineties were the grunge era of flannel shirts and bellyaching kids from the Northwest so Roxx Gang didn't have much of a chance—particularly not when the inevitable power struggles and personality conflicts cropped up. Blades supplemented his music income with a job for a timeshare company hawking vacation packages and eventually started stashing money in what he called his "L.A. Moving Fund." He got married, quit Roxx Gang, and then drove cross-country pulling a U-Haul trailer.

Once in Los Angeles, Blades played in a couple of bands that didn't last and made some bucks as a television extra, filling out the audience on talk shows and game programs. Then a friend introduced him to L.A. Guns front man Phil Lewis. On a rare rainy day in Southern California, Blades drove to a North Hollywood rehearsal space to audition for the band.

"I made sure that I went in there prepared," Blades said. "I want to impress these guys, which I did, you know. I remember Phil coming over to me after like two minutes and giving me a hug. It was like an instant chemistry."

Blades came from a similar musical background as Tracii Guns, which helped ease his audition. "Tracii's influences are more or less the same influences that I have," Blades said. "So it was a no-brainer to step in and play those songs."

The group offered him the gig on the spot. Blades had joined his second established band, a huge accomplishment that helped soothe the reality of a tumultuous personal life that

included a divorce from his wife. But it also cemented his identity as what he calls a "replacement rock star."

THE PLAN HAD been to see L.A. Guns perform at Biff's Sports Bar & Grill in Minnesota on Friday night, then to make the three-hour drive down to Iowa on Saturday morning to see them again. The group was scheduled to perform late in the afternoon at Rock Gone Wild, a four-day festival featuring acts like Warrant, Jackyl, Puddle of Mudd, Twisted Sister, Dokken, Great White, and many others. Altogether, the festival's marketing bragged of more than fifty acts rocking in the Iowa wilderness. I was looking forward to hanging out with Blades and meeting his pal Jon Levin, an attorney who now played guitar in Dokken.

Just weeks prior to Rock Gone Wild, there were media reports about a change of location. Less than fourteen days before the event, news leaked out that the entire festival had been canceled. Internet message boards were full of ripped-off fans who had invested money in tickets, transportation, and lodging. Plus, all the bands had organized their travel schedules around the event. The cancellation happened on such short notice that L.A. Guns decided to stay in Minneapolis. It was too expensive to change their flights and other arrangements, so they were going to chill for the weekend and hopefully pick up a booking for Saturday night.

L.A. Guns hit their dates mainly with fly-ins, like Great White. The economics of being gone for months on end with a bus and trucks was too much, which could be frustrating because the band was dependent on the local venue to provide much of the gear.

"The whole face of touring is changed, especially with the price of gas," Blades said. "You always wonder, 'What kind of amp am I going to have?' or 'Is the gear going to work?' It's hit or miss. The good thing with a bus tour and staying out is that you're situated, you have your own gear, you can get comfortable. That's one thing I do miss about going out on a bus. It's the luxury of playing on your stuff every night. But then you're paying five grand a week for the bus and then the gas on top of that."

Blades caught flights with two guitars bungee corded together and heavily padded. "And we'll take our merchandise. Steve [Riley, the drummer] takes cymbals and a box for the snare drum and pieces."

In Minnesota, the group stayed at a Quality Inn near the Holiday Inn Express where I had gotten a room. I could see their white rental van in the parking lot. Blades and L.A. Guns were a perfect example of the weird borderland that was home to many hard rockers and guitar heroes.

They never got any coverage in *Rolling Stone* or other music magazines, except for a single article about the dueling versions of the band. They didn't play arenas packed with tens of thousands of fans, unless they were on a major festival bill. And financially they didn't make anywhere near the amount of money that we expect of rock stars. Blades's Ford Thunderbird was far from the customized Lamborghinis and Bentleys shown on MTV *Cribs*. Detractors said groups like L.A. Guns should "pack it in" and "give it up."

But how many other jobs allowed people to travel the globe? After our first meeting at his apartment, I stayed in touch with Blades and he sent e-mails from Scandinavia, Japan, Australia, and Europe. Over time, I had seen him perform in Dayton,

Los Angeles, Minneapolis, and Cleveland. There was always a crowd, always people wanting an autograph, always a woman who wanted a photo. There was always someone who wanted to rock. And Blades was happy to oblige them.

"It never gets old," Blades told me. "I mean, I still get butterflies sometimes. It's kind of weird. But that's what keeps you going after so many years. For me, it was always that welcoming crowd—the energy that you get back from them. There's nothing like being on the road and you've done four or five shows in a row and the crowd's packed. All the pistons are pumping and firing and all the engines are firing. The band sounds great. The crowd is great. They're digging you."

THE FRIDAY NIGHT show had been well promoted by the bar so the place was crowded. The audience at Biff's tended to wear jeans and athletic jerseys—lots of Viking gear and University of Minnesota sweatshirts.

The bar was in a strip mall, nestled among the Beauty Nook, Jackson Hewitt tax service, and Rong Cheng's Chinese takeout. They employed an empty storefront nearby as a dressing room. The windows were covered with butcher paper and banners and a bouncer stood outside by the door. Folding tables were lined up like in a school basement and the band gathered around, nibbling on burgers and such, preparing for the show. To hit the stage, they exited the storefront, walked around the corner of the strip mall, and entered a back door at Biff's, which led right to the stage.

The L.A. Guns set list was chock-full of songs from the eighties catalog like "Sex Action" and "Rip and Tear." Of course, the big tune of the evening was the lighter-in-the-air

"The Ballad of Jayne." By that time, there were four women on the side of the stage watching the musicians. I didn't know which ones might have been girlfriends or wives traveling with the band and which ladies were local, looking for a shot at a rock star.

After the show, the band hung around for the meet and greet. Like Great White, they were patient and accommodating. While hard rockers who play clubs may very well get frustrated, irritated, or have attitudes, they're generally smart enough to save it for the dressing room. When you're drawing hundreds of people—instead of thousands or tens of thousands—each one of those fans counts. A local girl who worked at the bar manned the merchandise booth, selling T-shirts, compact discs, and copies of Blades's book *Snake Eyes*. Merchandise was a major boon to all bands, regardless of stature. The big arena acts can pull in tens of thousands of dollars a night just off T-shirt sales. CNN reported that KISS generated $700,000 per show just in merch. For a bar band, it'll be much less, but still a useful cash injection into the bank account.

The storefront dressing room was relaxed as the band cooled down after the meet and greet. Some guys drank a few beers; others downed snacks from the bar. I had grown up with Caligula images of the magical, mystical place known as "backstage." But the overt debauchery of the eighties was largely a thing of the past.

Metal journalist Lonn Friend had warned me. "There aren't groupie scenes to speak of," he said. "Hang out backstage at a Def Leppard show now. It's like family hour."

Instead of chasing naked women around Biff's with a squirt gun full of vodka in one hand and a video camera in the other, Blades and I chatted with bass player Kenny Kweens about

Judas Priest and Iron Maiden songs. The rockers sang out the riffs to tunes like "Hell Bent for Leather" and "Can I Play with Madness." Musicians have an uncanny ability to verbalize music. Normal people's vocabulary is limited to the *duh-duh-duh—duh-duh-DAH-duh* of the opening riff to "Smoke on the Water." Really simple stuff. But pros can "speak" a complicated riff in such a way that it's instantly recognizable.

Biff's employees drove the band, and a couple of women, back to their hotel and I returned to my room. I pulled out the tabs to "The Ballad of Jayne." The introduction featured a cool slide from the third fret to the fifth. I retrieved my guitar, turned on *SportsCenter* to cover the noise, and tried out the tune. I worked on it until the sun came up and the movements began to feel somewhat smooth, but it still sounded off. It was recognizable, but not correct, like a Bizarro version, half a fret off and full of buzz and bother.

AN IHOP WAS located squarely between my hotel and the band's. Over waffles and French toast, I told Blades about my struggles with "The Ballad of Jayne."

"It's tuned down, you know?" he said.

"No, the tab I looked at didn't designate that."

"Yeah, it's a half step down."

That's why my attempts were recognizable, but not quite right. Standard tuning on a guitar is E-A-D-G-B-E, something that I memorized with the phrase "Every asshole deserves good buttered éclairs." But rock songs often feature alternative tunings. Alternate tunings are generally employed to allow the band to explore a wider range of moods and atmospheres. They are also sometimes used to accommodate a singer's range, or

lack thereof. If an older vocalist could no longer hit the high notes, tuning down moved the whole song into a lower gear, so to speak. It's like finding a way to make fourth gear in a Corvette work when a broken transmission prevents you from shifting into fifth. "The Ballad of Jayne" was in D-G-C-F-A-D instead of the standard tuning my guitar was set to.

"Once you're tuned properly, just make a C major chord, then slide it up two frets," he advised. "That's the opening riff. Then G to a D."

I rushed back to my room, adjusted the tuning on my guitar, and checked the tablature I had copied from the Internet. Tabs are often the work of amateurs who deconstruct their favorite tunes in an effort to play them. As a result, they aren't "official" notations of the songs and can, frequently, be wrong.

After implementing Blades's tips, I quickly churned out a totally reasonable facsimile of the opening riff.

I turned off the television, unafraid of anyone hearing me play.

TO REPLACE THE lost Saturday gig at Rock Gone Wild, the guys in L.A. Guns worked out with Biff's management to perform an acoustic set. Blades and Lewis had been doing these stripped-down affairs at venues around the country, frequently at a casino in Wisconsin. The bar dispatched someone to procure acoustic guitars for the gig and the gang settled in for a relaxed show.

Unlike the previous night, when the band's performance had been well publicized, Biff's was largely empty. I arrived at the bar early on Saturday night. An odd assortment of activities was being set up throughout the space. On a section of green

carpeting, under the faux stained glass hanging lamps common in pool halls, a man in a Menard's construction apron set a cross-section of a tree trunk onto a folding metal stand. It was like a giant pizza, about ten inches deep and a couple of feet across. Eight nails stood around the periphery, inserted just enough to stay vertical. A large hammer was placed on a circle of red paint in the middle. The guy placed a fluorescent-yellow plastic bucket full of safety goggles below the stand. If you could drive all eight nails into the wood, without mis-hitting one, you got a free beer or something like that from the bar.

Employees pushed aside tables and bar seats to clear a wide section in the middle of the room. In that space they rolled out what looked like orange garbage bags or maybe a huge tent. There was a structure in the middle of it that was bolted down and weighted. Pumps kicked on and the orange stuff started to inflate, like an air mattress when you have company visiting.

"Is that a mechanical bull?" I said to myself, unintentionally speaking out loud.

"Yeah, it's a big hit with the crowds," said a blond waitress who walked by.

Finished inflating, the poufy orange material was like a bouncy castle at children's birthday parties. Square in the middle, like a proud steer protecting his corral, was the mechanical bull. The houselights stayed on as a few brave souls mounted the beast.

In Los Angeles, the Saddle Ranch Chop House on Sunset Boulevard has a mechanical bull and you'll frequently see Playmates, aspiring actresses, and the cosmetically enhanced cavorting on the machine's rhythmic gyrations. But everyone at Biff's who climbed aboard looked like they could possibly crush the metal stanchion holding it aloft.

Lewis wore a look of bemusement mixed with disgust as he saw the heifers riding the heifer. He and Blades sat on barstools on the stage and began the acoustic set as a handful of fans drew closer. A guy in a motorized wheelchair cruised around the open spaces in front of the stage. He wore a leather biker's cap and an acid-washed denim jacket. He had a small camcorder mounted on a tall, but thin pipe that rose up between his legs, like a fighter pilot's joystick.

After the performance, Blades shook his hands out, complaining about cramps and sore fingers. The strings on acoustic guitars are generally set higher from the fret board than on electric models. Playing rock songs that are meant for solid-body electrics on an acoustic can be punishing, especially when it's a borrowed instrument.

"My hands hurt all the time," I said to Blades as he opened a beer. "How do you deal with that?"

"You gotta just push through it, bud," he said. After a weekend of canceled shows, improvised acoustic gigs, and lengthy flights, I felt like Blades had more in mind than just building the strength in your hands when he made that comment.

10

A PHONE CALL FROM SPACE

The name thing with KISS can be confusing. Gene Simmons's birth name was Chaim Witz, which he changed to Gene Klein when he immigrated to America from Israel and then altered to his current moniker in the early days of the band. Paul Stanley's real name was Stanley Eisen and Peter Criss made the relatively easy transition from Peter Criscuola. Ace Frehley's real first name is Paul but the group decided there couldn't be two members with the same name and Paul Stanley had gotten there first. So Ace went by his high school nickname.

As a kid, I wondered how in the hell the members of the band got paid. Didn't their checks have to be made out to their real names? You couldn't make a deposit with a nickname. I mistakenly thought each local concert promoter had to pay the members individually, as opposed to handing over a big wad of cash to a band as a single business entity. I couldn't imagine the hassle that must have been involved as the musicians tried to cram their

dragon boots and capes into a tiny accounts payable office in the bowels of Rupp Arena as they stood around waiting for some matronly lady named Mildred to write out their checks.

Name confusion was a big deal during my childhood years.

Thomas had been a family name on my mother's side for generations. My grandfather ran a car dealership in Fitzgerald, Georgia, and was known by his initials, T. H. It was important to my grandparents to continue the Thomas tradition. However, they ended up having no boys. My aunt Cecia came first and then my mother came along. They gave her the first name of Tommie but referred to her by her more obviously feminine middle name of Glenda. She, in turn, passed on the going-by-your-middle-name practice to me.

So each year, on the first day of school, the teacher would read the roll and call out "Thomas" and I would have to raise my hand and explain that I actually went by my middle name. It's a procedure that has complicated my life ever since, as college professors, employers, car salesman, and bankers all need constant reminders. A pale-faced and shocked emergency room nurse once feared the worst when people kept inquiring as to Scott's condition while she only had records for a Thomas. I'm lucky I managed to escape with all my limbs and organs intact.

As an adult, the name issue continues to be a hassle. If the phone rings and the caller asks for Thomas, I immediately know that I forgot to pay the Visa bill. Half the time I pause as I debate saying, "He was hit by a bus last week." On the contrary, when someone asks for Scott, then it's clearly a personal friend.

So when I answered the phone and heard the familiar voice, the unmistakable accent of New York by way of the planet Jendell asking for me, I was thrown for a second. I had been nervously anticipating this call all week, ever since the publicist

confirmed the interview. But even though I knew it was coming, there was still a moment of disbelief.

The Spaceman was on the phone.

PAUL FREHLEY WAS born in the Bronx in 1951, the youngest of three children. The Frehleys were a musical family. His parents and both siblings played piano. His brother and sister were also proficient with the folk guitar. He dabbled on their acoustic instruments but wasn't impressed.

"I went to my friend's house and he had gotten an electric guitar and he plugged it in and turned the volume up. I hit a chord and it was love at first sound," Frehley told me.

The fact that he fell in love with an electric solid-body guitar and was unmoved by the acoustic is not a coincidence. Frehley's father was an electrical engineer and instilled a love of gadgetry and experimentation in the young boy.

"From the time I was a little kid, I was always interested in electronics," Frehley said. "I used to take apart the radios in the house. I think it was in my blood. My dad told me that when he was young, he used to make his own batteries. So I just inherited his curiosity and know-how. It's kind of stayed with me my whole life and then once I got into the electric guitar, I started taking apart the guitars and changing pickups and modifying stuff."

The young Frehley practiced and tinkered continuously, spending as much time deconstructing amplifiers as he did building an arsenal of guitar riffs. He invested countless hours in his room, practicing the leads and riffs on the radio.

"I practiced all the time," he said. "It was like I couldn't put it down. I was fascinated. I'll never forget the day I got my

first amplifier. I was just so fascinated by it. You could hit some chord and it sounds like you're in a big hole and it's coming out of this little speaker. Then I took apart the amp and that fascinated me even more. It was just all the elements were ripe because I loved music, I loved tinkering around, and the electric guitar allowed me to do that."

He focused on emulating the work of his idols Pete Townshend, Jimmy Page, Eric Clapton, and Jimi Hendrix. "I say I've never had a guitar lesson, but I studied with the best," he said. He began playing in neighborhood bands, often serving in two or three groups at once. He then quit high school in his senior year to devote more time to his goal of becoming a rock star. He continued gigging with a variety of groups, including an outfit called Cathedral. Looking back at over thirty years of musical history, few fans would consider Frehley a workaholic or an obsessive along the lines of some other guitar heroes like Steve Vai or John 5, a musician who seems tortured as well as liberated by his instrument. Frehley's wacky personality, legendary clumsiness, and ever-present cackle made it challenging to bestow the "compulsive" label on him. But in the early days, he was driven by an undeniable belief in his fate.

"I knew it was meant to be," he said. "If I wouldn't have joined KISS, I would have joined somebody else and been famous in another band. I sincerely believe that."

Of course, he did join KISS—who were then going by the name Wicked Lester—after walking into their loft on East Twenty-Third Street in Manhattan while wearing an orange sneaker and a red sneaker. The band was hosting auditions for their lead guitar slot and was, coincidentally, talking to Bob Kulick (older brother of Bruce) when Frehley interrupted. But when he plugged in, it was clear that his musical style meshed

well with the nascent band. They played the song "Deuce" for him and then he had to improvise a solo on the spot.

"I ripped off a blazing solo," he remembered. "It fit perfectly with the song." About two weeks after the audition, the band offered him the gig.

Although Frehley had not excelled in school, he had displayed promise as a graphic artist. When the group decided to change their name to KISS, he devised the lightning bolt treatment for the *s*'s. As a result of his interest in science fiction and gadgets, Frehley adopted the Spaceman persona when the group created their characters. Band publicity said he was from the planet Jendell and the space concept was used so consistently that it even explained his costumes. A KISS fan magazine featured a letter to the editor asking why Frehley never bared his chest while all the other members of the band wore costumes emphasizing their groovy seventies pelts. The editor responded that it was bitterly cold in outer space so Frehley needed more coverage.

As the band rose to fame, Frehley's showmanship inspired a generation of guitar players. By guitar snob standards, his style was relatively simple, relying on the minor pentatonic scale for his solos. But his attitude, his special effects, and his general "I could give a fuck" attitude endeared him to fans all over the world. It has been said that aspiring guitar players quickly left behind Space Ace's work and emulated the more complex work of Van Halen or Randy Rhoads. But it was Ace Frehley who got them to pick up the instrument in the first place. The late Dimebag Darrell was a huge fan and contemporary shredder John 5 covered Frehley instrumentals to honor his hero. It's worth noting that a *Rolling Stone* magazine reader poll named Ace Frehley as the fifth-most underrated guitar player.

Emphasis should be placed on the fact that it was the magazine's readers, not its staff critics, who placed him in that slot.

Frehley's penchant for electronics came into play when he devised a series of special effects to accompany his solos. In the seventies, he was most well-known for a three-pickup Les Paul that spewed forth a huge cloud of smoke before taking off and flying into the rafters.

"The original smoking guitar was nothing more than a smoke bomb inside the volume control compartment of a Les Paul," Frehley said. "But that ended up screwing up all the volume and tone controls and the pickups. So I got together with one of the engineers on tour. I didn't use the rhythm pickup, so we used the volume and tone knobs from that disabled pickup to trigger the smoke bomb. It's been an ongoing process and I've been perfecting that, making it smaller, more effective."

Another hallmark of Frehley's solo spot during a KISS concert was shooting rockets out of his guitar to destroy amplifier cabinets hanging from the lighting rig overhead. During the show, a screeching fusillade of flame would fly out of his Les Paul's headstock like a Stinger missile. Surprisingly enough, this was actually deemed a safer way to implement the special effect.

"It was supposed to be a laser beam," he said. "Right around that time, somebody had gotten blinded at one of Blue Oyster Cult's laser shows, so new legislation came out and limited the amount of wattage you could use in a laser onstage. All my plans to use a laser to blow up things in the lights was kind of put by the wayside. That was the advent of using rockets in the neck."

FREHLEY WAS NOT only responsible for introducing me to the chunk of a Les Paul and the distortion of a Marshall amp

stack. He also taught me about sex and drugs—or, at least the vocabulary of those pastimes.

The original 1975 double album version of *KISS Alive!* was packaged with a gatefold sleeve that opened like a book, so you had a section in your left hand and a section in your right. On the left was an image of scraps of paper with handwritten notes from the band. The text was meant to reinforce their stage personas. Frehley's note read:

> Dear Earthlings,
> The gravity on Earth isn't quite the same as on my
> planet, but I'm slowly getting used to it. I always
> wanted to play lead guitar and express myself visually
> to an audience. When I play guitar onstage it's like
> making love. If you're good you get off every time.
> Thanks for helping me get off.
>
> Love, Ace

Now, although I currently have a pretty foul vocabulary as an adult, it should be noted that I was a sweet and obedient kid. Family holidays inevitably resurrect the story of how my mother was summoned to the elementary school principal's office because a friend and I had gotten in trouble for writing curse words on a piece of paper. Mom was surprised that I would be involved in such an activity and my innocence was confirmed when I expressed surprise that my buddy would get in so much trouble for simply misspelling the word "duck."

"He only messed up one letter," I said. "What's the big deal?"

So I didn't know a whole lot of profanity and slang at the time. For years I thought it was a grammatical mistake or a sign of

poor editing when Frehley's note kept using the term "getting off." How do you get *off* something, I wondered. You're either off or you're on. I wondered if he meant the stairs or lifts on the KISS stage, or maybe he was referring to jumping *off* an amp stack that he was on previously.

Frehley also composed the KISS song "Cold Gin" that was featured on *Alive!* I loved the extended guitar sections and dual-axe harmonies in the song. The title was ironic given that "I didn't even drink gin, barely touched any liquor at all back then," said Frehley. The words just seemed to fit, he laughed.

I got the gist of the statement about only needing the cheapest stuff but I was confused by Paul Stanley's introduction to the tune when he said a lot of the people in the audience liked to drink vodka and orange juice. He referred to tequila and I thought he was saying "the killer" and I was simply misunderstanding his New Yawk accent.

In 1978, when the four members of KISS released solo records simultaneously, Frehley's effort was the only one to feature a hit. His remake of "New York Groove," originally performed by the British band Hello, reached number 13 on the Billboard charts. The song has achieved a certain cult status over the years, and was featured in the HBO show *Entourage* and in promos for USA Network's *White Collar*.

I was six when that record came out and my knowledge of drugs and alcohol was limited to recognizing the name Jack Daniels. That bit of comprehension was solely the result of my father's brief stint as an accountant for the distillery.

I loved the music on the album, especially the instrumental tune "Fractured Mirror" that featured a cool clanging of church bells in the background.

"I played a Gibson double-neck guitar on that," Frehley

said. "On one neck, we cranked everything as loud as it would go. But I actually picked the *other* neck. So what you're hearing is the sound resonating through the guitar's body and coming out of those superloud, but technically unused, pickups."

As much as I loved the music and the beats and the songs as a whole, I felt most of the lyrics on the record were nonsensical and almost Dr. Seussian. But in hindsight, song titles such as "Snow Blind," "Ozone," and "Wiped-Out" have pretty clear meanings. In fact, Frehley's nod to the 1963 Surfaris instrumental single "Wipe Out" featured lyrics that even a sheltered six-year-old should have been able to decipher when he explicitly sang about getting drunk. I was conscious of making sure I turned the volume down on that tune so my parents wouldn't hear it.

GENE SIMMONS AND Paul Stanley, the driving forces behind KISS, have portrayed Frehley as unreliable, lazy, and unfocused. And the guitarist himself has admitted to serious problems with addiction. By the late seventies, Frehley distanced himself from the band and the group resorted to a host of session players to keep the recording process moving. There weren't message boards and fan forums back then so band gossip was severely limited by today's standards. But I suppose I sensed a difference between the determined and businesslike Simmons-Stanley duo and the more laid-back Frehley. As a kid blessed to come from a stable family, I didn't understand drug abuse or alcoholism. But I think most KISS fans did realize that on some level Frehley was a bit flakey. But he was so cool, so likable that it simply didn't matter. At that point, the hard rock bands from the late sixties and early seventies like Led

Zeppelin seemed to have frighteningly dark, ominous relationships with narcotics. Frehley just seemed like he had fun and cracked up with his attention-grabbing cackle, the one that late-night talk show host Tom Snyder suggested he record for an album.

That's not to diminish the troubles his addictions caused. Most famously, he led the cops on a high-speed chase in his DeLorean on the Bronx River Parkway and also totaled a Porsche near his home in Connecticut. Frehley later wrote lyrics about the DeLorean chase in which he said Satan was in the car during a wrong-way joyride.

After leaving KISS, the guitarist launched a solo career in the mideighties with a group that switched between going by his singular name and using the moniker Frehley's Comet. The outfit released a few records that got some minor airplay and was known to metal geeks like me but didn't really crack the mainstream consciousness.

Over the years, Frehley reportedly made several attempts at sobriety. His most recent stab at cleaning up might be the one that lasts.

"There was a point in 2003 when I couldn't play guitar anymore," he told me. "That was pretty scary. I had fallen down a flight of stairs and injured my back and neck and my fingers didn't work anymore. At that point, when the guitar was taken away from me, I realized that it's time to make some drastic changes in my life. It's amazing how you can change your life and turn things around if you just decide to do some positive moves."

Those positive moves culminated in the recording and release of 2009's *Anomaly* album. The record featured all the bombast fans expected from the Spaceman but also displayed a

surprising amount of layers, particularly when it came to weaving in clean guitar tones and acoustic instruments.

"I used Gibson and Taylor acoustics on the record," he said. "And I have about six Ovations. On 'A Little Below the Angels' I strung an Ovation six-string instrument with the high strings of a twelve-string set. It's like an octave above and it's a trick I learned from country musicians."

On a lyrical level, most critics still wouldn't confuse Frehley with Bob Dylan, but his new outlook on life was reflected in his tunes. A song called "Change the World" on *Anomaly* contains the words: "When I woke up today, I thought I could change the world." I asked Frehley about the source of those lyrics.

"I wrote that song around the time of the presidential debates. Obama's campaign was about change. So if not consciously, I think subconsciously it was a little about that."

"Have you ever thought about your influence?" I asked. "For many people, you did change the world. At least their world."

"A lot of people tell me that. I'm flattered, but you know, when I started out, I never realized that I'd have that much of an impact on people's lives. Especially musicians who cite me as being an influence. It's a big responsibility and I try to be aware of that and keep that in mind in whatever I do today."

PHONE INTERVIEWS ARE usually conducted so the journalist doesn't get too much personal contact information. The subject calls from a manager's office or a hotel room if they're on the road. If the call does, for some reason, happen from home, then the subject blocks the number.

But when I placed the wireless phone back in the charger after talking to Frehley, I realized the number was from

Westchester, New York, widely noted as his place of residence. During our chat, he had made comments like "I'll be messing around downstairs" or "I'll be out back." It occurred to me that he could have forgotten to hit *67 to block his number from registering on caller identification. Was it possible that I now had Ace Frehley's home phone number?

I sat for a moment and thought about the brief conversation I'd just had with one of the single biggest musical influences of my life. I was still new enough with the whole interviewing musicians shtick to be excited and jittery long after the call was over. The subject matter itself wasn't life altering, by any stretch. This was not an in-depth, soul-searching conversation with a mystical guru sharing the meaning of life and happiness. Frehley was a straight-ahead, no-nonsense guy. He deflected many questions with a Bronxian "eh" and a shrug of the shoulders. It's easy to fall back on "fugetaboutit" stereotypes with any male from New York City. But it seemed appropriate for the Spaceman. You get the feeling that he could cure cancer and would pass it off as no big deal.

As I jotted down the number on the caller ID, I thought about the advice that Frehley had given me to slow down and be patient.

"If there was a riff that I couldn't play, I'd just slow it down," he said. "You know, something complicated? If you slow it down to half speed and try playing it and once you get it, once you nail it, then it's just a matter of slowly speeding it up. You get to a point where the tempo is the desired tempo."

I had been fooling around with the opening riff to Judas Priest's 1980 tune "Breaking the Law." It's straightforward enough, but there's a slight shift in there, like a car dropping down into a lower gear, that troubled me. I decided to take

Frehley's advice. So after getting off the phone, I got my guitar and stretched out the notes to agonizing lengths and focused on that shift. Within a pretty short order the opening riff started to come together.

My wife, Lara, was heading down to the laundry room and stuck her head in.

"Hey, I recognize that!" she said.

It was only a simple opening riff. Just a few plucks of the A string, first an open string, then the second fret, the third fret, and back to open. But I felt energized and ecstatic and proud, as if I had just performed emergency brain surgery on a Southwest Airlines flight somewhere over Arizona with a ballpoint pen.

I wanted to improve on my small success with the tune, to learn more about what it took to play the song properly. So I decided to go to the source.

11

PLAY FROM THE HEART

I feel it's very important to play the guitar from the heart," Glenn Tipton, guitar player for Judas Priest told me. "That's what I've always done, you know? I see the scale and the fret boards and they're just different patterns really. Nothing to do with music, really. It's very difficult to describe and I'm glad in a way. Coming from the heart enables you to play the guitar in a different way, in a unique way."

Tipton had been part of Judas Priest's dual-guitar attack with K. K. Downing for more than thirty years. Since Priest formed in 1969, the group existed in an earlier generation than most of my hair metal heroes. By the time I began paying attention to heavy rock in the mideighties, the band had already released eight albums, including the landmark *British Steel* in 1980.

A large part of Priest's sound was inspired by their hometowns in the industrial British Midlands. Economically depressed, still ravaged from the war, and with few options for young men, the area instilled a rage and aggression in local musicians. In fact, heavy metal from the Midlands shared some similarities with the blues from the American South.

"We didn't have the blues music, really," K. K. Downing said to me. He spoke slowly, with a cool British accent that dragged out his frequent use of the word "really" to what felt like multiple syllables.

"We didn't have that heritage of the black Delta blues that was geared for people that were impoverished and just totally working class or even considered lower," he said. "When we heard of that, it was people like the Rolling Stones, the Yardbirds, John Mayall & the Bluesbreakers, all those guys because of lot of those guys probably had similar experiences. Another realization that, of course, we didn't have a blues music of our own, the white man. We took it from the black man and just loved it. There was something there that we obviously wanted, other working-class white people. We weren't born with silver spoons in our mouths; otherwise we would love pop music and been all happy and everything."

Downing's early life was far from happy. His hometown of West Bromwich still struggled from the effects of World War II, and days in the Downing household were not pleasant.

"My parents should have split up a long, long time ago really, because it was a bad marriage, you know?" he said. "I didn't really get any support at all. It was very kind of archaic, my family home. When you think about it, my mom and dad got married literally just a few years after the war. Rationing went on for quite some years. It was slightly the Dark Ages to be honest. The country had just been at war and in turmoil so long. It was pretty tough. My father wasn't a great father at all. He never worked. He was disgruntled really about being married and soon he's got kids around him. He was a gambler and stuff like that. So basically at the age of fifteen, I left school as soon as I possibly could and got a job away from home."

Tipton's childhood was better. The family didn't have a lot of extra cash, but his father always provided for the clan and spent time with the young boy outdoors, fishing and hunting, something Tipton continues to enjoy to this day. And his mother taught piano lessons, which meant music always floated through the house. The musician said he had a great childhood. But still, the surrounding area was rough.

"It wasn't a great place to grow up," he said. "It was the industrial park of Birmingham: Blackheath. The name speaks for itself." He left school at seventeen and began working in the local industries, toiling for British Steel. He did not begin playing guitar until he was nineteen—practically an old man by guitar hero standards—on a Hofner acoustic model, then a Rickenbacker, before managing to obtain a Fender Stratocaster.

Downing also invested time on less-than-sophisticated instruments. He constructed his own guitar before finally saving enough to purchase a Gibson SG. He lived in a hotel where he was an apprentice chef, until a holiday trip to see a guitar legend derailed his culinary career.

"I actually went to see Jimi Hendrix play at a festival called Woburn Abbey and I had about a ten-day holiday from the hotel," he said. "I went with a friend and we were young and influenced by quite a lot of things. So we saw that festival, which was brilliant, and there was another in Germany, so we went. Then we went to another festival." The young lads stacked concert on top of concert and didn't return home until six weeks later. The hotel fired prodigal Downing.

"They ripped all my Hendrix posters off and tucked them in big red polythene bags and they were all outside the hotel in the street. I just picked up the remnants and had to go, unfortunately, back to the family home. I always thought, 'Well,

I don't care anyway. I'm going to get a job to earn more money to get better gear and better equipment."

Hendrix amazed Downing and a childhood buddy when they actually got to meet him, briefly, behind London's famed Royal Albert Hall.

"It was just the two of us, you know, hoping to get an autograph," Downing recalled. "Sure enough, Hendrix arrived, with a guitar case, and he got out of his car and we got his autograph and then he went into the gig. It was fantastic—just a fantastic moment."

Downing formed Judas Priest—named after a line in the Bob Dylan song "The Ballad of Frankie Lee and Judas Priest"—and the band's first gig was in 1971. By the midseventies, the group added Glenn Tipton, who had been performing in an outfit called the Flying Hat Band.

Early records like *Sad Wings of Destiny* and *Sin After Sin* hinted at the hard-core, metallic, buzz saw sound that Priest was developing. *Stained Class* and *Hell Bent For Leather* established the group as an emerging force in worldwide metal. It was around this time that the group began to wear leather and S&M gear. In the group's early days, they favored the floppy hats and frilly shirts of sixties-era Haight-Ashbury, which didn't jibe with the heavy sounds they produced. So at vocalist Rob Halford's direction, they began shifting to wearing all leather and studs. As a rule the group all wore black, although Tipton included some red in his stage leathers. This look proved to be a foundation for the heavy metal bands that followed Priest. To this day, hard rock bands display the Priest influence every time they pull on a heavy leather jacket or studded wristband.

I remember looking through the back of *Hit Parader* magazines at advertisements for fingerless gloves that featured studs

on the knuckles. Although I didn't actually wear much metal regalia as a kid, the gloves and attire were interesting to me. But they were useful weapons for my friend Alex. He had moved to our small town from out of state and proceeded to do everything possible to *not* fit in. However, I bonded with him over our love of hard rock and his parents' willingness to rent us R-rated movies that showed bare tits in shower scenes like *Police Academy* and *Porky's*. He constantly talked of saving his money so he could buy those studded gloves and beat up bullies at school.

The year 1980 saw the release of *British Steel*, a seminal record that changed hard rock and heavy metal history. "Breaking The Law" and "Living After Midnight" were radio mainstays and the soccer anthem–like "United" and, shockingly, reggae bass riff of "The Rage" added additional depth and scope to the album. The tune "Metal Gods" also appeared, an appellation that would later be applied to the band and vocalist Rob Halford, most specifically.

Two years later, the group released *Screaming for Vengeance*, featuring the single "You've Got Another Thing Comin'." In 1986, *Turbo* demonstrated a more polished, more sanitized approach to music. Clearly an effort to cash in the hair metal craze, the record featured radio-friendly songs like "Turbo Lover" and "Parental Guidance." The latter tune was a direct attack on Tipper Gore's Parents Music Resource Center (PMRC), which had singled the band out for what the stodgy congressional crowd considered forced oral sex at gunpoint.

The band also sported more colorful and less intimidating outfits that mixed purples and other colors in to the predominantly black color scheme. In spite of these nods to the mainstream—or maybe because of them—*Turbo* wasn't completely

accepted by the group's hard-core fan base, largely because of a revolt against the group's use of technology on the album. The album was covered in keyboards, foot pedals, and guitar synthesizers (just like my Roland crazy ray gun–looking guitar), although the kinks still hadn't been worked out in most of those new gadgets.

"That early technology gear was fairly limiting but it was fun at the time," Downing said. "I think in all honesty, if most electric guitar players were to own up they would say that at some point they were musically in a rut, basically milking what they had. For me, I guess, I was kind of stuck. We used pentatonics and natural minor scales and not much more to be honest. So when a new sound came along, it kind of opened up a few more doors. It would have been great then if somebody said, 'Well, have you tried this harmonic line?' You know, give me a scale or whatever. I guess when something came out that had a completely different sound, you used it to create a little bit more music with *sound* rather than with music theory."

In the late eighties, I sort of lost track of Priest. I hadn't purchased any of their records in those years, but the group generated headlines when they were sued in 1990 after two Nevada youths shot themselves with a 12 gauge after listening to Judas Priest. The grief-stricken families, and the attorneys who saw a chance to make a buck, argued that *Stained Class* had subliminal messages commanding listeners to commit suicide. The band vigorously denied the claims and vocalist Rob Halford quipped that such a strategy would be counterproductive. If they *were* to use some kind of subliminal messaging, it would be to tell fans to buy more records, not kill themselves. The lawsuit was subsequently dismissed by the courts.

Then in 1991, Halford left the group and formed a series

of industrial and hard-core metal groups, including one outfit that featured a young guitar player named John Lowery, who would later become known as John 5. In 1998, Halford announced his homosexuality on MTV, leading a generation of listeners to wonder how they missed the hints in songs like "Hell Bent For Leather."

In 2001, Warner Bros. released a film called *Rock Star*, starring Mark Wahlberg and Jennifer Aniston, about an unknown singer in a tribute band who joins the real band he idolizes, one of the biggest rock groups in the world, Steel Dragon. I had such high hopes for the movie because the producers had been thorough enough to fill out the cast with legitimate rockers. Drummer Jason Bonham, guitarist Zakk Wylde, and Dokken bass player Jeff Pilson were all in the movie. Even notorious rock photographer Neil Zlozower got some screen time. The plot of the movie was loosely based on the story of Judas Priest. After the legendary Rob Halford quit the group, unknown singer Tim Owens, from Akron, Ohio, was invited to quit performing in a tribute group and sign up with the real thing.

Unfortunately, the movie turned out to be awful. The ending, when Wahlberg's character leaves metal behind and finds his "true" voice in a Seattle coffee shop wearing a ratty green sweater and strumming an acoustic guitar, was especially bad.

Halford returned to Priest in 2003 and the group settled into the icon slot of the heavy metal genre. Today, the group is universally acknowledged as part of the metal pantheon and their contributions have been acknowledged by even mainstream pop culture. The group performed on the finale of *American Idol* in 2011 when they rocked the usual pop-schlocky stage with "Living After Midnight" and "Breaking The Law" with contestant James Durbin. The band's instrumental tune

"The Hellion" was also used by Honda to hock minivans with a Marshall amp in the back.

Over the years, Tipton and Downing have developed different relationships with the guitar. Tipton tends to devote intensive amounts of time and then leaves the instrument alone.

"There are times that I love it and I can't put it down," Tipton said. "There are times I don't want to go near it. I think that's because I'm not one of these guys that plays the guitar day after day after day, day in and day out. I need a break from it. When I feel like playing the guitar, I get into it, totally get into it and love the instrument, and then I put it down before I get sick of it. I've always worked that way. It just keeps me in love with the guitar and in love with my instrument. Actually, I haven't got a guitar in my house. All my stuff's in the studio."

On the other hand, Downing remains obsessed, and comforted, by the guitar. He would leave Judas Priest, but the instrument would always be there.

"It's been a partner though life because I'm still single," Downing said. "It's been good to me and loyal. That fact that I haven't had a wife or offspring, immediate family, it's something I felt has been a great partnership, inseparable. I guess most of my girlfriends have all seen it as a bit of a threat. I could always sense that they were a bit jealous. It was almost like they treated it like there was another girl in the room. There's been times when I've wanted all my guitars lying around in the front room, just so I can sit down and look at them," Downing countered. "It sounds crazy, but they are a thing of beauty and you always get—it doesn't matter how much you spend on a guitar—you always get that reward every time you look at it, the lines and the shape. Maybe I'm a bit of a sicko. Maybe those girls were right."

Downing's life and musical career came full circle when Judas Priest performed at the 2006 Teenage Cancer Trust benefit show held at the Royal Albert Hall.

"I was driven in the afternoon to the back of the building, same door where I had waited for Hendrix," he said. "I got out of the car with a guitar case, which I don't normally. It's very rare that I actually have a guitar brought. It was really kind of a déjà vu type of thing. There were about thirty to forty fans and I was signing autographs and it was just like I'm thinking, 'This is crazy. I'm going to go in there. I'm going to do a sound check. I'm standing at stage right, same as Hendrix.' I never was, and never will be, the great guitar messiah that he was. But it was just so cool and very rewarding for me to have that experience."

GLENN TIPTON SAID you should play guitar from the heart. So I plugged in my B.C. Rich Warlock, the most aggressive and mean looking of my instruments, cycled through the available tones on the amplifier until I reached the setting marked "80s: Brkn the Law" and tried to get pissed the fuck off.

As I got settled, the sounds that came out of the guitar were loud and distorted, like most of heavy metal. But what characterized the Judas Priest tone was—and there's simply no other way of describing it—a *metallic* quality. There's a cold and smooth sheen to the guitars, like a coating of aluminum foil over top of the chords. It's as if you dipped the strings of a guitar into surgical grade stainless steel.

"Breaking The Law" was about disillusionment, frustration, and a feeling of being trapped. The tune speaks to the economic realities of people who have gotten the degree, or

put in the time at the factory, only to discover there's nothing waiting. The narrator of the song turns to criminal activity, both for illicit thrills as well as expression of a certain class anger. My own criminal history was pretty lackluster, aside from some petty teenage shenanigans stealing road signs. So I had nothing from the police blotter to use as reference.

However, I had plenty of class rage to draw on.

As a child, my family occupied a murky financial borderland between the haves and the have-nots. Horse racing is a rich man's sport. So the fact that my father worked in that business placed us in certain mint julep circles. But the fact that we had a small farm with no employees and we shoveled shit all day put us into the category of blue-collar workers who remove their stinking shirt at the end of a sweaty day and drive home in a primered El Camino with the windows down and Merle Haggard on the radio.

As a result, I attended cotillions and debutante-type functions but had to bag groceries to pay for my outfits. And in college and graduate school, I maintained a jam-packed schedule of jobs to pay for tuition and rent. One of the more infuriating gigs—but at the same time, hilarious—was my job as a humanities tutor for a highly successful firm in Oxford, Mississippi.

This was before the Internet and before the large chain tutoring companies like Kaplan. A man in his fifties named J. J. Jones had previously been employed at the university before offering ACT and SAT test prep to high schools throughout North and Central Mississippi. And tutoring college kids was a brisk enterprise as well.

J. J. accomplished two major breakthroughs that ensured his tutoring business would succeed. First, he generated enough cash flow so he didn't need students to pay when the tutoring

session was complete. Instead, they could sling a signature on a piece of paper and the bill would go home to Mom and Dad. The students would frequently lose track of their total account and wealthy families throughout the South bragged about little Jenny's hard work in chemistry. So when the end of the semester rolled around, it was not unusual to see students who owed more for tutoring fees than they paid for an entire semester's tuition.

The other key to J. J.'s business was that he was a fun guy, made sure that the tutors were friendly (as much as possible), hired hot college girls to staff the front desk, and generally turned each night into a party atmosphere. The fact that the firm's front door was ten steps away from a popular bar called Proud Larry's didn't hurt the ambience either. J. J. made it *cool* to get tutoring. You would overhear frat boys, sorority girls, and independents at the mailboxes saying, "I'll see ya at J. J.'s tonight."

I handled almost all of the humanities. Anything that could be read, written, or argued about, I got the call. The routine was that J. J. would phone me with an appointment time and a heads-up on the subject so I could prepare.

One day I returned home to a message full of laughter on my answering machine. Finally, J. J. managed to croak out, "Just call me."

"You're not going to believe this," J. J. said when I rang the office. "I got a girl that says she needs help understanding the *Kama Sutra*."

"And just how am I supposed to improve that understanding?" I asked.

"Maybe we'll set a couch up in the back," he said. "She's a cute girl. You'll get a kick out of it."

An English professor taught the ancient Indian text as part of a sophomore Masterworks of World Literature course that students nicknamed Erotic Literature. The official explanation was that the *Kama Sutra* was illustrative of the culture that created it. Although maybe a controversial selection, it was, in the professor's view, no different than the racial attitudes and slurs expressed in *The Adventures of Huckleberry Finn*. And it should be stated for the record that the class used the Sir Richard Burton translation of the ancient text, not the photographic version that pubescent boys shoplift from the bookstore. The rest of the syllabus was comprised of D. H. Lawrence and Ovid and the like.

The student was a slender blond with blue eyes named Katie, dressed in the obligatory Ole Miss sorority girl outfit of running shorts and a frat-party T-shirt. She was exactly the kind of woman that I never had the nerve to approach in a bar or speak to on campus. She was an education major and said she signed up for the literature course because it was rumored to be an easy A.

"But it's turned out to be a little weird," she blushed.

I choked out terms like *yoni* and *lingam* and tried to explain why it was deemed appropriate to have sex with this caste but not that caste and stared at the wall a lot during the session. As much as I had joked with J. J., it was an uncomfortable hour.

Katie couldn't speak more than a few words without mentioning her boyfriend, a douche bag named Hunter from Madison, Mississippi, an affluent town near Jackson. I worked with him on almost every nonmathematical course he ever took in college. And with each session, my urge to drive my pen through

his temple got stronger and stronger. Hunter had bushy brown hair that hung down into his eyes and he wore Polo shirts and khaki shorts with a braided brown leather belt that was three sizes too long. He didn't even make a halfhearted attempt to conceal his lack of interest in school. He would sit down and say he had a Faulkner exam the following day.

"But I didn't read any of the books," he said, looking me square in the eye.

"What books were on the syllabus?" I asked. "Did you bring any of them for us to flip through?"

"No, I never bought any of them."

I knew I shouldn't be bothered by the Hunters and Katies who populated the Ole Miss campus. I was making fifty bucks an hour pretending to prepare them for a Faulkner exam or a *Kama Sutra* quiz, so how was that any different than them pretending to care? But it still infuriated me that I had to work so hard while people like that sleepwalked through school and then waltzed into cushy jobs at Daddy's bank.

So as I sat on my couch, holding my medieval weapon of a guitar, as the amplifier hummed and every small movement sent distortion and feedback through the wire and out the speakers, I thought about all those nights when I worked until midnight and then walked by bars full of college kids having fun until I arrived at the back door of a steak house where I would go inside, grab an apron, and wash dishes until 3:00 in the morning. It wasn't recollections of robbing a liquor store and it wasn't harsh memories of a brutal childhood in war-torn Britain, but it was enough to fire me up and to feel like my attempts at "Breaking The Law" carried more urgency and more fire than usual.

THE GUITAR SHOP where I took lessons from Doug closed as a result of increased rent. He now welcomed students to his home, a gray structure that looked like it should be condemned. Situated next to a shipping company garage, Doug's driveway was a precarious strip of concrete that made goat paths in the Khyber Pass between Pakistan and Afghanistan look well maintained. A HAUNTED HOUSE sign hung on the back porch and 1970s tower speakers hung from the ceiling by chains. They were covered in plastic wrap to protect them from the elements. A pack of barking, slobbering hounds greeted every visitor and a giant gun safe stood in the kitchen.

Although I was making progress on pieces of songs here and there, I didn't always have a chance to work on Doug's exercises. There were times when I showed up for a lesson no more accomplished than the previous week. Adult life did manage to intrude on, and delay, my guitar escape.

Generally, whenever I didn't have anything practiced, I would ask him questions. My knowledge of the guitar—the terminology at least—was sufficient to keep him busy talking for most of the half-hour lesson so I could hide my lack of progress on the instrument itself.

"What's a power chord?" I asked him.

"There's a lot of frequency and harmonic aspects to that question," Doug responded. "But most simply, they're a relatively easy way to play certain chords. A normal chord is composed of three or more notes. Power chords just have two different notes."

Power chords feature prominently in hard rock and heavy metal music, not only because of their economical fingering.

The technical frequency and harmonic issues Doug alluded to also produce a powerful sound, especially when played through a heavily distorted and violently loud amplifier. They contribute to the overall bludgeoning effect of heavy metal music.

Although intellectually curious about power chords, I wasn't sure that I should try to employ them in my practice. I was still trying to learn the "normal" fingerings of many chords and I wanted to do things properly. I was trying to balance a dedicated and methodical approach to learning the instrument with an autodidact's scattershot method of gulping down information. I was also trying to incorporate the various tips I'd gathered from rock stars into my practice regimen while being less reserved in my life and career.

> MARK KENDALL, GREAT WHITE: *Get a teacher and learn theory.*
>
> BRUCE KULICK: *Walk, don't run, and how to play harmonics.*
>
> OZ FOX: *Stretch your fingers; don't move your hands during scales.*
>
> STACEY BLADES: *Tune down and use the proper chords for the opening riff.*
>
> ACE FREHLEY: *Slow down; take your time when you struggle with something.*
>
> GLENN TIPTON: *Play from the heart.*

I was getting better and even enjoying the mistakes and the challenges. To be fair, I had yet to play a single song in its entirety, but my little collection of snippets was getting better and better. I used different guitars for my practice sessions depending on my mood, but generally stuck with either the B.C.

Rich Bich or the Fender Telecaster. The luxury artist signature series Warren DeMartini Charvel and George Lynch ESP were more complicated instruments, primarily because of their tremolos. Also referred to as whammy bars, these tools sat at the end of the bridge, closest to your pick hand, and enabled the musician to make wild variations in pitch, like a daredevil pilot doing loop-the-loops. Tremolos on earlier model guitars always knocked the guitar out of tune, so sophisticated guitars started using locking nuts at the top of the fret board, near the guitar's headstock, to help keep things from going sideways after a dive-bomb solo. The locking nuts worked great for that purpose, but they also made tuning the guitar a challenge for an amateur like me. So those instruments remained in their cases.

I was also still feeling very cautious around my guitars. The first step of my practice sessions was a thorough hand washing. Then I would check my fingernails and file them down to the quick. In *Practicing: A Musician's Return to Music*, classical guitarist Glenn Kurtz gets almost fetishistic in his approach to practice and preparing his fingers. "With a metal emery board, then with very fine sandpaper, I file the nails on my right hand," he writes. "Even the tiniest ridges can catch on a string and make it raspy." He then quotes historical music texts from the 1700s and 1500s that provide a variety of prescriptions for proper nail grooming. Kurtz's manner of classical guitar relies on fingerpicking, as opposed to using a metal or plastic plectrum like most rock musicians. So his focus was on the pick hand.

I, however, was not so zen about my nail care, sawing away with the motions of a convict trying to file through a prison bar. And I focused on my left hand, the fret hand. In my guitars-are-still-precious mind-set, I worried that my fingernails would

somehow scratch the fret board, which is ironic since one of the most popular trends in guitar manufacturing was building brand-new instruments consciously distressed so they look like they'd been beaten to shit and left out in the backyard for an entire December. Like $200 distressed jeans, the "road-worn" look was popular on guitars—but not for me.

Glenn Tipton had told me that a guitar was just a tool to do a job. "That's what a guitar does for me. It fills a role in a song," he said. But my reverence for the instruments continued, even as my repertoire of riffs and licks increased. On some level, however, I thought I needed to get over my protectiveness of the instruments if I were to ever truly play them. It was like my friend who collected lavish and expensive cookbooks but never made any of the dishes because he didn't want to soil the pages in the kitchen. While I might not ever smash guitars onstage like Pete Townshend or John 5, I had to be willing to risk a few scuffs. So I thought I would learn from a guitar genius who both adored and abused his instruments.

12

THE VIRTUOSO

In the dimly lit dining hall, I felt surrounded. It was just a matter of time before everyone else in the room—all the folks in yoga pants, hemp T-shirts, and Birkenstocks—identified me as an imposter, an interloper who ate red meat, lusted after imported gas-guzzling sports cars, threw away soda cans, and owned a firearm. Hippies are supposed to be kind and accepting, but when you're the lone person in the room with a Republican voting record, it can still be frightening—almost as scary as the plate in front of me.

From the buffet table in the middle of the room, I had selected something called lentil loaf, mashed potatoes with vegan gravy, and salad with organic ranch dressing. The potatoes and salad weren't bad, but the lentil loaf was crusty and brown, like a dry creek bed in the Mississippi summer. I tentatively cracked the surface, like breaking through a crème brûlée, but the interior of the substance consisted of layers of petrified something. It made me think of an old horse patty in the fields where I grew up.

I was determined to go into this whole thing with an open mind. Everyone else seemed to enjoy the meal, although it was

hard to tell since speaking out loud was discouraged in the hall and I didn't know anyone to whisper with. I was fully aware of the fact that it was probably my fast-food-and-soda-addicted palate to blame. After two dusty bites, I decided to stick to the salad and potatoes.

At least I would lose some weight in the next few days.

KRIPALU WAS A nonprofit yoga and holistic healing center located in Stockbridge, Massachusetts. Situated in the Berkshire Mountains, the center attracted thirty thousand people a year to study yoga, massage therapy, or simply to get away on a spiritual retreat. It was October and the mountain fall foliage also served as a draw for visitors.

After dumping the remains of my lentil loaf in the compost bin, putting my napkin in the recycle bin, and the dishes in the wash bin, I attended an orientation session welcoming newcomers to Kripalu. A perky woman told us where we could find the daily yoga sessions, how to schedule a healing arts appointment, and to remember a few rules, namely that we should remove footwear before entering the classrooms and that noise should be kept to a minimum after 9:00 PM. Looking around the orientation session, I saw a few other imposters in jeans, rock concert T-shirts, and high-end running shoes. One guy wore snakeskin cowboy boots. "He must be one of us," I thought. The woman went over the schedule for the various evening events, ranging from guided meditation to advanced yoga to Alien Music Secrets, the course that brought me to the Berkshires. I was to report to the Main Hall at 8:00 PM.

The main building at Kripalu was located on the grounds of a nineteenth-century estate that featured what was, at the

time, the largest private dwelling in the United States. In 1917, Andrew Carnegie bought the property and used it as a summer retreat. After Carnegie's death, the building eventually became a seminary in 1922. A fire gutted the institution, and the current facility was built in 1956. The concrete halls of the main building felt like a fifties-era school. Several steps led up to the main room, and I heard a tremendous roar of feedback as I took off my shoes and placed them in a low cubby.

The Main Hall had clearly served as a sanctuary when the building was a seminary. It was a brick-walled chapel, with an arched roof and high windows. At the far end of the room, where the Christian altar once stood, was a statue of dancing Shiva, placed reverently in front of gold drapery.

In front of the altar were two Carvin amp cabinets, a couple of chairs, a pedal board with effects, and a few wedge-shaped monitors. A dark-haired man was bent over adjusting the effects as a squealing sound bounced off the walls. Then he stood up as a cloud of feedback harmonics gathered around him and I realized that wasn't some tech. It was Steve Vai.

I first noticed Steve Vai (even though I didn't know his name at the time) in the 1986 film *Crossroads*, starring Ralph Macchio, Jami Gertz, and Joe Seneca. The flick is about a classical guitar student obsessed with the blues. The kid tracks down a nursing home resident that supposedly performed with the legendary Robert Johnson. The young boy and the old man head south to the Mississippi Delta in an effort to learn the blues and save a soul. Macchio was known for his super successful film about the student-mentor relationship that culminates with a karate-chop ass whipping of the local bullies. This time around, instead of high school kids in skeleton costumes, Macchio battles Satan himself. Or, more specifically, he battles the

devil's guitar hit man, who was portrayed with radical exuber-
ance by Steve Vai. Although the movie was dreadful, I thought,
"Who the fuck is making that amazing, unearthly sound?"
when I watched the duel between Macchio and Vai.

The guitar player cemented his place in my musical con-
sciousness when he joined David Lee Roth's solo band in 1985.
Diamond Dave's first single was a tune called "Yankee Rose,"
which featured an introduction of Roth holding a conversa-
tion with Vai's guitar as the virtuoso made convincingly human
laughter sounds.

When I mentioned Vai to other guitar players, they inevi-
tably shook their heads and whistled in exasperation. Stacey
Blades said, "Wow. That's a whole 'nother level of skill there."
Oz Fox, meanwhile, had said Vai was at the pinnacle of the in-
strument. "That guy, he *is* music. There's definitely huge, huge
divine intervention with a man like that."

As everyone settled in the room, Vai sat down and pulled
over a microphone. He adjusted his sunglasses and said he
had admired the healing work done at Kripalu ever since his
twenty-year-old son, Julian, studied massage therapy here.

"I get to talk about all the really weird shit when I'm at
Kripalu," he chuckled. Vai had taught Alien Music Secrets,
his form of guitar workshop/motivational speech/philosophi-
cal discourse at other locations around the country. But those
events were usually just a single three-hour session. This par-
ticular offering at Kripalu stretched over three days and pro-
vided attendees with much more interaction with the guitar
god.

There were about forty to forty-five people in the room.
Probably 65 percent of them held a guitar in their hands. I had
brought the Telecaster along with me, but left it in the case

leaning against the wall in my guest room. There was Antonio from South America, Kirk from Vancouver, and a dude named Landon from Alaska. A lady named Monique had traveled from Eastern Europe. A New Yorker named Steven wore a T-shirt with Christopher Walken's outline on it, with a cartoon dialogue bubble begging for more cowbell. Each time a person gave their name and hometown, Vai asked why they chose to attend this event.

"I have a problem collecting guitars," I said in front of everyone. "I have about ten or fifteen instruments, but I've only just recently begun to play. This is part of a few first steps in trying to finally learn how to play."

Vai smiled and said, "So this is like a twelve-step program for you."

An older guy with a bulky jazz semiacoustic guitar said that he wanted to take this course because his influences were John Coltrane and Steve Vai. "That's like beef yogurt," the artist laughed in response.

After all the intros, Vai leaned forward into the microphone. "The fascination of me sitting here will fade away soon enough," he said in a warm and comforting voice. "And we're going to be people trying to make discoveries. Nothing more, nothing less."

THE MUSICIAN WAS born in 1960 to John and Theresa Vai and raised on Long Island where his father tended bar. He originally played the accordion but then became enamored with the rock sounds of Led Zeppelin, Jimi Hendrix, Queen, and others. Music came naturally to him. "I could hear anything and it was like, 'Oh, okay, I get it,'" he said. "Everything I

heard, I saw. Music, on paper, to me, looked like art." Although he displayed an almost innate understanding of music, school was a challenge and he described himself as "below delinquent" in other subjects.

While the concept of music seemed ingrained in his being, the guitar as an instrument was both alluring and intimidating to Vai.

"The guitar was a scary instrument; it was so gorgeous," he said. "Whenever I would see one, I would get really excited. I was afraid to play it because it was so beautiful and so cool. I was inferior."

Eventually he obtained a guitar and started teaching himself to play. An older musician in the neighborhood told him, "If you think I'm good, you should see my teacher, Joe Satriani." Vai started taking lessons from Satch and the lessons eventually turned into six-hour jam sessions.

Satriani's name is revered in guitar circles for both his instruction and his performing career. In addition to instructing Vai, Satriani mentored Kirk Hammett of Metallica, David Bryson of Counting Crows, Larry LaLonde of Primus, and Alex Skolnick of Testament and then later Trans-Siberian Orchestra. The world learned what those students saw on a daily basis when Joe Satriani released *Surfing with the Alien* in 1987, which became one of the biggest hit records ever for instrumental guitar players.

The confluence of genius is always fascinating. Sports teams may boast a roster of all-stars, but those are manufactured groupings. General managers, scouts, player personnel staffs, and huge budgets are responsible for bringing talent together.

Bands and musical scenes are another sort of predetermined combination of talent. Musicians hang out with similarly

talented folks. Or, aspiring superstars flock to the latest locale of record company signings. In the eighties, for hard rockers, it was Los Angeles. Warren DeMartini of Ratt had a story of sort of aimlessly strumming a guitar with Jake E. Lee (who would eventually play with Ozzy Osbourne) while the duo sat around their Southern California apartment.

"We were both night owls, so we just stayed up real late practicing guitar," DeMartini said. "Sitting on the floor with our backs up against the coach watching a really fuzzy TV channel, replaying *The Andy Griffith Show* reruns and sort of working out the parts to songs that ended up being 'Bark at the Moon' [a tune Lee recorded with Ozzy Osbourne] and 'Round and Round.'"

As cool as that story may be to hair metal historians, the fact is that those were musicians from different areas who relocated to Los Angeles specifically *because* of the music that was being made there. It was inevitable their paths would cross.

But the sheer randomness of two dudes like Vai and Satriani—who jammed in Long Island bedrooms, shag carpeting on the floor, sound bouncing off wood-paneled walls—growing up to be two of the most amazing musicians on the planet is staggering.

"You seek out like-minded people," said Jenny, a fellow student who had traveled from Savannah for the course. "I'm not surprised that someone as driven as Steve Vai found a buddy in Joe Satriani."

"But you have to have access to them!" countered a guy named Robert from Maine. "What are the odds of the two greatest guitar players ever living near each other? That's like Michael Jordan growing up down the block from Larry Bird."

Benefiting from Satriani's tutelage, but still driven by an

almost inhuman level of single-mindedness, Vai became obsessive about his practice regimen, regularly logging thirty hours straight of practice. He took the instrument into the bathroom and played scales while sitting on the toilet.

"The word 'dedication' isn't even a part of the vocabulary because there *is* nothing else," he said. That focus was rewarded as the young musician began seeing his prowess on the instrument grow. He was beset by self-esteem issues as a child, but then, "I played guitar and realized I could do things," he said. "But I was in pain when I wasn't playing. When I was in high school, nothing mattered but playing the guitar. It was like an addiction."

In *Talent is Overrated: What Really Separates World-Class Performers from Everybody Else*, Geoff Colvin argues that "the factor that seems to explain the most about great performance is something the researchers call deliberate practice . . . Deliberate practice is also not what most of us do when we think we're practicing golf or the oboe or any other interests. Deliberate practice is hard. It hurts. But it works. More of it equals better performance. Tons of it equals great performance."

While Vai didn't use the term "deliberate practice," he certainly had implemented it at an early age. Whereas most beginning guitarists rush to master "Smoke on the Water" or "Stairway to Heaven" as quickly as possible and they become mediocre at the dozen or so mechanics involved in the songs, Vai broke tunes down into their smallest components and techniques and then focused on those tiny maneuvers for weeks and even months. He played single chords endlessly, mulling over the mood that a C minor evoked, creating and reciting out loud fictional stories that matched the sounds he made. He spent weeks just working on his vibrato technique,

ultimately arriving at a circular motion that is unlike any other guitar player. To this day, he has to play something perfectly eleven times in a row before moving on to the next challenge. And his definition of "perfect" is unlike anyone else's standards.

"I guarantee you, anyone in this room that put in the hours I did, you would shred me under the table."

THE NAME OF Vai's class, Alien Music Secrets, was fitting because the extraterrestrial was a perfect way to describe his music. Imagine that life forms from another galaxy visited Earth and picked up a guitar. Without any preconceived notions of what the instrument *should* sound like, they would probably produce songs similar to those Steve Vai composed.

After attending the Berklee College of Music, where he eventually was awarded an honorary doctorate, he joined boundary-pushing Frank Zappa's band. He then moved to the West Coast and performed in Alcatrazz, replacing the departed guitarist Yngwie Malmsteen. After a stint with David Lee Roth, Vai briefly joined Whitesnake in 1990, alongside one of my favorite bass players, Rudy Sarzo. Since then, he had focused primarily on his solo material. In concert, he veered from subtle and delicate melodies that dissolved like cotton candy to brutal and frenzied whammy bar plummets that threatened to destroy the instrument within his large hands.

Onstage, he often wore extravagant costumes and played guitars that glowed in the dark or featured LED fret markers. He situated a fan at his pedal board so his long brown hair would blow in the wind like a romance novel cover model.

And he punctuated his speech with freaky expressions like

"training your ear is like growing eyeballs on your fingers" and "vibrato is the soul of the note" and references to guitar tones that sound like "a ham sandwich."

All of this led me to expect Vai to be an eccentric loon. But when someone asked for the best piece of advice he ever received from his mentor Frank Zappa, the guitarist's response took an unexpectedly practical turn.

"Frank took a piece of paper and wrote something down," Vai said. "This was supposed to be the most important thing for me to learn. He put the paper in my hand. I opened it up and it was the name of a publishing attorney."

He shifted in his chair, adjusted the microphone, and then spent several hours on the mechanics of the music business. He was well qualified for such a lecture. On a trip to Southern California once, I did some digging and pulled up Vai's home address. It was not far from a main street, just down from a strip of shops. But the brick mansion sat off the road, protected by a large wrought iron fence and a row of trees. It wasn't opulent, some hip-hop show-off palace. But it was still pretty damn nice—nice enough that I felt uncomfortable after driving by a couple of times, on the chance my rental car might show up on surveillance video.

"I've made millions of dollars where my friends have made nothing, but they sold more records than me," Vai said. He didn't seem like he was bragging. Rather, he was pointing out what was possible simply by paying attention to the business side, instead of relying on untrustworthy handlers.

Vai's most basic business advice was to protect your work. His voice took on a stern tone when he instructed the group. "Don't *ever* think your intellectual property isn't valuable."

Although he didn't discuss it at Kripalu, a musician's name

is also clearly important. And putting that moniker on a series of products is a cornerstone of Vai's business interests. In this manner, he is not unlike most famous guitar players, most of whom have signature-model instruments built to their specifications and then sold to the public. The Warren DeMartini Charvel and the George Lynch Kamikaze in my own collection are examples of the trend. Fans want to play what their heroes play, and on some subconscious level, there is the insinuation that you'll sound like the famous rocker. Mars Blackmon told us, "It's gotta be the shoes!" as Air Jordan cocked back a dunk. Guitar companies perpetuate the same concept.

In Vai's case, he actually changed the course of guitar design with his Ibanez signature models. In the late eighties, he worked with the Japanese corporation to design the Universe seven-string guitar, an instrument that provided a wider range of tones than the usual six-string instrument. Seven-string guitars were favored by many of the so-called nu metal bands of the nineties such as Korn and Limp Bizkit.

Celebrity relationships are big business for the guitar manufacturers. Although the companies do not release specific data about sales, one industry observer speculated for me that Ibanez had made twenty-five thousand Vai JEM models from the late eighties to the current day, which run about $2,000 per instrument. No one outside of Vai's camp knows exactly how much he makes per axe sold, but 10 percent to 20 percent royalty rates on signature guitars are not unheard of. So taking just the low number into consideration, that's a $5 million payout to Vai over the last twenty years for guitars.

To round out your collection of all things Vai, you can add the following items to your shopping list.

- Steve Vai signature guitar cable from DiMarzio: $100
- Steve Vai Bad Horsie wah pedal from Morley: $100
- Steve Vai Jemini distortion pedal: $200
- DiMarzio Steve Vai 2" Italian Leather ClipLock Strap: $100
- Carvin Legacy Series amplifiers, designed with Steve Vai: $450 to $2,500

Artist percentages on smaller items like effects pedals probably aren't the same as the payout rates for signature guitars, but it's still something. Factor in your choice of at least six different songbooks for about $20 each and an online lesson program in collaboration with Vai's musical alma mater, Berklee, which starts at $1,200, and his slice of the pie gets bigger and bigger with each nibble.

In the middle of the business discussion, the Eastern European lady, Monique, asked why so many bands "make a deal with a devil." At first, I thought she was referring to situations in which bands sign bad deals with questionable characters. But then it became apparent; she really was talking about Beelzebub himself. That started an incantation of evil forces continually appearing in art—as she saw them—that included Aleister Crowley's appearance on a Beatles album. Then she went further. "Do you know about Illuminati?" she asked Vai. She started listing names and said, "It goes all the way to George Bush and even Obama!" A few people stifled chuckles.

It wasn't the only kooky moment worthy of an *X-Files* theme song sound bite. At various times during the event, Vai invited different people to join him onstage. He would ask a little about their backgrounds and interest before playing a little bit. A young guy named Ronnie, dressed all in black, took his turn.

He had shaggy hair, a chinstrap beard, and a pierced eyebrow. He clutched a Fender Jaguar–like instrument. It's a slightly off-kilter-looking guitar that was favored by Kurt Cobain of Nirvana, an unusual choice when compared to the sleek hot rods in the room. Bringing that guitar to this event was like driving a sixties land-shark Cadillac to a gathering of slinky Italian exotic supercars.

Ronnie rambled about how he was combining music with sacred geometry. It was a lengthy explanation that lost most of the people in the room. Finally, when he performed some of his geometrically magical compositions, Vai praised him for combining math and music, but he said the playing was sloppy. "First of all, you gotta tune up."

As we closed out the first day's session, Vai gave everyone a piece of homework. He instructed everyone to select a song they wanted to play from beginning to end. The goal was to build a repertoire of songs that could be played flawlessly.

IN THE EVENINGS when I was trying to find something in the Kripalu cafeteria to sate my greasy junk food palate, a friend was jabbing a needle into Lara's ass at home.

In spite of my initial reticence about full-scale medical intervention in our attempts to have children, my wife and I had finally seen a reproductive specialist. We were placed in the "unexplained" category of infertility. She was good. I was good. There was no medical reason why it wasn't happening. So we had started the process of in vitro fertilization.

This involved Lara getting an inordinate amount of daily shots for a period of several weeks. Some were fairly small-gauge needles into the stomach that she could administer. But

she needed help with the medications that had to be speared into the backside and I struggled with the task each night. While I was on my guitar trip, a trusted female friend assumed the mantle of Official Injector in our household. Once again, music provided an escape from the troubles of life and anxieties that come from stabbing your spouse while she wants something so badly that she's biting her lip to keep from yelling in pain.

The next day in class, Vai stressed that playing the guitar is not a contest. He admits that he was obsessive to an unhealthy degree about playing guitar and getting better, and he was ruthless in providing constructive criticism to people in the class. But while the world may see him as a guitar hero, he doesn't expect anyone else to live up to any measurements but their own.

"Don't worry about what others think," he said. "It's a cathartic process of self-discovery. It's about you and your instrument." He stressed repeatedly that playing guitar at any level was a valid and worthy enterprise for self-fulfillment.

Toward the end of the Alien Music Secrets class each day, Vai began bringing people up onstage to jam with him. One or two people had gotten up here and there throughout the lectures and demonstrations. But this was a procession of guitarists, one right after another. Some were very, very good and he would smile and their duet would go on for a few minutes longer than others. But with everyone, he was gracious and inviting.

I wasn't the only one to stay in my seat, although I might have been the only one too scared to join the musician. Some people in attendance at the event were purely fans, with no interest in ever picking up a guitar. Two blond sisters named

Susan and Heather were huge fans who followed Vai performances all over the country. They first saw him on the David Lee Roth tour and have since become friendly with Vai's family and manager. I was thankful that there were other people who stayed seated during the jam session.

At some point, someone looked toward the back of the Main Hall. I noticed people smiling and pointing. Behind us, five or six women leapt and ran in the open space of the room. They wore yoga pants and tank tops and held their arms out to the side as they twirled and danced. Instrumental guitar hero music isn't exactly disco. You don't normally encounter people cutting a rug to songs like "Building the Church" that feature a blazing keyboard-style guitar fingerboard tapping intro that is the aural equivalent of a strobe light.

The dancers flung themselves around with abandon, not noticing the class's giggles or not caring.

A man with a Yamaha Pacifica sat down after his time onstage. "I jumped out of a plane once," he said to a group of us. "That's what this felt like."

The lineup of guitar players from the class had slowed to a trickle. Vai leaned into the microphone and said, "Anyone else?"

A kid who looked barely in his twenties named Brian made his way to the front. He carried a Steve Vai Ibanez that he borrowed from someone. He sat down in the chair and Vai asked him what he wanted to do.

"I don't know," Brian said. "I don't really know what I'm doing with this thing."

Vai reassured him and said he would be fine.

"No really. I have never held a guitar before."

Even though he frequently wears tinted glasses, Vai's eyes

clearly bulged out. He made a face at the crowd, sort of the shocked and surprised look that made Macauley Culkin famous in the *Home Alone* movies.

"We'll make it a bit more even," Vai said and he flipped his guitar over so that he was playing it backward, as a left-handed musician would. "You just do whatever sounds good to you," he told Brian.

And together they made a bizarre, untrained, horrible mess of music. But they had fun and Brian had an experience of a lifetime. In the days afterward, I found myself thinking about that missed opportunity. So what if I embarrassed myself? I would never see any of those people again. I should have just pushed my guitar picks in the center of the table, so to speak, and gone all-in.

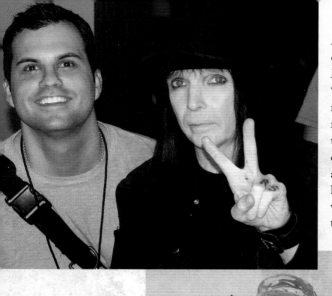

A Crüe insider once told me that Mick Mars was a "lovably cranky misanthrope and recluse who likes to theorize about dinosaurs, aliens, and the meaninglessness of life." I wish I had gotten to interview him.

With Bruce Kulick at the KISS Expo.

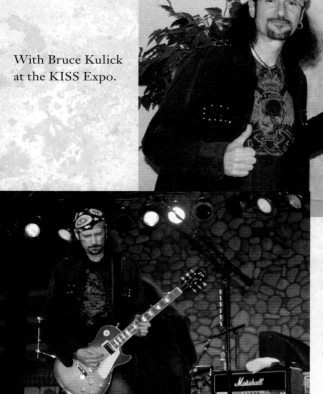

Bruce Kulick, in the groove, with a Les Paul.

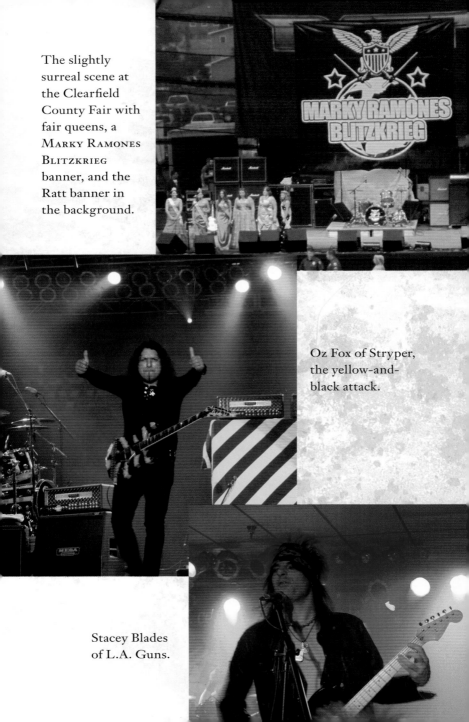

The slightly surreal scene at the Clearfield County Fair with fair queens, a MARKY RAMONES BLITZKRIEG banner, and the Ratt banner in the background.

Oz Fox of Stryper, the yellow-and-black attack.

Stacey Blades of L.A. Guns.

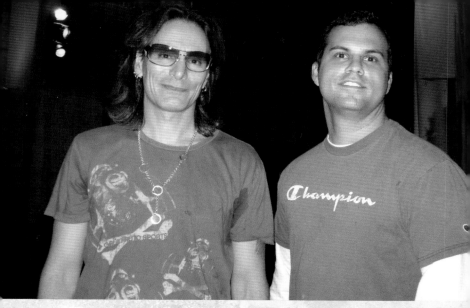

Me with the maestro, Steve Vai.

Steve Vai with one of his signature guitars
(this one he calls Flo III).

Warren DeMartini of Ratt with one of his custom Charvels.

Brad Gillis of Night Ranger with his battered but beloved Strat.

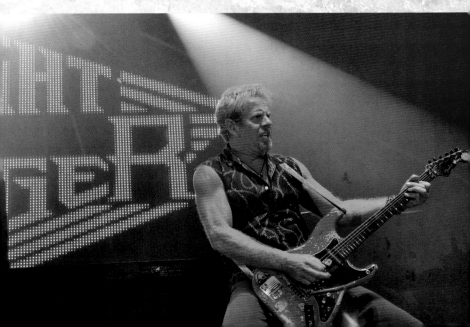

Me with Bruce Kulick at the Rock 'n' Roll Fantasy Camp.

During my chance at recording history, I got replaced by a studio ringer.

Me and the Spaceman
(I'm desperately trying to act like I know what I'm doing).

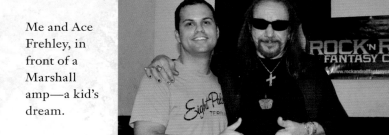

Me and Ace Frehley, in front of a Marshall amp—a kid's dream.

With Rudy Sarzo, a headbanger extraordinaire— but also one of the kindest, most generous people I've ever met.

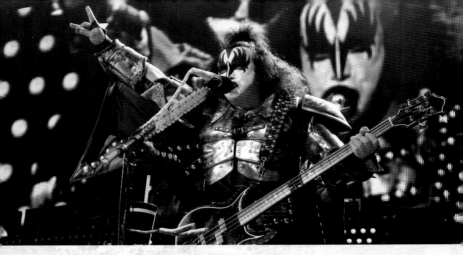

Gene Simmons, not a guitar player but someone who often wields an axe on stage.

Tommy Thayer and Gene Simmons modeling the latest in footwear fashions.

Tommy Thayer and Gene Simmons.

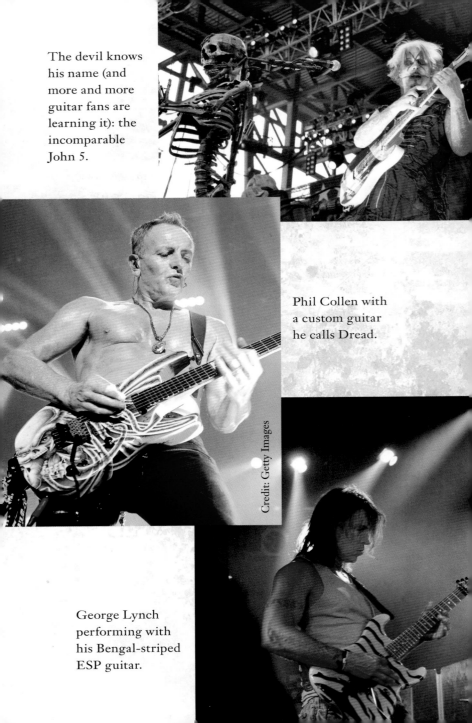

The devil knows his name (and more and more guitar fans are learning it): the incomparable John 5.

Phil Collen with a custom guitar he calls Dread.

Credit: Getty Images

George Lynch performing with his Bengal-striped ESP guitar.

13

GUITAR HERO CALLING

Back at home after returning from Kripalu, I started the homework Vai had given to our class. He said to write down—it had to be on paper, the guitar god was big on setting concrete goals—a song or songs that you wanted to play perfectly. Then tackle those tunes with a microscopic focus, striving to master the smallest of techniques.

My set list was based on the musicians I had met, or endeavored to meet, on this journey. I had "Forever" by KISS, the tune on which Bruce Kulick had shown me the harmonics, and "The Ballad of Jayne," which Stacey Blades explained to me. I added "Lay It Down" by Ratt, with Warren DeMartini providing the monster opening riff.

As if I weren't already a huge fan, interacting with Vai in Massachusetts had taken my admiration to an even higher level. But it would have been ridiculous to add one of his compositions to my initial attempts. There was no way I could play that stuff, or would be able to do so anytime soon.

And that was completely fine with me. I had no problem being reminded that he was great and I was a beginner. That

didn't hurt my feelings at all. I found it strange that people felt otherwise.

The eighties heyday of guitar hero worship was bookended by two musical eras, each characterized by emotion and attitude more than sophistication and precision. Punk in the late seventies and grunge in the early nineties both featured garage band musicians. Proponents of the genres were quick to point out that the musicians "were just like me" and that "you could envision yourself doing that kind of music." They said the guitar heroes and rockers were too larger-than-life. They couldn't relate to the excesses. Instead they wanted musicians who sang about issues affecting normal kids.

In *My So-Called Punk* by Matt Diehl, punk legend Brett Gurewitz is quoted as saying, "Punk rock was rock music where I had a chance. Part of the appeal of punk rock, and one of its defining characteristics, is its populist nature. Punk music is for anybody—anybody can do it. You don't have to be a virtuoso, you don't have to know music theory, you don't have to be fucking skinny like Jimmy Page, you don't have to have cheekbones like Mick Jagger. All you have to do is have a lot of heart and put yourself out there. It's inclusive."

On an intellectual level, I understood that argument. But on a more emotional level, it made no sense to me. If I wanted to experience art that mirrored my own life, I could just look around to see a bucktoothed country boy who had no car and very little money. I didn't need to purchase a cassette or concert ticket to experience that. I lived it every single day.

The "they're just like me" argument about music also breaks down when you apply it to other aspects of life. For some reason, our culture has used this "anyone can do it" qualification with music, while neglecting to employ it anywhere else. Imagine

saying to someone, "I just can't relate to Michael Jordan. I know he's the greatest basketball player ever, but his talent is boring. I'd rather watch the fat, overweight recreational league down at the local YMCA instead of the championship Bulls." Or, "You know guys, the *Sports Illustrated* swimsuit issue just doesn't do it for me. Why can't they put some girl with pimples and a little pudge on the cover? She's more like us than the supermodels!"

To me, art—whether literature, film, music, or other mediums—was about exactly what Kip Winger had described to me at Rocklahoma: escape. I wanted material that I could never produce about adventures I would never have with people I would never meet.

The fact that now, as an adult, I *was* actually meeting some of them was just a bonus.

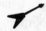

MY PARENTS BOUGHT a new farm shortly before my sophomore year of high school. There were slightly less than ten miles between the old place and the new home. But those miles crossed a county line, which meant phone calls to my friends were now long distance.

Late one evening, I was chatting with a girlfriend and suddenly there was silence on her end of the line—no dial tone, no "your call did not go through, please hang up and try your call again." It seemed like the line was still active; there just wasn't anything there. On the other end, I hadn't heard a comet crash into my girlfriend's house. I hadn't heard any yelling to get off the phone, nothing. I said her name a few times and then gave up. I had one of those eighties phones that didn't have a cradle; you just sat them on the table to hang up.

At school the next day, I learned that my girlfriend had, in

fact, fallen asleep in the middle of our discussion. Her end of the line remained open the whole night, which not only did wonders for my confidence but also made me question just how invested she was in the relationship. But that was forgotten soon enough.

Until Dad received the phone bill a month later.

Now it should be said that my father is not a profligate man. He reuses paper plates, drives fifteen minutes out of the way to save a penny or two on a gallon of gas, and uses an ironing board as office equipment. So when he received the bill for an uninterrupted eight-hour long-distance conversation, it is putting it mildly to say that he was not—at all—pleased. I had to get a job to pay that phone bill—not do a few extra chores and help out around the house or save an allowance (because I didn't receive such a thing). I had to actually go out, apply, interview, and obtain employment at a video rental desk in a grocery store for the express purpose of paying off one single phone bill. The lore of Quentin Tarantino and the film *Clerks* have rendered incorrigible video store employees a cliché. Our lot wasn't that bad, but one requirement was that you had to watch the incredibly violent and disturbing 1978 revenge flick *I Spit on Your Grave* during open hours with customers in the room without getting caught.

All of this left me irreparably scarred when it comes to telephones. I use them frequently for work, teleconferences, and interviews. If it is *planned*, then I'm fine. But for anything that is not scheduled and predetermined, I do not ever want to answer the phone. And if I do, I strive to finish the conversation in three minutes or less.

Lara and I were watching *The Office* on television one night and the phone rang. There is always a hesitation as we look at

each other and wonder whether the call is worth answering or if it's a telemarketer to ignore. Our phone line is through the cable company, so the caller ID appears in the upper left side of the screen. The black box appeared, with white letters and a phone number. The name read "DeMartini, Warren." I had been talking to his publicist again, but hadn't expected him to call. So seeing that name from my childhood splashed across my television was unnerving.

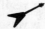

WARREN DEMARTINI'S MOTHER bought him a guitar when he was seven. He smashed the instrument to bits, in emulation of the Who's Pete Townshend. It was eight more years before he saved enough cash to purchase a new electric guitar. This time, he kept it intact.

Born in 1963, DeMartini grew up in San Diego, the youngest of six children. In his teens, he took guitar lessons and quickly became adept at the instrument, performing his first public gig at La Jolla High School. Shortly after graduation, he moved to Los Angeles to join a band that would grow into Ratt. He was hired to replace the group's departed guitarist Jake E. Lee, who had been poached by Ozzy Osbourne.

In 1983, Ratt recorded an independent EP that was highlighted by the tunes "You Think You're Tough" and "Tell The World." The cover featured the legs of model Tawny Kitaen, who also graced some of the band's later album artwork, with five mice clinging to her stockings. The record gathered steam on the Sunset Strip and attracted the attention of influential radio disc jockeys.

"Joe Benson created this show called *Local Licks* and at five o'clock on a Friday drive time, he would devote five minutes to

do a little intro on a band and play a demo tape," DeMartini said. The radio show selected Ratt for a feature one day, but actually kicked off the segment early.

"We didn't even have the radio on," DeMartini told me. "At the time, we were all living in this one-bedroom apartment, three of us: Robbin, Stephen, and me. You could almost hear Robbin screaming from down the block, running to the apartment, you know, and throwing open the door. He's like 'Turn it on! Turn it on!' That was a really great memory. It was the first time we heard Ratt and it wasn't one of us putting it on. It was a weird feeling. It was sort of similar to when a plane gets airborne. It was like, this is playing and we didn't cause it."

It was during this time that DeMartini was given the nickname Torch, for reasons misunderstood by fans and guitar historians. Most people assumed it was because of his speed on the instrument, but in reality the name started as a joke about the band's poverty and morphed as a result of a fan mail mistake.

"The nickname at the time was Thread," DeMartini told me. "A friend of Robbin's named me Thread cause we didn't have a lot of food money back then. So that's how it started. The EP was doing really well and there was a brief period where we would meet in our manager's office right on Hollywood and Vine. And because there was a fan address on the EP, we were starting to get fan mail and we would all gather in these band meetings. And each guy would read one. A letter ended with 'Oh, I really liked the guitarist with brown hair. I think his name is Torch.' Ever since that letter, you know."

Funds were so tight, the musicians would go see a band just to have a comfortable place to hang out. "You sort of buy one beer and make it last for six hours just so you could stay in the place," he said.

The EP performed well enough that the group was signed to Atlantic Records and they immediately started work on what would become 1984's *Out of the Cellar*. Initially in Ratt, Warren DeMartini and Robbin Crosby shared lead guitar duties. "Round and Round," the massive hit that broke the group worldwide, gave DeMartini a few bars of a solo, then Crosby a chance, and finally the two axe men combined for a dual-lead harmony like Judas Priest had made famous. However, as the band got more popular and drugs and alcohol became more prevalent, Crosby's lead work seemed to fade away and DeMartini was recognized as the guitar hotshot in the band. He didn't let loose with extensive solos, instead blasting a short section of speed interspersed with longer, more drawn-out notes.

Invasion of Your Privacy, my favorite Ratt record, was released in 1985. The guitar tones just growled on songs like "Lay It Down" and "Dangerous But Worth the Risk." I asked DeMartini about the gear used on that album because I had, for no specific reason, associated him with Laney amplifiers. But he said they stuck to the old tried-and-true amps.

"I'm pretty sure it was a Plexi Marshall. Probably a '68 or '69 Plexi Marshall and, later, a '70s Marshall hundred watt," he said. "Probably together in one big room."

By this point in the group's history, they were headlining arenas. I saw them perform with Bon Jovi as the opening act. Addictions, money issues, and power squabbles started to fray the band's cohesion, but they kept it together enough to release two more records in successive years. Looking back, the band churned out albums at an incredible pace of one a year, while groups like Metallica, Guns N' Roses, and Def Leppard slaved for half a decade on a single disc.

"You manage to get it done no matter what your time

allotment is," DeMartini said. "We did the Ratt EP in two days. Mixed it in maybe a day or two. If it was more than that, it wasn't much more. *Out of the Cellar* was cut pretty quickly. It wasn't a total rush but nothing took longer than it needed to."

Along with Mötley Crüe, Ratt was known as one of the more party-intensive bands of the era. Vocalist Stephen Pearcy said in a 1987 published interview that "our tour bus is like our pirate ship—it's where we rape and pillage . . . Ratt is one big rock-and-roll party and when anyone hops aboard our tour bus, they better know what to expect." The band's contract stipulated that promoters plaster backstage walls with centerfolds, have a case of champagne chilled, and supply piles of condoms. But somehow DeMartini managed to avoid being specified in the hedonism. He may very well have participated, but he wasn't singled out in the media like Crosby and Pearcy were. Similar to the way John Paul Jones avoided much of the tragedy and turmoil that afflicted Led Zeppelin over the years, Ratt's guitar player seemed to emerge from the eighties unscathed.

Rock journalist Lonn Friend once summed up the scene of surviving headbangers and their lifestyles today. "Most have kids, in their teens, close to grown up, doing their own thing," Friend wrote to me in an e-mail. "Most are divorced, not once, perhaps twice. Only Warren DeMartini stays married. He and Kathy have been together more than 20 years. An absolute enigma."

The guitar player himself was protective of his family and kept the details of his personal life personal. Bandmate Bobby Blotzer released a book called *Tales of a Ratt* in which he claimed DeMartini had family money socked away. The drummer wrote candidly about finances, opening the accounting ledgers, and providing specific figures in a way that very,

very few rock memoirs have the guts to match. During the nineties grunge apocalypse, when times were tough for glam metal bands, Blotzer took over a carpet-cleaning business. He relates a story of cleaning carpets with the Los Angeles Forum in the background, just eight years after Ratt had sold out the venue. In the book, Blotzer describes DeMartini as a "trust fund guy" and that "I've been told he's related to the Mars chocolate family."

During our conversation, DeMartini certainly had plenty of stories about challenging times and he deflected questions about how he remained so seemingly levelheaded. He didn't seem the type to pat himself on the back for anything, much less for staying straight. Like everyone else, he had challenges in life and used those to forge an optimistic view.

"Those times that were tough, I think created a sort of outlook that was, you know, always kind of looking for the brighter side. And the guitar was such an awesome tool to transport you into that world. It was something I could easily get lost in. It ended up being a little bit therapeutic."

After a number of years on hiatus, the original members of Ratt re-formed and recorded an album called *Infestation* that harkened back to the band's classic recordings. New guitarist Carlos Cavazo stayed on for the album and injected a certain amount of life into the band, allowing them to return to the dual-guitar attack that made them famous.

"I'm really excited about it," DeMartini said. "The double-lead sound, we were really conscious of visiting that again. I just really like the sound when there are two guitars doing a lead line together."

The new record and tour also provided an opportunity for DeMartini to compare his original custom guitars with their

contemporary replacements. The instruments he played on the tour were new models, designed to look like those legendary axes I adored as a kid.

"The ones from the eighties, most of them have one and seven-eighths necks on them and they sound amazing. But now I really prefer one and three-quarters. However, the sound of those originals is just *the* sound. It's just the combination of everything. Everything matters on a guitar. It matters how old the paint is. It matters how thick the neck is. So a one and three-quarter inch neck is going to sound different than a one and seven-eighths neck on the same body. So I did notice when I picked up the original Charvel with the sword paint job, it just lined up perfectly with my memory of the sound from the original recording. It's not a better or worse sound; it's just that it's *that* sound."

After decades of performing, DeMartini still saw a limitless fret board of musical opportunities ahead of him.

"It's infinite," he said. "A guitar is one and three-quarter by two and a half feet space of wood and wire and frets. And it's a door to the infinite, you know? I feel like I'm never going to know everything and I'm always learning more. I suppose some people like to sail the world. It's kind of like that musically. It's never ending."

EACH MORNING BEFORE catching the school bus in junior high, I listened to Ratt. While music was a consuming factor in my life, I didn't have the cash for snazzy stereo systems like the one Ferris Bueller adjusted at the beginning of his day off. Instead, I amassed a hodgepodge of musical devices

and scattered them around the country so I would always have access to tunes.

I first listened to KISS albums on a record player that my mother handed down to me. It was set up in a centralized room, but I lengthened the wires so that the speakers could be placed in my bedroom. I would drop the needle on *KISS Alive!* in the den, dash into my room before the tune started, and grab my tennis racket or BB gun fake guitars and be ready for the imaginary stage before the famous line started, "You wanted the best, you got the best!"

I also had a portable red eight-track player that my aunt and uncle gave me. I slammed in the cartridges for the *Dynasty* and *Destroyer* releases from the masked rockers and clunked through the songs, pounding the button to change programs.

In Georgia, my grandmother had one of those massive console stereos constructed to look like a piece of furniture. You lifted a lid like the hood of car to reach the record player inside. It was several years old but still smelled like new wood. I distinctly remember listening to the 1978 solo releases from Ace Frehley and Paul Stanley on that console, laying on the green shag carpeting with my ear next to the speakers, because it was late at night and the volume had to be kept to a minimum. There probably aren't many people who can say—or would admit—that hearing Paul Stanley sing "Hold Me, Touch Me" conjures images of Grandma. But those records were the soundtrack to the time I spent in her home.

For traveling between Kentucky and Georgia, I had one of those portable cassette recorders that were the size of an encyclopedia. It sounded like shit. My uncle was a talented musician and whenever he criticized the music I loved, I always blamed

the poor acoustical qualities of that tape player. Later, as Walkmans became more prevalent, I had one of those for travel and long car rides.

By the time I discovered Ratt, I had procured a small GPX boom box from a five-and-dime type store called TG&Y. The chain was named for its founders, but my grandmother always told me the acronym stood for "Turtles, Girdles, and Yo-Yos." That boom box cost $18 and I hoarded birthday money to get it.

The pinnacle of my childhood stereo equipment was another fine piece of GPX sonic engineering. It had a record player, an equalizer that was more to make you *think* you were adjusting the sound more than anything else, a dual cassette deck, and two speakers. It was around a hundred bucks and I scrimped and saved to get that thing. Even with today's digital iPods and equipment, I still expect to hear the clunk of the buttons on those tape players before music begins, purely because of the lost hours I spent with that stereo.

Whatever piece of equipment I had at my disposal, Ratt was on it before school. I would get on the bus and talk to my friend Amy about the band. She played the flute in the school orchestra but was good-natured and patient about my musical obsessions. When you live as far out in the country as we did, bus rides took a *long* time.

I thought she would be impressed: that listening to that type of music, that early in the morning communicated an edge, a toughness, a worldliness and sophistication beyond small-town Kentucky. It wasn't like I was shooting speedballs at 7:00 AM or drinking a six-pack of beer before algebra. But I still thought it separated me from all the other sleepy-eyed kids nodding off as the bus bounced around roads that were so narrow you had to pull over if another vehicle approached.

AT THIS POINT in my guitar practice, I had never played with another human being. I had never even attached a strap to the instrument, much less tried to fashion chords while standing upright. But I was feeling more comfortable with the bits and pieces of songs I had been working on. My arsenal of licks included the solo to "We're Not Gonna Take It," the opening riff of "Breaking the Law" and snippets of "Forever" and "The Ballad of Jayne." I was feeling so proud of my accomplishments that I got carried away in my quest of the guitar and invested a huge sum of money in an event that I thought would force me out of my comfort zone. I had failed to summon the courage to even hold a guitar in the vicinity of Steve Vai, one of the Virtuosos in my guitar player constellation. To compensate for that failure and get another chance to share the stage with one of my heroes, I wrote a check and signed up for rock camp, where I would perform with the Spaceman himself.

So I asked DeMartini for some advice on taking to the stage for the first time.

"Be as prepared as possible," he said. "The night before, make sure that your strings are changed if you like fresh strings. Not only changed but stretched out. Make sure you have spare batteries for any pedals or gear. When I was starting out and I would be nervous, the only thing I could do to help was just be as prepared as possible. Just cover, and then re-cover, your bases."

I had tracked DeMartini through concerts in Oklahoma and Pennsylvania and while I didn't meet him in person, the phone chat set me at ease somewhat. It didn't remove the anxiety that I had or erase the fears that I had made a terrible

mistake. But it did give me something to concentrate on instead of worrying.

I laid out my supplies like a Mount Everest expedition at base camp, checking and rechecking that I had everything. Extra strings? Electronic tuner? Picks?

The guitar choice was bothering me. K. K. Downing had told me that when planning for a tour you needed a guitar that was "a working tool that you really need out there. Something that is going to fly well. It's going to climatize well. It will stand some knocks. It's repairable. They become as much a working tool as your suitcase. You want a good suitcase that's going to last and it's going to work for you." So I had to choose an instrument that would do the job.

By this point, I was pretty proficient at the basic chords. And a G just never sounded right on the B.C. Rich Bich I hauled to my lessons. I always thought I was going out of tune; some chords would sound fine while others were slightly off. I liked the looks of the Bich and I liked the wide ebony fret board, but something wasn't right. For my adventure, it was important that I have the proper instrument.

Lara was in bed reading when I walked in carrying the Bich and the Telecaster.

"Does this sound right to you?" I asked and I played a G on the more outlandish guitar. She said it sounded fine she guessed. Then I did the same thing on the Telecaster.

"That sounds better," she said. "No doubt."

I figured out that something was off with the frets on the Bich. It wasn't that I was doing anything wrong; it was the instrument itself. As I had accumulated my guitar collection over the years, I had made my choices based on visual appeal and childhood memories. But since I couldn't play guitar at the

time of acquisition, I couldn't really give prospective instruments a test drive. It was like purchasing a Ferrari or Lamborghini without being able to operate a stick shift. I flashed back to the day I got the Bich. Without any prompting from me, the salesman eagerly offered a $200 discount on the instrument, which I happily accepted. Now I knew the truth. It had hung there on the wall for months, ignored by practicing musicians, waiting for a sucker like me.

I had requested to be placed in a metal group, so the Telecaster seemed like an odd choice. It's more frequently associated with country music than heavy rock, although John 5 and Jim Root from Slipknot both played Teles. But my ESP and Charvel axes were just ridiculously over-the-top. I would attract far, far too much attention with those. So I placed the Telecaster in a case and piled all the rest of the gear into a backpack. I had the equipment sorted out.

But first, I had to have another conversation. This time, I wanted to know about taking a big step, about dealing with nerves.

14

BLOOD, SWEAT, AND STRATS

A brunette who appeared to be in her early forties tapped me on the shoulder and giggled. She had a soccer mom haircut and wore jeans with a white blouse.

"How do you get one of those?" she asked while pointing to my backstage pass. Her friends snickered nearby and the brunette smiled broadly. These conversations happened with some regularity while I attended concerts during my guitar hero odyssey. There was a time decades ago when I dreamed of circumstances like this.

I stood in "the pit," the narrow trench-like space between the first row of audience members along the barrier and the stage. At bigger shows in bigger cities with bigger crowds, navigating the pit was like playing football in a submarine: a crash of beefy security guards, a battalion of grizzled concert shutterbugs, and a handful of roadies and techs dressed in black, all dashing back and forth and fighting for space in gaps only two or three feet wide, while amped-up crowd surfers and unconscious druggies were passed overhead. However, this was the Covelli Centre

in downtown Youngstown, Ohio, so although the crowd was a respectable few thousand fans, they calmly stood along the movable metal fence. And the security guards were more often older, gray-haired men and clean-cut college kids, not the 'roid monsters with shaved heads, goatees, and Oakley sunglasses normally staffed on big stadium security teams.

During the metal heyday, backstage passes were frequently laminated and hung from a shoestring-like rope. Nowadays, they were peel-and-stick affairs, with a date or city scribbled in magic marker. They were cheaper to produce and easier to prevent from being recycled among groupies and fans. But they still held an allure for audience members and fans.

The woman smiled and asked if I would take her picture along with her friends. I didn't have the heart to admit that I wasn't a professional photographer and that the image, most likely, wouldn't turn out. Her pals leaned in and I snapped the shot. We chatted some more and she asked to see the photos on my camera. She cycled through the images stored in memory, squinting at the small display on the back of the Nikon. When she saw some photos I had taken earlier, from the stage looking out at an empty arena, she cooed.

"You were onstage earlier?"

"Yeah, the guys were showing me around."

She scribbled something down and handed me a scrap of paper. Her e-mail address was on it. "For the photo, you know. To send it. You can send me the picture whenever you have a chance."

Although I wasn't experiencing much debauchery on my guitar hero tour, scenarios like this made me fully aware of the power of the pass. I was a nobody at a triple bill of Night Ranger, REO Speedwagon, and Styx in Youngstown, Ohio,

and yet random women initiated conversations and handed out their contact info without a moment's hesitation.

I'm not suggesting that the soccer mom was willing to blow me in the parking lot for a chance to get backstage. It's even likely she wanted nothing more than a snapshot commemorating her night out with friends. But the fact that she started the conversation was telling. She was probably the third or fourth woman to approach me that evening. Interestingly enough, no men asked for snapshots or how to get passes.

If I got that kind of treatment from middle-aged women at nostalgic rock concerts in the Midwest, then I had no problem believing the tales of excess that surrounded Guns N' Roses or Mötley Crüe when they were the biggest bands in the world, performing to younger, hotter, and hornier audiences.

TRIPLER ARMY MEDICAL Center sits on the Moanalua Ridge and overlooks Honolulu, Hawaii. It's painted a bright Pepto-Bismol pink and has served as the primary medical hospital for forces stationed in the Pacific Rim since 1948.

Brad Gillis was born at the facility in 1957 while his father was stationed in the islands during a stint in the navy. The Gillis clan moved to Alameda, California, after a transfer and that's where the budding guitar player grew up. He has fond memories of his childhood in the Bay Area with a mother who played piano and a good-humored father. "My dad was a hoot," he remembered. He spoke with me in the dressing room of the Covelli Centre, blasting out huge chunks of speech at a time. Many musicians responded in one or two words and you had to work hard to draw them out. With Gillis, you pointed the microphone in his direction and he was off, spitting out fully formed paragraphs.

His blond hair was short and he had a goatee. His skin was freckled from what looked like plenty of afternoons in the sun. He looked like someone you might see at a softball game, or knocking back a beer while fishing off a nice boat.

Like so many other musicians of his generation, Gillis was inspired to pick up the instrument after seeing the Beatles. His older brother had a friend who played guitar and provided some basic tutelage.

"He taught me seven major chords," Gillis said. "I played those chords. He said, 'Whatever you do, just listen to every song on the radio. You will hear these chords in those songs.'"

The young musician and his brother devised a method of running headphones through a preamp and record player so Gillis could play along with his favorite tunes. This style of learning was common among musicians in the pre-Internet era. Back then, you didn't have the tablature and online videos that I spent so much time watching. Instead, you only had records, along with maybe a few guitar magazines, and you just had to figure things out for yourself. Many guitar players who came of age in the sixties and seventies tell stories of a precarious balancing act between holding the guitar and the record player, using an elbow to slow down the LP.

"So then Hendrix came out, Janis Joplin, Santana, Led Zeppelin," Gillis recalled. "All this shit came out and I go, 'Whoa man!' I sat for ten hours a day and just practiced."

His father was a boxer and into baseball, so it's not surprising that Gillis played sports during his early childhood days. His right pinky finger is bent to this day, a result of a football injury. But a brief moment on the stage led Gillis to abandon other interests and focus on music.

"I played the talent show at my middle school," he said. "I

played 'Gloria.' It was just me playing guitar and singing and a drummer. We didn't have a bass player. At the end, all the middle school girls were screaming. I was like, 'This is what I want to do.'"

After finishing at Alameda High, Gillis played in club bands and eventually joined a band called Rubicon that drew enough attention in the Bay Area to play the Cal Jam II in 1978.

"The biggest day of my life," Gillis recalled, "two hundred fifty thousand people, Ontario Motor Speedway with Aerosmith, Heart, Santana, all these big huge bands."

Rubicon morphed into a band called Ranger that featured bass player and vocalist Jack Blades, drummer and singer Kelly Keagy, guitarist Jeff Watson, and keyboard player Alan Fitzgerald. Ranger held down some opening slots for bigger acts like Sammy Hagar and recorded a demo tape they used to entice record label interest.

In March 1982, Gillis was driving down the road when a radio DJ announced that guitar hotshot Randy Rhoads had been killed.

"I actually pulled over my truck," Gillis said. "He was one of the newest, greatest guitar players to come on the scene. I had just seen him a few months before that in Oakland and he was being touted as the next Eddie Van Halen. I saw the show and was amazed at his playing. To hear he died in this plane crash just threw me for a loop."

After a local gig the following weekend, someone backstage mentioned he could get Gillis an audition to replace Rhoads in Ozzy Osbourne's band. The guitarist sarcastically said "sure" and the gang all had a good laugh.

THERE'S A SCENE in that *Rock Star* flick where Mark Wahlberg's character gets a call to audition for his heroes in Steel Dragon. It's early in the morning and he thinks he's been punked. While it's doubtful that the movie's writers had Brad Gillis in mind when they penned the scene, he certainly knows how it feels to be in a similar scenario.

At 8:00 AM on a Sunday morning, the phone rang. Gillis answered to a female voice with a posh British accent calling him Bradley and identifying herself at Sharon Arden, the manager of Ozzy Osbourne who later married the singer.

The guitarist thought the call was a joke and wanted to get back to sleep—until the lady said that Ozzy was coming to the phone.

"Hello Bradley," the supposed Prince of Darkness said. "I want you to learn eighteen songs. Write these songs down . . ."

Back in the seventies and early eighties, there was often a delay on long-distance phone calls, particularly transcontinental chats. That delay indicated it couldn't be a Bay Area friend pulling a prank. And the unmistakable accent was also hard to deny.

"I thought, oh God, this is for real!" Gillis said. "I turned pale white and just freaked out. I grabbed a pen and started writing down all these songs. He said they wanted me to fly out on Tuesday and I thought, 'I've got to learn all these songs in two days.'"

Gillis knew the Oz's big hits like "Flying High Again" and "Crazy Train." But the more obscure numbers would have to be digested somehow in short order. He put the word out for any friends with Ozzy or Black Sabbath records to come over, posthaste.

At the airport in New York, a limo driver held open the door for Gillis and put his luggage in the trunk. The young

guitar player stared at the New York City skyline and lights as the massive car sailed toward the Helmsley Palace Hotel in Manhattan. This was the West Coast musician's first visit to the Big Apple and he wondered how many other axe slingers were auditioning for the gig. On arriving at the hotel, the guitarist discovered there was no reservation in his name and he didn't have a credit card. He paid $150 in cash for the night's stay, taken from his entire stake of $200. Shortly after sitting down in his room, he was summoned to a master suite upstairs at 1:00 AM.

"I knocked on the door and there's this huge party going on with probably fifty to seventy-five people in this giant master suite. I walked in the door and saw Larry McNeny, the road manager."

McNeny was in the process of taking over the road manager job from a dismissed employee. Ozzy's bass player Rudy Sarzo has described McNeny as looking exactly like Eric Clapton, which turned out to be a huge coincidence since the guy also worked for Slowhand. In fact, McNeny said that he was often asked for autographs by confused Clapton fans.

Gillis explained the situation about the room reservation and McNeny pulled out a roll of money, peeled off five $100 bills, and handed them to the guitar player.

"I hope this helps," he said.

"That'll work," Gillis laughed.

Ozzy's suite at the Helmsley Palace was packed with young people milling around. Gillis assumed that many of them were his competition for the axe-slinger spot.

"No, no, it's just you Brad," McNeny said. "These guys are radio people, magazine interviewers. You're the only guy and if you can't cut it, we're going to have to find somebody else."

The road manager didn't waste any time. He immediately led Gillis over to meet Ozzy Osbourne. The singer didn't beat around the bush either. He instructed Gillis to go get his guitar. The awestruck guitar player responded that he didn't have an amplifier, just his instrument. Oz told him it didn't matter. Just go get it. Gillis ran to retrieve his '62 red Stratocaster.

"It was like the E. F. Hutton commercial where if Hutton speaks, everyone listens," Gillis remembered about his audition. "We started walking up these stairs to the master bedroom in the suite. The whole room got quiet and watched me walking upstairs. I sat on the end of the bed and he sat on the floor with his legs crossed."

Gillis was instructed to play "Flying High Again," a single from Ozzy's 1981 album *Diary of a Madman*. The young man plucked out the tune on an electric guitar with no amplifier and as soon as he completed the song's intricate solo, Ozzy leapt to his feet.

"Brad, I love you," the singer shouted. "Pull me through. Pull me through this." Osbourne had been incredibly close to the deceased Randy Rhoads. The guitar player's death further exacerbated a tenuous situation with Ozzy, who was notoriously dependent on drugs and unstable even before the accident. In his 2010 memoir *I Am Ozzy*, the singer writes, "By then I was having a total physical and mental breakdown." In fact, in the days after Rhoads's death, Ozzy repeatedly argued that he should quit performing, that the accident was a foreboding omen.

So his relief was palpable at realizing Gillis would be able to fill the slot in the band, if not the void in his soul. Ozzy threw open the door to the suite, looked at the crowd below, and bellowed that he had located the new guitar player.

"Everyone started clapping and I came down the stairs," Gillis said. "And everybody's on me. 'Who are you?' 'Where are you from?' And that's when the whirlwind started."

He made his stage debut with Osbourne on April 12, 1982. With no stage clothes, someone pulled out a red Ferrari jumpsuit and zipped the guitar player in. Sharon Osbourne patted him on the back and told him to have a good show. Under difficult circumstances, Gillis performed well, with one notable exception.

"I remember screwing up 'Revelation (Mother Earth).' That's the tune where it's a slow ballad and halfway through, it kicks into the fast chunk section. I went to that section a whole verse too early and Ozzy looked over at me and gave me this look like, 'Oh god, you're screwing up' and I stopped the fast part and went back to the slow ballad section. I ended up getting through the song and the rest of the show. But I'll never forget because the next night, Sharon comes up and says, 'Bradley, have a good show tonight but don't fuck up.'"

The reconfigured band toured America, Japan, and Europe for almost ten months, highlighted by a recorded show that would be released as the *Speak of the Devil* album. Fans slowly accepted Gillis in the guitar slot, though they were still apprehensive about anyone replacing the legendary Randy Rhoads. I asked him how he dealt with the nerves of such a pressure-packed situation and he stressed the importance of knowing the material, rehearsing, concentrating on getting your parts right, and just keeping a level head. He also said it was helpful to have an encouraging bandmate or a mentor you could lean on after a bad gig or when you had questions.

"Whenever I thought I wasn't doing well or wasn't playing right, I'd go to Rudy Sarzo and he'd let me know that 'hey man,

this is a huge gig and you're doing a great job. Don't worry about it.' Rudy's great with that and he gave me the utmost confidence."

But then Sarzo left to join Quiet Riot and Gillis's former bandmates in Ranger—now calling themselves Night Ranger—received an offer from a record label. But the executives included the stipulation that the axe slinger had to rejoin his Bay Area mates.

"I decided to quit Ozzy's band and go back to Night Ranger," Gillis said. "It was tough for me, but with Ozzy I was a sideman and with Night Ranger I was definitely part of the band. We split publishing and they were all my bros and I just felt like I'd have more longevity with the group. So I came back to Night Ranger and in early 1983, our *Dawn Patrol* record and the Ozzy *Speak of the Devil* record both came out in the same week."

And that's how Gillis had—confusingly—first entered my musical consciousness when I was ten years old. In the early eighties—long before he opened his home to reality viewers all over the globe—the Prince of Darkness was a bit too scary for me, so I wasn't aware of Rhoads's death or Gillis's movement between Ozzy and Night Ranger. But even though I didn't know his identity at the time, I did in fact see Gillis perform live.

THE KISS SHOW that I browbeat my father into taking me to was my first concert of any sort. I didn't know about opening acts. So when the houselights went down in Rupp Arena that evening and I saw some dudes in jeans and tennis shoes instead of capes and demon boots, I thought we'd been ripped off.

"Did KISS not make it?" I asked Dad. He either didn't know

or maybe he couldn't hear my question with all the toilet paper in his ears.

The group's name was Night Ranger, which seemed interesting enough. But the rangers in my Dungeons & Dragons books all had cool leather knee-high boots, green cloaks, and longbows. These guys just had normal instruments, including a drum set turned in to face the stage instead of out at the audience as normal, and to my dismay, a healthy-size rack of keyboards.

Writer Chuck Klosterman has argued in print that the "use of keyboards and synthesizers is the *Roe v. Wade* of 80's metal." At the time, as a ten-year-old headbanger, I had strict standards: Keyboards were for pussies. They were instruments that I saw in church and in the band room at school. I had never seen a keyboard belch fire or shoot lasers so they, undeniably, sucked.

I seethed in my seat as Night Ranger progressed through their set. I figured this was going to be like one of those television awards shows where the announcer teases, "Coming up, KISS!" and you sit there for four hours before your favorite band plays one song as the final credits roll.

Over time, I softened in my attitude toward keyboards and became a Night Ranger fan. The guys from Mötley Crüe sang backup vocals on some of their songs and Gillis's time with Ozzy definitely helped solidify the group's rock pedigree. They were heavy enough, but featured softer ballads that I thought would appeal to the ladies. When I went on dates, I frequently played Night Ranger, thinking that tunes like "When You Close Your Eyes" and "Four In The Morning" were more conducive to romance than songs about brawling with cops from the Crüe or my other usual musical choices.

The group's piano-based ballad "Sister Christian" dominated the airwaves in 1984. The song came on the radio one night as my parents and I sat at the Bourbon Drive-In waiting for the feature to start.

"That's the same band that we saw with KISS," I told my dad.

"No way," he countered as the quiet melody floated out of the speakers. "No way that's the same group that did all that hollering and screaming."

When I told Gillis about thinking his band was some sort of third-rate stand-in for KISS, he laughed. Fellow guitarist Joel Hoekstra giggled from a corner of the dressing room where he warmed up by playing classical music on an acoustic guitar.

"SHE'S MY SHOVEL," Gillis said when I asked about the battered Stratocaster his guitar tech had shown me on the side of the stage. It's a 1962 model that he obtained in 1979 when a friend abandoned a project to paint the guitar. It wasn't a huge acquisition at the time because the guitar player had a black Les Paul Custom that he adored. But he started customizing the Strat on a bit of a lark.

"I had a Datsun 240Z that was custom painted with red-orange paint," he said. "I had an extra can left over for touch up. I sold the car, but still had the paint. I thought, 'Shit, I'll paint this guitar in car red.' I took it to a body shop."

He then had the neck and headstock painted black, which was an unusual treatment back then. He added a Floyd Rose tremolo, changed the pickups, and made numerous other alterations.

"Whatever the hell I wanted," he said. "An extra fret, locking nuts, tuners, I changed everything. Then I started playing

and I thought, 'This is a fucking great guitar.'" The instrument has never been far from his side for the last thirty years.

The interesting thing about workhorse guitars is how they are treated with both reverence and abandon by their owners. These instruments contain decades of sweat, memories, successes, and failures. They carry the scars of tens of thousands of miles on the road. They often have the dried blood of musicians caked in cracks and crevices. On his website, Steve Vai writes movingly about one of his instruments that he calls Evo:

> Although Evo is just made of out wire and wood, I'm afraid of how much emotional investment I have in her. I think when you play an instrument long enough it becomes an extension of yourself in ways that run deeper than anyone may understand but you . . . For me, Evo has been the voice of my heart and seen the depth of my most depressed emotional frames of mind to my most euphoric moments of joy and divine love, and she usually gets the brunt of it all. I have cried, screamed, prayed, and bled through that instrument, and like I said, although she is only wire and wood, there is an emotional investment in her. I'm afraid at how much I love her.

Musicians aren't the only ones to cherish their guitars. As fans, we invest tremendous sentimental value (and therefore, a cold hard cash value) in the instruments that produced our favorite songs—enough value that celebrity-owned guitars fetch huge amounts at auction. Eric Clapton's Fender Stratocaster, nicknamed Blackie, brought an astounding $959,500 at a Christie's auction in 2004. Slowhand sold the instrument, along with many others from his collection, to raise money for

his drug rehab program in the Caribbean. The idea of parting ways with the guitar didn't seem to bother him, at least not when compared with the good work the money would make possible. But I went out and purchased a lottery ticket, hoping to win enough to buy the guitar. My plan was to win the auction and then loan the guitar back to Clapton. It just didn't seem right—in my mind—that he should be without the guitar. After his passing, maybe it would come back to me or to a museum.

But in spite of the fervor with which the instruments are honored, the musicians still manage to thrash them around every night. I've seen Vai play his cherished Evo with such abandon and fury that I thought he would rip it apart onstage. It felt like watching a cheetah tear into a gazelle on *Wild Kingdom*.

Brad Gillis was no different with his beloved '62 Strat.

"I still beat the shit out of that guitar," he said. "I'm still playing it hard."

AS THE HOUSELIGHTS went down, Night Ranger appeared on risers in front of a video screen with the band's logo. Gillis had changed from when I saw him earlier in the day. He now wore a sleeveless black shirt and deep-red pants. He wailed away on the red Strat during songs like "This Boy Needs to Rock" and "Sing Me Away." Known for his use of the instrument's tremolo arm to produce wildly pitched sounds, Gillis whipped, cranked, and tapped on the gadget.

My guitars were hardly celebrity-owned instruments worth high prices. And I had no personal investment in them, beyond just the memories they evoked. Certainly I had not depended on one to make my living for thirty years like Gillis and his

red Stratocaster. Yet I was always nervous around my guitars, afraid to scratch them or scuff the paint. Watching Gillis whip his around, after seeing how Vai treated his, I realized I shouldn't worry so much. The guitar was an instrument to communicate and explore, not to be kept in pristine condition. Although I had my gear squared away and the bases covered and re-covered for my upcoming adventure, Gillis advised me to take it easy when I worked with a band for the first time.

"Kind of sit back and take a ride instead of interjecting too much," he said. "Don't try to run the show."

There was no worry of that. I wouldn't try to run the show. I was more concerned with not ruining the show.

15

GRANDPA SEX, RINGER TAMBOURINE PLAYERS, AND ROCKING THE WHISKY

At the Rock 'n' Roll Fantasy Camp in Los Angeles, I had assumed that we would arrive at the rehearsal space and there would be a white board with song parts charted out. There would probably be a computer in each room so we could look up this tune or that riff and print out the transcriptions. The marketing materials had stressed that all skill levels were welcome and the whole point of this weekend was to improve your skill on the instrument, so I figured we would assign each song, maybe break up into smaller groups or even head off by ourselves and work on the sections. I guessed I would have at least some amount of time to devise a way to not humiliate myself.

I was wrong.

Instead, we plugged in our guitars and Rudy Sarzo asked, "Okay, everyone know 'Bang Your Head'?" All heads in the

room—except for me—nodded in agreement and the thunder started. Our two drummers pounded out the signature descending introduction to Quiet Riot's 1983 single and the group was off and running.

I stood there, clueless, and made eye contact with Kevin, a guy with twenty years of guitar-playing experience. I smiled and shrugged my shoulders and he realized I was lost. He pointed the neck of his guitar toward me and exaggerated his finger placement, in what I would experience countless times over the weekend as the musician's way of bailing out the idiot. But it didn't matter.

"There's fucking tons of different ways of fingering each chord!" I screamed inside my head. "And you're ten feet away from me. How in the hell am I supposed to see what you're doing!"

Sweat ran down my back and my eyes darted around the room, trying to see if any of the other musicians noticed my struggle. They were all focused on their own instruments and performance, being propelled forward by the monster bass player with decades of platinum success to his credit. They hadn't noticed me, yet.

So I took a page out of the Milli Vanilli playbook: I faked it.

I turned toward the wall like I was adjusting my amp, reached down, and eased the volume on my guitar down to zero. Then I turned back toward the group and started wailing away like I was Eddie Van Halen.

After the second chorus of "Bang your head! Metal health will drive you mad!" the guitar players all made eye contact as the solo approached. I demurred and waved my hand, as if offering a table full of gourmet food to my guests. Ever so gracious, I allowed the other two axe men a chance to take the solo.

After "Bang Your Head" was over, the band adjusted their instruments so I bumped the volume on my Telecaster back up enough to where you could hear a few squeaks and squawks as I mucked around.

"How about some Dio?" and then the group was off again. We didn't have a keyboard player to rock the famous intro to "Rainbow In The Dark," but the guitar players had the vibrato technique down sufficiently to carry the tune.

I reached down and turned my guitar off again. Sarzo leaned toward me and angled his right ear toward my idle amplifier. His long brown hair dangled down and covered his face. It was loud as fuck in the small rehearsal space, yet he pointed toward my amplifier and then motioned to the sky.

"I'm okay," I yelled back at him.

During the break, Sarzo came over. "Go ahead and turn your amp up," he said. "You're fine."

"Oh yeah, I will. I just need to settle in."

Ian, a Scottish-born software engineer who played a white Joe Satriani Ibanez model valiantly tried to cheer me up.

"I think you were sandbagging a bit," he said. "You're better than you had us believe last night. I could tell you knew what was going on."

I objected and Ian, in his kindness, continued.

"No, seriously, I could hear your chords. You were doing just fine."

It was a physical and acoustical impossibility that any sound vibrations I was making were reaching his eardrums, but I appreciated his attempts at including me. I just wondered if the band's good will would last the weekend when they learned how clueless I really was.

THE PREVIOUS EVENING, in a precamp social event at the Gibson Guitar Showroom in Beverly Hills, while the rest of the campers took turns jamming on Hendrix and Bad Company tunes, I worked up the courage to approach my counselor.

Rudy Sarzo was smaller than I expected, and thin. He wore glasses and was dressed simply in jeans and a long-sleeve T-shirt. Sarzo first attracted musical attention when he was the bass player for Ozzy Osbourne's band after the Prince of Darkness left Black Sabbath. Rudy was blessed by the rock gods to work with Randy Rhoads. In fact, Rudy was sleeping on the tour bus when the crashing plane carrying Randy Rhoads sheared the bus in half. Over the years, so many people had asked what it was like to perform with Rhoads that Sarzo wrote a poignant book entitled *Off the Rails: Aboard the Crazy Train in the Blizzard of Ozz* about his relationship with the guitar player.

After leaving Ozzy's band, Sarzo returned to one of his original outfits, the Los Angeles–based Quiet Riot where he racked up the first-ever heavy metal number 1 single and album. In 1987, he left QR and joined the metal supergroup Whitesnake, a band that rocked pretty hard but is, unfortunately, more remembered for their massive manes and music videos featuring Tawny Kitaen writhing on the hood of a Jaguar. Like many of the metal guys, Sarzo went a bit off the radar when grunge hit in the early nineties, but he had remained busy, playing sessions and doing other work. Currently, he was splitting time between Blue Oyster Cult and Ronnie James Dio's band.

Born in Cuba, Sarzo had the remainder of a slight accent and as I introduced myself, I struggled to hear him over the jamming

musicians. After some chitchat, I confessed my inabilities.

"Look, I have to admit something," I said. "I can't really play guitar. I've only been playing for a little while and struggle with some of the most basic stuff."

"That's okay," Sarzo said as he held out his hands. "This is as much your fantasy as everyone else's. You've got just as much right to be here."

What he probably meant, although he was too polite to say it, was that my money was just as good as all the other people's in the room. The Rock 'n' Roll Fantasy Camp was started in 1996 by show business veteran David Fishoff. The event offered primarily baby boomer bigwigs a chance to relive their teenage years in a band and jam with a few rock stars. Camp attendees got the chance to play for umpteen hours a day, rock with their idols, record a song at a major studio, and play a gig at the legendary Whisky a Go Go—all for the low, low price of $4,500 for three days. My skill on the instrument couldn't compete, but my check cleared just like all the rest of 'em.

Fishoff's team separated the musicians into different bands, based on skill level and musical taste. There were about forty attendees at my camp, and a full half of them had attended a previous event. Scattered among our group were fat-cat financial planners, a veterinarian, a father-and-son duo from the East Coast, and a cute teenage Russian girl with hair down to her waist and a penchant for black leather pants.

In my band there were two guys from a Bay Area software company, a logistics warehouse dude, a nuclear engineer from New Mexico, and a kid in his twenties who was at the camp because his mom won his slot in a raffle. The experience levels ranged from several years playing music to one guy who had

been playing guitar for twenty years and had an active band. No one was remotely as inexperienced as I.

"You'll be fine," Sarzo told me. "People get nervous, but in your own lives, you are all successful at what you do. There are CEOs in this room, entrepreneurs, and successful people. Everyone knows how to deal with stress and pressure. You just have to take what you do every day and apply it to the music. You'll be fine."

In addition to Sarzo, other counselors included Howard Leese, former guitar player for Heart; Slim Jim Phantom, the drummer from the Stray Cats; Sandy Gennaro, drummer for Joan Jett; Ron Nevison, a producer who worked with people like Eric Clapton; Rami Jaffee, a keyboardist who had played with the Foo Fighters; and Teddy "Zig Zag" Andreadis, a keyboardist who had rocked with Guns N' Roses and Alice Cooper.

After the party was over, shuttle buses returned the campers to the Renaissance Hollywood Hotel & Spa and my bandmates gathered in the hotel bar to get to know each other.

As part of our weekend's activities, we had to decide on a set list of three songs and one of them had to be a KISS tune. Each RRFC features a big star who doesn't work with you on a daily basis but shows up for a couple of hours and jams with all the bands. Previous camps featured Roger Daltrey and Aerosmith's Steven Tyler in the headliner slot. Ace Frehley from KISS had mounted something of a career comeback with the release of his first solo album in more than a decade, *Anomaly*, and he was the big name at our session—and a major reason why I plunked down the cash.

Kevin was the only other major KISS fan in our group. His luggage bulged with rare Frehley posters and other memorabilia to be autographed. He also carried a Gibson Custom

Shop Les Paul Ace Frehley model, an axe I always lusted after but couldn't afford. The guitar was modeled after Space Ace's stage instrument and featured three pickups (most LPs only had two), lightning bolt inlays on the neck, and Ace's face on the headstock.

So clearly Kevin was a fanatic, but the rest of our gang only knew the main hits like "Rock And Roll All Nite" and maybe "Shout It Out Loud."

"'Do You Love Me' has that cool guitar part at the end," I suggested.

"Yeah, that's a good tune," Kevin agreed. "Or, we could do something from Ace's solo records." He raised the very valid point in that Ace hadn't performed a number of KISS tunes in more than a decade, a fact that would come back to bite one of the other groups. But he was doing a solo tour to support his new record so that material would be practiced and fresh in the rocker's mind.

"He'll be more familiar with the stuff he's doing right now," Kevin suggested.

The hotel bar closed and we took our discussion to Ujesh's room. He was a drummer who fanatically followed the Philadelphia Eagles but lived in the San Francisco area where he was a marketing honcho for a computer technology company. He had attended a previous camp where Bruce Kulick had been his counselor, and he got to jam with Steven Tyler. Ujesh had such a good time that he recruited his coworker, Ian the guitar player, to return for this engagement.

Ujesh opened his computer and queued up a series of songs so the group could hear the tunes Kevin and I suggested. As we discussed song possibilities, it dawned on me that my mind for worthless trivia and my extensive knowledge of music (songs,

performers, and gear—not how to perform it) was giving the guys the wrong impression. It was time to come clean.

I sat in a custard-yellow armchair and admitted my inadequacies on the guitar.

"I want to learn, get better, and participate, but I don't want to ruin your weekend either," I said. "I don't mind sitting out or something. I don't want to hold y'all back."

The guys were kind and understanding. Ian said the key was just to find something within the context of the song that I was capable of executing. That brought me back to my original assumption that there would be charts and tabs and all kinds of stuff, that there would be discussion and tutelage between songs, that I would be able to stand in a corner and just strum a C chord for hours on end. Obviously, I was incorrect in that assumption.

The group decided on performing the song "Rip It Out" from Frehley's 1978 solo record. There is a cool drum breakdown in the middle that could showcase our dual percussionists. And since it was a highlight of Frehley's live performances, he would have recently practiced it.

As I walked back to my own room, I thought of ways I could contribute to the band, since my guitar playing wasn't exactly going to propel us to the top of the charts. With my writing background, I thought I might be able to help compose lyrics on the original tune we would create over the course of the weekend. And I also thought about band names. Every group at the Rock 'n' Roll Fantasy Camp has to have a name and we hadn't really decided on anything in the hotel bar. The guys seemed to want something that acknowledged Frehley's presence. I came up with Mismatched Sneakers, an allusion to Space Ace's shoe selection when he auditioned for KISS. But the band had also seemed to want to pay homage to Sarzo as well. During

our conversation at the bar, several references to Cuban this and that were tossed out. I wrote down Cuban Duckies on my notepad, a nod to the bass player's ethnic background matched with the name of a teenage gang that Frehley ran around with.

One of Frehley's bands prior to KISS was called Cathedral. And Sarzo was arguably most well-known for Quiet Riot. So I combined those two to form Riot in the Cathedral. I liked the way it sounded and the contrast of moods the two main words conveyed. I hoped the guys liked it as well.

AFTER THE INITIAL flurry of songs, Sarzo began leading the group. He explained that a band is like an arrowhead. The rhythm section was in the back. In our case, we had Ujesh and John from New Mexico playing drums. Bass players were few at this event, so instead of having another camper, Sarzo himself was performing with us. They occupied the widest part of the arrow.

In the middle were the guitar players—Ian, Kevin, and me. Ian was small and had slightly graying hair. His equipment was meticulously maintained and he kept a small notebook on his amplifier to record details about his effects settings. Kevin was balding on top, with curly hair on the sides. He looked a little more weathered, proof of his years in bars actually performing music. Then there was me, the imposter.

At the narrow tip of the metaphorical arrow was Dave, the youngest guy in our band, the recipient of the winning raffle ticket to attend the camp. He wore a baseball cap turned around backward on his head.

"The singer is the point of the arrow," Sarzo continued. "Everything that we do as a band is to propel that point. We

have to support the singer. That point will take us where we want to go."

Friday was devoted to getting our set list down. The group had already decided on "Rip It Out" during our discussion in Ujesh's hotel room. Sarzo wasn't familiar with the tune but after he listened to it once and chatted briefly with Kevin about the chord changes, he had it mastered.

We tried "Cum On Feel The Noize," Quiet Riot's monster 1983 hit. I always felt that Carlos Cavazo's solo in that song was one of the best in eighties metal. But Quiet Riot songs were in an unusual key to maximize singer Kevin DuBrow's voice. We just couldn't seem to gel on the tune and someone suggested Neil Young's locomotive train of an anthem, "Rockin' in the Free World." It featured a relatively simple chord progression and the group tossed out the idea, I felt, primarily so that I might have something I could keep up with.

And we also left room for an original song. Each Rock 'n' Roll Fantasy Camp band has to write a brand new tune, which would be recorded at the iconic Capitol Records on Saturday. So we left that slot in our set for the time being.

At lunch, I shared my band names with the gang. They all liked Riot in the Cathedral and we moved forward with that moniker.

The RRFC staff was determined to make everyone feel like a real rock star. If someone broke a string, there were crewmembers there to change it. If a drummer broke a stick, which happened to us frequently as Ujesh and John pounded away like Animal on *The Muppet Show*, someone brought you a fresh set. And then there were the band managers, attractive young women assigned to each group to keep you moving and

on time. Our manager was a pretty brunette named Lisa who grabbed the mic and belted out Dio tunes with us from time to time. She loved the headbanging classics and fist pumped during every song.

The afternoon passed quickly. Sarzo was instructive while still being flexible. He led us through the set a couple of times and would then let the band just yell out songs at random for a change of pace. Riot in the Cathedral went through our three songs dozens of times, but also played tunes by ZZ Top, Ozzy, Black Sabbath, and tons of others. Other band counselors were more dictatorial, forcing their groups through the same set list over and over. Sarzo stressed the importance of staying loose and not getting too stressed, so he let us alternate between serious rehearsal and jamming on any tune someone tossed out.

Never once did I make a noise on my Telecaster that anyone could hear. I settled into a pattern of watching and trying to learn. I would *try* to get the chords down. It was just so incredibly fast. I had never played guitar with anyone else, unless you counted my lessons with Doug. I hadn't even really been playing along to recordings when I worked on snippets of "Breaking the Law" or "Forever." I realized that I had been playing the musical equivalent of molasses.

It was like only riding on a bicycle and then strapping in to an Indy car as your very first experience with automobiles, or shooting hoops by yourself in the driveway and then stepping onto the court with the Kentucky Wildcats as your first team to play.

If I couldn't get the fingering, then I would focus on the strum pattern, just trying to keep the rhythm. I was sweating and my hands screamed in pain. I was working—in my own fake fashion—as hard as anyone.

Sarzo punctuated his instructions and advice with humorous analogies. At one point, he wanted the drummers to take a slower pace, but also kind of dirty and sleazy in a Rolling Stones manner.

"Imagine your grandfather having sex," he said. He lifted his elbows like doing the chicken dance and slowly thrust his hips forward. The image stuck and became an inside joke during the course of the weekend.

When it came time to work on the original tune, Sarzo asked if anyone had segments of songs from their own personal repertoire. Kevin, the most experienced musician, had a tune about a musician leaving his girl to go on the road. "She don't know" featured heavily in the lyrics. Sarzo asked if anyone else had suggestions. Ian brought out a lick that was from a guitar instrumental he had written. Within moments, Sarzo had shown the group how to meld those two disparate elements into a surprisingly catchy tune. Our singer, Dave, scatted out gibberish to keep with the rhythm of the song, but used the "she don't know" phrase from Kevin's original lyrics.

Sarzo suggested that I just keep a steady rhythm and he sang a kind of pattern that he described as like the word "chicken" with the emphasis on the last syllable so it came out "chic-KEN." Ujesh graciously tried to bail me out by saying, "Just keep singing in your head, 'havin' chic-KEN, havin' chic-KEN, havin' chic-KEN."

Steve Vai could make his guitar talk and laugh like a human. I wondered what chords he would employ to verbalize poultry because I was clueless. I tried to just keep a rhythmic strum going while holding down a G chord.

The song came together pretty quickly and I started to

comprehend the allure of performing in a band. I had never done the garage band thing with anyone, but now I understood why so many millions of people spend at least a little time in a group, however ragged the outfit might be.

Crammed into that tiny rehearsal space, the guys focused, worked hard, and generated something out of nothing. This song didn't exist an hour earlier. Now it did. It was like those rare moments I had experienced on a sports field when the team is focused and executing a single vision of play. Except this was just seven guys in a much smaller space. You could see each other's eyes, catch the grins, and laugh.

And Jesus Christ the noise! It was a glorious, soul-lifting, eardrum-pounding vortex of sound. It might have seemed like shit to anyone else, but to me, it was better than any KISS concert or symphony orchestra. It was ours.

AFTER DINNER, THERE was an instructive session where all the bands gathered in a larger space to listen to jams and lectures by the counselors. These moments often provided jaw-dropping moments with musicians that you *thought* weren't terribly impressive.

Howard Leese, who played guitar with Heart from the seventies through the nineties, was one of the counselors at the camp. While I certainly knew Heart's catalogs, I wouldn't call myself a fan of the band. So I thought, "Eh, okay" when Leese walked in. But then he plugged in an orange-red Paul Reed Smith and played "Somewhere" from *West Side Story* using *only* harmonics, I was astounded. And although I never found myself cranking up the volume on Heart's signature tune "Barracuda," when the

guy who wrote that immediately recognizable riff plays it three feet away from you, it's hard to not be impressed.

Bruce Kulick was not working at this session of the Rock 'n' Roll Fantasy Camp because of touring commitments with Grand Funk Railroad, but he did come in to speak at the night session. He recognized me from our weekend in Evansville and glanced at my wrist.

"What happened to your watch? Did you get divorced and have to sell it?" he asked, referring to the Breitling I had worn during our interview. I had left it at home, thinking it didn't match well with a rocker vibe. It was good to see Kulick again.

In front of the group, he played the solo to "Forever," the tune I had been working on. He also played the solo to "Tears Are Falling" from the video that I loved so much as a teenager, saying it was influenced by Yes and guitarist Steve Howe's work.

During the day, each band had its own rehearsal space. But at night, after the class session, the spaces were given a musical theme and campers were encouraged to tour the practice rooms and jam to different kinds of music. Our room was the metal room, while others were designated as the blues room, the Beatles room, and so forth. Campers could drift in and out of rooms at will, jumping in and jamming wherever they wanted. But Riot in the Cathedral was having so much fun, we didn't leave. We continued to play with the same guys we had already spent ten hours with. Other folks came in to join us, most notably guitarists from other bands who wanted to say they had played with famous bass player Rudy Sarzo.

If Sarzo was bothered by us butchering his music, he didn't show it. During the jam sessions, he sat in a folding metal chair between the two drum sets, lowered his head so that his hair

dangled over his signature Peavey Cirrus bass, and held every-thing together. He was a picture of heavy metal zen, barely moving except for a slight nodding of his head to the rhythm.

Shuttle buses started departing for the hotel, giving camp-ers a chance to turn in early for the night. But we stayed until the very last one, not wanting the day to end.

It was well after midnight when we returned to the hotel. I pulled some sheets of paper out of my guitar case. Our band manager, Lisa, had printed out the chords and tablature to "Rockin' in the Free World" so I could practice that evening.

The guys were right. The song was indeed simple. The chorus is just a G to D to C and then E minor. Individually, I could easily play those chords. I just had to quicken the transi-tions between them, so I practiced until the sun came up, took a shower, and went downstairs to meet the shuttle to start the whole thing over again.

THE MAIN FOCUS of Saturday was getting the original tune tight so it could be recorded in the afternoon. Our singer, Dave, came in with scraps of paper where he had jotted down lyrics. The song had evolved into a tale of unrequited love en-titled "She Don't Know My Name." The narrator professes his love for a woman who won't give him the time of day before he starts getting increasingly agitated and obsessed. "You gonna know my name!" Dave screamed toward the end of the song. It was annoyingly catchy, sort of like early Eminem singles, with a riff that lodged itself inside your brain and a repetitive "she don't know" vocal. We ultimately rechristened the tune to "My Name Is Dave."

After several run-throughs of the original song, Sarzo warned us about the iconic figure we would meet at Capitol Records.

"Eddie Kramer can be demanding," Sarzo said, giving a sort of locker-room pep talk from the coach. "He won't pull any punches and some people can't handle that. But you have to be ready for him. You guys can do it."

Kramer had earned the right to have things his way. The South African–born engineer and producer had worked with people like Jimi Hendrix, Led Zeppelin, KISS, the Rolling Stones, Santana, and others. He saw—and in some manner *oversaw*—the creation of some of the greatest tunes in rock music history. Think about the chugging riff to Zeppelin's "Whole Lotta Love." Kramer recorded that song.

During a break, I told the guys that I was going to sit out the recording session at Capitol.

"Here, I can kind of hide in the volume of the band," I said. "But when we're plugged in to the mixing board, with everything isolated and highlighted, there's no way. Kramer's gonna figure it out immediately. And we're going to be stuck there for hours while I keep screwing up."

To their credit, the guys felt strongly that I should do *something* that would be captured on the recording. Ujesh suggested that I play the tambourine and Kevin said I could share the backing vocals. Throughout the morning, I smacked a tambourine against my palm on every snare drum beat. Simple, plodding, but something I could accomplish. I was nervous, but determined to do a good job for my bandmates.

On the ride over to Capitol, Sarzo suggested that we tweak our band name a little. He was afraid that discussing a riot in a cathedral might be offensive, like we were picking on a

particular religion. Instead, he suggested changing the name to Riot in the Temple, the final word being a more open-ended term. Ujesh joked, "So we can offend the Hindus and Jewish people instead of the Catholics." But we were fine with his suggestion.

Everyone in the van got nervous as the big metal gate opened and the van pulled into the Capitol Records parking lot. The iconic round building, featured in so many television shows and movies as part of the Hollywood skyline, towered above us. Just inside the lobby, plaques for Capitol's diamond-status albums hung on the wall. In the recording industry, a "gold" record indicates five hundred thousand copies sold, while "platinum" means a million sold. But "diamond" status is reserved for the super rare albums that move ten million units.

We walked down a darkened hallway and descended a flight of stairs. From there, we emerged in a cavernous open room. Studio A had over fifteen hundred square feet of space, two isolation booths, and had hosted sessions by Frank Sinatra and countless other stars. The floor was tile, while wood slabs hung on the walls halfway up the vaulted ceiling. Microphones were cranked at every angle, scattered around the room like robot workers in a *Star Wars* film. Everyone started setting up their gear while Lisa and I took photos.

Kramer was a trim man with gray hair combed back over his head and a goatee. He wore a gray button-down shirt with the sleeves rolled up and black jeans. He spoke quickly, keeping everything moving. He came over the studio intercom system and asked each musician to play a few seconds so he could adjust the levels.

Sarzo stood in the middle of the room, so he could make eye contact with all the musicians and keep everyone on track.

Just before Kramer counted down to start, Sarzo made the "grandpa having sex" gesture we had adopted as our symbol of team unity.

The gang nailed the song pretty quickly. There were a few run-throughs, Ian did a couple of isolations on the guitar solo, and we moved on. I hoped my Riot in the Temple bandmates had forgotten about my tambourine opus but someone mentioned it to Kramer and he led me into the isolation booth. A slender drum tech with a German accent stood outside the door and handed me a tambourine. Kramer told me to don the headphones and he ran off to the control panel.

The main studio was empty. The rest of Riot in the Temple was in the control room with Kramer. Through the headphones, I heard the producer cue me up, I heard the click track start, and then I heard the rough mix of the song.

I held the tambourine in my right hand and banged it on my left palm. Trying to match each beat on the snare—*bap, bap, bap, bap*—my palms were sweaty and the tambourine slipped in my right hand.

"Hang on, hang on, hang on, mate," Kramer said over the intercom.

He came into the booth and moved me around, farther from the microphone, then closer to the microphone. He waved the tambourine in the air as he said, "Try it like this." I thought he meant distance from the mic.

The click track started again, then the music, and then I matched each beat of the snare. *Bap, bap, bap, bap.*

Without saying a word, Kramer appeared in the booth a second time. He slid open the glass door, and motioned for the German drum tech to join us. He looked me in the eye while he handed the tambourine to the tech.

"Sorry, Mr. Tambourine Man," he said as he left the booth.

The drum click started, then the music, and then the tech unleashed a fucking symphony of the tambourine. There were flourishes and fades, loud bangs, and subtle tickling. Sweat poured down the guy's face and he grimaced with the pain in his palm from the tambourine. And then we were done. The tech stayed in the main studio to straighten up as I joined my bandmates in the control room.

"Goddamn, you were doing some amazing stuff on there," someone said.

Kramer kept quiet and I didn't have the heart to tell everyone that a session player had replaced me on the tambourine.

BACK AT THE rehearsal space, we prepared for our concert. The finale of the Rock 'n' Roll Fantasy Camp was a performance at the one-and-only Whisky a Go Go on the Sunset Strip. We intended to play "Rockin' in the Free World," then our original tune, and finally "Rip It Out" with Ace Frehley.

Ujesh mentioned that at the previous camp he'd attended, some bands played four songs instead of just three. And our iteration of the event had fewer groups. He felt we should do four songs. "They're not going to pull the plug on us," he said.

The gang decided to add the Ozzy classic "Crazy Train." The problem was that Dave didn't feel comfortable hitting the high notes in the song. Kevin, who sang with his bar band, agreed to take over the mic but didn't think he could sing the challenging tune and play guitar at the same time. It wasn't a song he normally performed so he didn't know the guitar parts.

Lisa brought in the lyrics and the band played the song.

With Sarzo on bass, it was near impossible to not sound at least respectable. But it was noticeably thin. We dropped from two guitars (Ian and Kevin, let's not even count my miniscule contributions) on the other songs down to just one. Ian did a yeoman's job holding it together and pulling off the solo. And he adjusted his effects unit, trying to yield a fuller tone. During a break, I implored Kevin to help out on guitar.

"Can't you just strum a rhythm pattern or something while singing? I can't do shit and Ian's all alone on that song." He had played for decades. Surely there was *something* he could do to flesh out the sound.

"Dude, that song's no joke."

As the day drew to a close, I asked Lisa to print out the tablature to "Crazy Train." I intended to stay up all night practicing. Maybe there was at least one section that I could execute. But at the hotel that evening, when I looked at the papers, it was like Egyptian hieroglyphics. The Randy Rhoads guitar parts featured hammer ons, pull offs, pick scrapes, and every other possible technique. As Kevin said, that song's no joke. Ian was going to have to go that one alone.

BY SUNDAY MORNING, I was exhausted. I hadn't slept in two days and my fingers felt like I had typed a Stephen King novel on an acid-covered keyboard. Sharp pains in my fingertips extended up into my forearms.

At the rehearsal space, a corner was piled with posters and mementos. Ace Frehley was scheduled to drop in at some point and Kevin had brought all his stuff to be signed. Other musicians had come by during the course of the camp. Session drummer extraordinaire Kenny Aronoff, for example, stopped

by for a ten-minute chat and posed for a few pictures. That's what we expected from Space Ace.

We ran through the set list a couple of times and then just started jamming. Sarzo wanted to keep everyone loose for the evening's performance.

"You don't want to overprepare," he said. "Sometimes, people push too much and they just get locked up. You guys are sounding great. So now we need to not peak too soon."

In my hotel room, I was okay with "Rockin' in the Free World," but with the band, I got nervous and couldn't keep up. So I was back to dialing down my guitar on most songs.

Around noon, we were told to start tearing down our gear and preparing to move back to the hotel. The afternoon was free so that people could relax before the gig. We had packed away all the guitars and were chatting when one of the roadies opened the door. He rolled a Marshall amp with one hand and held a tobacco sunburst Les Paul with the other.

"What's that for?" Kevin asked.

"Ace. He's gonna play with you guys."

At holiday gatherings my family always shares the story of the Christmas when my aunt, uncle, and grandmother had traveled to our home in Kentucky. Most of the crew went out for the evening, leaving just my brother, my grandmother, and me at home in front of the television on Christmas Eve.

Mimi, as we called my grandmother, kept suggesting that my brother and I go to bed. She was much too lenient to actually instruct us to hit the hay.

"You don't want Santa Claus to come and catch you awake," she teased.

I was young enough that Santa was still a part of my holiday season, although I was always skeptical. My older brother

should have known better. But we stayed in front of the TV, ignoring Mimi's suggestions.

Then we heard some noise.

In the window, looking into our den, was Santa Claus! The beard, the red hat, the whole thing. My brother and I rocketed off the couch and dove under the covers, afraid that we had been caught, and that no toys would be delivered.

What we later discovered was that my uncle had dressed as Santa to deliver presents in a local nursing home. He and my parents thought it would be fun to surprise us.

The point is that however quicksilver fast my brother and I moved that Christmas Eve, it wasn't as urgently as Kevin and I rushed to get our gear set up. The air in the rehearsal space popped with guitar cases snapping open. We plugged in and then eagerly awaited a visit from Saint Ace.

He walked in the room with some of the RRFC staff in tow. He was dressed as he usually did these days, in sunglasses with a black button-down shirt open over a black T-shirt, jeans, and cowboy boots. A silver cross hung around his neck.

Frehley said hello to everyone and asked what we wanted to play. He cackled "all right!" when we told him our song selection. He patted his pockets for a guitar pick like a smoker checking for cigarettes. I handed him one and then the drummers counted off.

The Spaceman stood right next to me, crowding me into the wall. I peered around his shoulder to watch him perform the song that I had heard so often over so many years. The cliché is that life flashes before your eyes in a threatening moment. My life wasn't in danger, but it did flash through my head as Frehley played that solo. Family homes in Kentucky, my grandmother's house in Georgia, road trips with my pal

Charlie in high school, and hours upon endless hours of fantasizing about sharing a stage with KISS and Frehley. The song was over quickly, but it seemed to last forever.

He set the guitar pick on top of the amplifier when we were finished and I snatched it like a game show contestant hitting the buzzer.

As we broke up after Frehley's visit, Sarzo told us to skip dinner.

"If you eat, then just have something light," he advised. "When you've got a full stomach, you're lethargic. You don't want to be slow and lazy for the gig tonight."

Ujesh and I sort of complied with his instructions. We ate at the busy McDonald's near Hollywood and Vine, but did so early enough in the afternoon that the fast food would have time to digest—or to pour out of our system if the nerves got to be too much.

BASKETBALL FANS REVERE Madison Square Garden. Real hoops fanatics take it one step further and honor Harlem's Rucker Park, home to famous summer leagues and playground legends. NASCAR folks daydream of Talladega, golfers yearn to play at Augusta, and actors have visions of Broadway.

When I was in high school, I felt that way about the Whisky a Go Go. Founded in 1964, the venue had hosted virtually every major rock band to come from—and many who passed through—Los Angeles, including: Alice Cooper, the Doors, the Byrds, Frank Zappa, Led Zeppelin, Cream, the Police, Talking Heads, and many others.

Most specifically to my musical tastes, the club was home to Van Halen, Mötley Crüe, Ratt, Guns N' Roses, and other eighties metal bands. I knew I wasn't going to truly "play" the

Whisky because of my innovative silent guitar technique. But still being in the building and onstage no less, in front of an audience, was nerve-wracking.

Riot in the Temple unloaded in the back along with the other groups from the Rock 'n' Roll Fantasy Camp and piled through the narrow backstage door. On the second floor was an area that overlooked the stage. It had been roped off for camper access only and served as sort of a staging area for keeping gear and shit. We were fifth on the bill, after other camper bands named Death Panel, Atomic Waste, Surreal, and the Flu. Most groups played their songs and brought Frehley out for the finale. Kevin's suggestion about sticking to tunes Frehley was more familiar with paid dividends when the Spaceman screwed up a turn in "Do You Love Me" with Surreal.

As we waited for our chance, the techies looked at me a little weird when I warned them that I was intentionally turning the volume down on my guitar. But they recovered quickly enough.

Onstage, I took up my position on the right, similar to where I stood in the rehearsal space. A large speaker hung from the roof, making it impossible for me to face the crowd as a performer would normally do. Instead, I turned inward, toward my bandmates, which helped my nerves as I could hide my left hand slightly. The positioning made it more difficult for people in the audience to see that I wasn't fingering the chords properly or keeping up with the other guitarists in the band. I assumed they wouldn't be able to discern my instrumental silence through the sheer overall volume of the band and club's PA system.

The songs passed by in a blur. I was sweating, more from nervousness than the heat. At one point, the speaker monitors

went out on Ujesh and he screamed that he couldn't hear any-
thing. Sarzo, the veteran of thousands of shows, turned, smiled,
and mouthed, "Keep going!" Then Frehley was onstage and
performed "Rip It Out" and it was over.

On the recording of the concert given to each camper, Riot
in the Temple sounds small and thin. Partially that's a result
of any concert recorded from the mixing board. Even profes-
sional bands have experienced that. But it's possible that we did
indeed sound quiet and meek.

But onstage, to my ears, surrounded by amplifiers and
friends and legendary musicians in the hallowed hall of the
Whisky, it sounded massive and loud, powerful like the rap-
ture, like rock-and-roll dreams come true.

Afterward, we hugged and screamed, like an athletic team
who won the championship. And in a way, we did. Riot in the
Temple was chosen as the best band of the evening's show. Two
other groups out of the seven had been disqualified so we were
only competing with four outfits. But we didn't care. If there
had been champagne, we would have covered each other in it.

My experience was a lie because no one had heard what I did
on the Whisky stage that evening. But that lie was life altering
to me. I understood the camaraderie of a band, the friendships,
the nerves, and the success. I grasped why people were so taken
with the guitar, how much fun it can be to look across the room,
throw out a ZZ Top riff, and have your mates follow along.

Riot in the Temple's time as a band was fleeting. We had
been together just three days. But thanks to Rudy Sarzo's gra-
cious tutoring and good humor, thanks to the kind understand-
ing of the musicians in the group, we had a great time.

Over drinks at the Cat Club, a small rock bar next to the

Whisky, Ujesh was probably the one who said it first. But it became a common question as we partied into the night.

"You guys want to come back and do it again?"

I promised that I would be able to play a searing solo the next time I saw my brothers in the band.

16

THE MAN WITH THE POINTY GUITAR

After the Rock 'n' Roll Fantasy Camp, I met my friend Henry for lunch in West Hollywood. Normally based on the East Coast, his swing through Los Angeles for meetings coincided with the time I was wrapping up the camp. We sat outside and picked at sandwiches while he inquired about my latest musical meetings.

"So, how's your fucking quest going?" he asked.

"Pretty good. It's hard to get some guys to spend any time with you. Even the dudes who are playing to small clubs and tiny crowds. They still think they're packing arenas. Or, they've got better shit to do than explain to me how to bend a half step. But I've reached a lot of the guys on my guitar hero constellation, or at least the lower ranks."

"And how are you on the guitar itself?"

"I thought I was doing pretty well, but the Camp kicked my ass. I couldn't keep up with even the simplest tunes and my fingers feel like they're going to fall off." There were deep grooves in the calluses on my fingertips, like after a heavy truck drives

through fresh snow. It was probably because I always reverted to holding down a G chord whenever I got confused so I ended up frozen in that shape for hours. The ruts were so pronounced that it was difficult to fret any other chord, like the resistance you encounter changing lanes on a snow-covered highway.

"Well, shit, you shouldn't feel bad about that," Henry said. "You've only been playing for a short time, in the whole scheme of things. Even tips from guitar fucking heroes aren't going to shorten the time it takes for you to build up the muscle memory. Besides, just the fact that you're doing this is pretty cool. Fucking kooky, but cool."

"I thought your perception was that this whole thing was idiotic."

"I don't get your fascination with these fucking guys," he said. "But that's maybe because I work in this business. I'm probably sick of the bastards. But I do understand heroes and how cool it would be to learn from them. Back when I was playing sports, I would have been in fucking heaven to get some tips from the guys I watched on TV."

He took a sip of his drink and squinted into the sunlight, staring down the Strip.

"Most of us are just assholes," he said. "We give up our childhood passions for work or booze or the fucking old lady or whatever. So it's cool that you're going after this quest with the determination you are. If you were some guy at MTV or *Rolling Stone*, it wouldn't be a big deal. But for a regular Joe Fucking Schmoe to hunt these guys down, that's pretty impressive."

I appreciated his sentiments. There had been times when I felt like a hearing-impaired Don Quixote, tilting at Marshall amp stacks, and accomplishing very little. But I had set a goal

to reach as many guitar players as possible and I was determined to see that through.

"Who's next on the list?" Henry asked.

"Probably the hardest guy to reach, someone I can almost guarantee won't talk to me."

"Then why fucking bother? Just move on to the next dude?"

"Because this guy is the first guitar player I ever saw live, at my first concert."

ALTHOUGH I DIDN'T know who he was at the time, Vinnie Vincent was responsible in some ways for fueling my guitar hero fascination. His performance that evening in Rupp Arena contributed to my love of KISS and my obsession with the instrument. But I had no idea how to find him. Apparently, no one else did either. He had been unseen and unheard from in more than a decade.

He was born in 1952 with the real name of Vincent John Cusano in Bridgeport, Connecticut. He was a session player who performed with Dan Hartman (who later had a hit single with the 1984 pop tune "I Can Dream About You") and also wrote music for the *Happy Days* television show. Brought in to replace Ace Frehley, Vincent's tenure was short-lived before being dismissed from the group. Allegedly, the guitar player constantly complained about his salary and working conditions. And, according to some insiders, he was justified at least some of the time. C. K. Lendt, former vice president of KISS's business management company, traveled with the band for nearly eight hundred concerts. In his book *Kiss and Sell: The Making of a Supergroup*, he points to one instance in which the

band lodged Vincent in a shithole hotel in Manhattan. "It was a rundown place, frequented by hookers who paid a weekly rate, with a lobby that stank of rancid cooking odors from the adjoining coffee shop."

Whatever the reason, the guitar player was eventually ousted from the band.

He formed his own act, the Vinnie Vincent Invasion, and released two records in the mideighties. In many ways, Vincent's solo recordings became the very essence of what critics disliked about guitar heroes. He had a shrill tone on the albums that generated a feeling similar to chewing on tin foil. There were endless solos that spiraled nowhere. And he preferred vocalists who could shriek like a hawk grabbing a rabbit, employing Robert Fleischman on 1986's *Vinnie Vincent Invasion* and then Mark Slaughter on 1988's *All Systems Go.*

Since I knew it would be tough to speak with Vincent himself, I talked to Robert Fleischman about his recollections of the guitar player. The singer was perhaps most well-known for working with Journey in 1977 and co-writing their hit "Wheel in the Sky." He was currently living in Richmond, Virginia, and fronting a band called the Sky.

A mutual acquaintance introduced Fleischman and Vincent, and the two began writing songs, including the tune "Do You Wanna Make Love."

"Then, after that, he gave me a phone call telling me he was offered the job with KISS," Fleischman said. "I said, 'Yeah, you should do it. You're living in a small apartment, just do it.'"

After Vincent left the masked rockers, he touched base with Fleischman to restart their project, and they went into the studio with renowned engineer and producer Andy Johns, who had worked with Led Zeppelin, the Rolling Stones, and others.

They recorded a handful of songs. Fueled by those recordings, Vincent signed with Chrysalis Records.

"From the very get-go, I was given the impression that this was going to be a band, but he went and got a solo deal," Fleischman said. "He basically aced me out of the whole project."

But by this point, Chrysalis wanted Fleischman involved in the project and kept pushing for his return. Concerned by the way he had been treated, the singer initially declined numerous requests to rejoin the project. But the impending birth of his son caused reconsideration. Fleischman agreed to do a full-fledged album for a "shitload of money," as he said. That album turned out to be the 1986 release *Vinnie Vincent Invasion*.

The singer says that the recording sessions took forever but that Vincent was an amazing guitar player. He could play anything, any style, immediately. But their personalities didn't mesh.

"It doesn't sound like Vincent ever meshed with anyone, from what I can tell," I said. Fleischman laughed.

"Am I wrong in that? What was your experience with him?"

"He's just his own worst enemy," Fleischman said. "He's always trying to weasel someone out of something. I don't want to use the word 'genius' with him, but it's like that old idea that insanity always accompanies genius."

Fleischman had no plans to tour with Vincent or do anything beyond recording the record. So after the album came out, the group recruited Mark Slaughter as the singer and had him lip-synch over Fleischman's vocal recordings for the video of "Boyz Are Gonna Rock."

There were a few bright spots on the Vincent albums of the era. "Baby-O" had a screeching opening riff followed up with a catchy chorus. A ballad called "Love Kills" was used for the

Nightmare on Elm Street 4: The Dream Master soundtrack that started with acoustic guitars before kicking into gear. And the finale to his first record, at the end of the song "Invasion," was a repeating alarm-like sound from the guitar that was perfect for annoying the hell out of anyone within earshot.

In person, Vincent appeared in a series of outlandish outfits, frequently featuring pastel colors. He was a physically small man and even with his KISS platform shoes, other musicians towered over him. He rocked a customized Jackson Randy Rhoads guitar that looked like two flying *v*'s mashed together, with the wings slightly offset.

Vincent's band dissolved around 1988 as the record company lost interest and his mates found other gigs. Drummer/bodybuilder Bobby Rock joined Nitro and then jumped on the Nelson twins' particular brand of hair metal bandwagon. Vocalist Mark Slaughter and bass player Dana Strum formed the chart-topping band Slaughter.

By 1989, Vincent had filed for bankruptcy. And this is when things got dark.

Reports had him living in Nashville, Tennessee, but sightings were few. Rumor was that he was working in the studios as a songwriter and session guitar player. While Gene Simmons has been unrelenting in his criticism of Vincent, even the Demon acknowledged that the shredder could write a good tune.

The only sort of official news relating to the guitar player revolved around lawsuits. For almost a decade, he filed legal action after legal action against his former employers. Although the details varied slightly, the main point was that KISS owed him royalties and used his likeness and work without permission.

The organization's response was usually that Vincent had

never been an official partner in the band. They claimed he was basically a work-for-hire on a salary. Royalty structures are complicated in music, but the band said he got what he was due and they owed him nothing further. The "employee" status was true not just for Vincent, but every member of the band since original rockers Ace Frehley and Peter Criss departed decades ago. Gene Simmons and Paul Stanley are the true "owners" of KISS and everyone else works for a paycheck, albeit a damn good one.

Ultimately, Vincent's cases largely proved fruitless. In October 2006, the United States Supreme Court refused to hear the guitar player's appeal on lower court rulings in which he lost lawsuits seeking $6 million from KISS.

While Vincent's legal wrangling had wound through the courts, his children were dealt a tragic blow.

In the early eighties, Vincent was briefly married to a woman named Annemarie and the couple had twin daughters named Elizabeth and Jessica in 1983 before divorcing. By the nineties, Annemarie Cusano lived in Shelton, Connecticut, and worked as an executive assistant at Executone in nearby Milford. Her boss said in published media reports that she was well liked, never missed a day of work, and led blood drives and Toys for Tots efforts in the office. Friends described her as a devoted mother who cared for her daughters in spite of significant financial challenges.

Robert Fleischman said he met Annemarie and even had a Thanksgiving dinner at the guitar player's home.

"She was incredibly sweet," he said. "I remember that she was the first woman I ever met with a tattoo. I don't recall what it was, but I remember being impressed at a woman with a tattoo."

On January 3, 1998, Cusano failed to pick up the girls from a sleepover with friends. The twins tried reaching their mother on her beeper but never got a response. Family members went to Cusano's home and found the lights still on the Christmas tree, a half glass of wine on the table, and a purse containing credit cards and cash hanging from a doorknob. They said it looked like she had simply run out for a quick errand.

WTNH television station in New Haven reported that family members found a letter Cusano had written to one of the twins with the line, "You and your sister are the most important things I've ever known."

Local media picked up the story of the missing mother and ran photos of Cusano, showing her to be an attractive redhead. Residents were urged to look for her 1991 red Mazda 626. Meanwhile, police searched for leads and responded to tips that Cusano had been spotted at various locations in the area. A relative told the *New Haven Register* that "while I'd like to think she's on some beach somewhere with a piña colada, she only had a small amount of cash with her and how far can you go on fifteen dollars?" Family members looked after the girls.

Phone records from the Cusano residence ultimately led authorities to a boarding house in Hartford, forty-five miles away. Some media reports indicated that her shirt was found in the building. The red Mazda was located around the corner.

Four days after Annemarie Cusano went missing, the twins told the police their mother had a second job, to supplement the income she made at Executone. She was working as an escort, believing she could earn between $300 and $1,000 a night to help make ends meet. The girls said they didn't originally say anything because they wanted to protect their mother's secret

in case she came home. According to some reports, they didn't even know the full extent of her work because Cusano had told her daughters she was working as a masseuse.

Cops focused on a thirty-seven-year-old ex-con named Gregory McArthur. The escort company had provided McArthur's address and request for an appointment to Cusano on the night she went missing. In media reports, police spokesmen described McArthur as a "sexual predator." They eventually located him in Boston where he had been jailed for the rape of a homeless woman.

Although he changed his story several times, McArthur allegedly confessed to police that he fought with Cusano and choked her to death. He fought extradition to Connecticut but eventually returned to face charges some years later. In 2000, the suspect led police to Cusano's remains, which he had dumped in a wooded area near Boston Neck Road.

Gregory McArthur was convicted on December 13, 2002, of felony murder, manslaughter in the first degree, kidnapping in the first degree, and larceny in the third degree. He was sentenced to sixty years in prison. Appellate courts upheld his conviction in 2006.

Outside of the family members, no one really knows the nature of the relationship between Vinnie Vincent and his ex-wife at the time of her death. Media reports at the time stated that he was traveling from Tennessee to Connecticut. But he neither issued any public statement nor was quoted on record.

I was always struck by the oppressive sadness and almost surreal nature of the situation. The murder of any woman is tragic enough, especially one that leaves behind teenage daughters. But the identity of the twins' father adds a different element to

the tale. A sort of rock star seeks millions of dollars in compensation from one of the most famous bands in the world while his ex-wife turns to prostitution to support their children. No one knows if he would have given Cusano any money if he had won his lawsuits against KISS. So it's pointless to blame the band in some way. But it still seems so weird.

I e-mailed the attorney listed on Vincent's Supreme Court appeal. I knew he couldn't provide any personal details or address for his client. I simply asked that he pass along my request and Vincent could reach me if he was interested. I never heard anything.

Fans on the Internet had launched a message board where they discussed Vincent's music, appearances, and other things related to the guitar player. There was a message from the administrators of the site, urging people to refrain from trying to find Vincent or to pester him in any way. Their strategy was to let him come to them, when he was comfortable, a sort of gentle coaxing, hoping their hero would step out of the shadows.

He did so in 2011, although not in a positive manner.

After a series of press announcements and websites promising new music and a signature series guitar, Vincent attracted mainstream media attention when he was busted for domestic violence. The Rutherford County sheriff's department said that Vincent's current wife, Diane, came to their offices "covered in blood" and stinking of alcohol. Diane told cops that Vincent had punched her in the face and "dragged her through a pile of glass." Officers sent to the home found Vincent and plastic containers with the remains of dead dogs. In the post–Michael Vick world, the bizarre animal graves raised even more red flags, as if a wife covered in blood weren't weird enough.

Vincent was ultimately released on $10,000 bail. Animal control authorities cleared Vincent of any wrongdoing related to the dead dogs. In a rare public statement, Vincent claimed that poor weather had prevented an excavator from digging graves for the pets at the time of his arrest.

The guitar player then made a deal with the state, "temporarily retiring the case for a year." He was ordered to complete eight hours of anger management courses and if nothing else happens in the interim, then he could petition the court to dismiss the case and expunge his record.

I made more attempts to contact the guitar player through various attorneys and emissaries, even going so far as booking a plane ticket to Nashville. I had the address of the property where he had been arrested, so I knew I could find that. But at the last minute, I skipped the flight. What was I going to do? Knock on the tall fence that surrounded the property and say, "Can Vinnie come out and play?"

I had spent a weekend with Bruce Kulick and performed, sort of, with Ace Frehley, highlights of my own personal KIS-Story. Mark St. John, another guitarist for KISS, died in 2007 of a brain hemorrhage.

Vinnie Vincent, the axe slinger who performed with KISS at my first concert thirty years earlier, would be one member of The Elder that I wouldn't try to reach.

Because there were a still a couple other musicians on my list, I had to make one final push to see what I could learn from them. I was encouraged by getting an assignment from a guitar magazine—a legitimate outlet, not some half-assed and ignored blog or 'zine—through a connection made at the Rock 'n' Roll Fantasy Camp. The article wasn't anything related to

my personal guitar heroes so it didn't open any doors on my journey. But I saw it as a reward, as a positive payoff from the risks I had taken by attending the Camp.

And I knew I had to wrap this quest up. While our initial attempt at in vitro fertilization wasn't successful, Lara and I were moving full speed ahead with more treatments. No holding back this time. Sooner or later, I wouldn't be able to just pick up and dash off after a guitar player.

17

BENDING BEHIND THE NUT

The Grammy Museum in downtown Los Angeles is a highly polished affair, featuring modern architecture and lots of chrome and glass. Housed within the L.A. Live complex, the institution's neighbors include the Staples Center arena, a huge movie theater, ESPN's West Coast studios, a Ritz-Carlton Hotel, and numerous restaurants and bars. Fans lined up around the corner of the building to see guitar virtuoso John 5 speak and perform.

I had originally seen the musician at a very different location: Mom's Music in Louisville, Kentucky, a new building designed to look like an old Western town. Two taller sections stand out, separated by smaller structures, so the overall effect is that of multiple buildings instead of just one. Wooden railings separate the parking lot from the store entrance and benches are scattered around. Inside the sprawling store, hardwood floors and rustic design elements continue the Western vibe. John 5 signed autographs and posed for pictures after a clinic at the store. I managed to get a moment with him to blurt

out my quest of interviewing guitar players and he agreed to chat. But it took several attempts before we finally connected, shortly before his appearance at the Grammy Museum. I hoped to follow up with him there.

Despite the incredibly different venues, John 5 drew several hundred people to hear him lecture in both cities. Those crowds were most noticeable for the wide range of ages packing the seats. There were a surprising amount of gray-haired men interested in listening to a highly tattooed heavy metal artist. But John 5's life and career were a study in contrasts and surprises.

I was a fairly recent convert to John 5's work. He was one of the few guitar players that I tracked down for my quest who didn't adorn my walls as a child. That's because John 5 was my age, born just one year before me. He was interesting because he was the one who made it, who accomplished his dreams, who listened to the same guys I did—and who obsessively worked until he shared the stage with them.

BORN JOHN LOWERY, the guitar player grew up in Grosse Pointe, an affluent suburb of Detroit. Often we think of musicians coming from difficult circumstances, but the well-to-do Lowery family actually had a couple of servants and staff members in the home.

As a child, John 5 was fascinated by the seventies television show *Hee Haw*. He watched the series repeatedly, engrossed by the styles he saw and the music he heard. He traces his love of country music and Fender Telecasters back to those childhood days of watching the shenanigans and saa-lutes!! of Buck Owens, Roy Clark, and Grandpa Jones.

"And big-breasted women," he said. "Telecasters and boobs. I owe that to *Hee Haw*."

His parents gave him a Fender Stratocaster when he was seven and John 5 locked himself away, practicing obsessively. In addition to the musical styling of the gang on *Hee Haw*, Ace Frehley's work with KISS was an early inspiration. His family was supportive of his musical desires and the young boy practiced so much that his anatomy actually changed. The guitar man frequently held his left hand up next to his right to illustrate the freakish size difference.

John 5 began performing in local groups at an early age and tells the story of bounding out onstage and falling down in his very first performance. He laughed and said that he's never had such an embarrassing moment onstage since. Although fans frequently point to an incident with Marilyn Manson at the 2003 Rock am Ring festival in Germany. The singer wore platform boots and Mickey Mouse ears and appeared to kick John 5 in the chest. The guitar player bellowed at Manson and threw his Telecaster onto the stage before awkwardly retrieving it and continuing with the show.

At thirteen, the dedicated KISS fan went to a Detroit area hotel to try and meet his heroes. He ended up in an elevator with Gene Simmons and summoned the courage to ask the Demon for an autograph. Simmons rolled his eyes and grudgingly agreed but a disappointed John 5 said, "Nah, that's okay." The interaction didn't spoil his love of the band and he continued to accumulate KISS merchandise, posters, and records. His fascination with KISS actually led to discovering one of the era's most influential guitar players.

"I bought the Van Halen record specifically because it had Gene Simmons's name on it," John 5 said. In a similar manner,

I had discovered the bands Keel and Black 'N Blue because of the very same reason.

From that point on, he was inspired by EVH's work, perhaps to the detriment of his instrument collection. He managed to get Texas blues legend Stevie Ray Vaughan to autograph a Stratocaster. The bluesman signed it "Play with feeling." But a teenage John 5 traded it for a cheap Kramer because everyone wanted to copy Van Halen at the time.

John 5 knew that a musical career wasn't possible in Detroit.

"People ask me how to make it," he said. "And they get disappointed when I tell them that they have to move. They have to go where their music will be heard. I knew I had to leave my safe nest and move to California."

At seventeen, he loaded up his Ford Thunderbird and prepared to make the drive to California. A well-known metal drummer happened to be from the Detroit area and made plans to catch a ride with the young kid. Awestruck at transporting a famous rocker from such a big band, John 5 jumped at the chance to chauffeur the drummer. But the trip turned out to be quite an educational experience for the sheltered guitar player.

"This guy starts throwing up, says he's sick, and he needs to see his doctor," John 5 said. "I'm nervous and anxious to help so I agree to stop by the doctor's place on the way out of town. He directs me to this slum and keeps saying he needs his 'medicine.' We pull up to this dump and he goes inside. I wondered what kind of doctor would have this as his office."

Once in Los Angeles, the aspiring musician did not rely on his family's wealth as a safety net. He settled into a warehouse that was little more than a squat. And he began performing whenever and wherever he could. One band was called Alligator Soup and the group performed at legendary hard rock club

Gazzarri's in 1989. There were less than five people in the audience. But in attendance were Rudy Sarzo and his wife. Sarzo, at the time, was in the chart-topping Whitesnake, and he liked what he saw in John 5. After the gig, Sarzo took the guitar player to Denny's at 2:00 AM, where they talked about building a career in hard rock.

He began getting work as a studio musician, doing sessions cheaper and with less takes than other guitarists. He amassed a diverse set of credits, including work with hip-hop act Salt-N-Pepa; pop acts Wilson Phillips, the Go-Go's, and Rick Springfield; hard rock luminaries such as David Lee Roth and Rob Halford; and he even performed music for the *Baywatch* television show.

One of his first major exposures to life on the road came when he toured with country vocalist k. d. lang. On that tour, he met a multi-instrumentalist named Larry Campbell who played banjo, lap steel, fiddle, and other instruments that inspired a sense of diversity and a desire to be as well-rounded as possible.

"I figured if that guy can master all those instruments in the country genre, I should be able to master country music on just the guitar," John 5 said.

After k. d. lang and a succession of other gigs, he was invited to join Marilyn Manson's band. He had been performing under his given name of John Lowery until that point, but he was rechristened John 5 by the shock rocker.

Fans frequently asked John 5 if he was musically challenged while playing with Manson. His solo releases were masterworks of guitar technique whereas the singer's body of work was more about atmosphere and mood.

"I liked the music," John said. "But obviously it wasn't full of solos and behind-the-nut bends. But that's okay. It was

Manson's band, not mine. I was there to support his work and his songs."

That attitude partly explains why John 5 developed such a burgeoning career as a sideman. He was respectful, humble, diligent, and toiled endlessly to make the star look good. It's a philosophy that might strike many people as surprising given John 5's appearance and overall vibe.

His arms and torso were covered in tattoos and he frequently wore psycho-killer-clown styles of makeup in public appearances and publicity shots. His outfits ran the gamut from a jumpsuit covered in what appeared to be blood to heavily adorned jeans covered with patches and stitches. I saw him once in a black military coat and hat strikingly reminiscent to an SS officer's outfit. He wore black latex gloves to complete the look.

His 2007 solo release, *The Devil Knows My Name*, featured numerous references to serial killers, and just six seconds into the disc a speaker's voice says, "One form of pleasure that he got was inserting 27 needles of varying sizes shoved up into his pelvic region," a reference to turn of the twentieth-century serial killer Albert Fish. The murderer had the nickname the Werewolf of Wysteria, which is the title of the final track on the album. All the songs on John 5's 2008 solo release, *Requiem*, were named after torture devices. He told *Guitar Player* magazine, "I find the macabre fascinating, it's all over history. In researching the torture devices I heard music to describe each one."

The dark side was not just an affectation or hobby for the musician. It was also a curse. As his career blossomed, John 5 was dogged by a series of tragedies. He may not look like a bluesman from the Mississippi Delta, but the guitarist still

frequently looked over his shoulder, certain that hellhounds were on his trail.

"Each sort of career milestone was followed by something awful," John 5 said. Family members passed away, often right around major concerts.

"I named the record *The Devil Knows My Name* because I really think that's true," he said.

With these interests and background, it's not surprising that he meshed with the superstar antichrist Manson. You can just picture the two musicians on a tour bus, dissecting kittens and bellowing, "Put the fucking lotion in the basket!" at victims suspended from a truss in the vehicle's undercarriage.

But that imagery must be balanced by John 5's assertion that he doesn't drink or take drugs. He curses occasionally but certainly not like a lot of rockers. His voice is quiet and you might describe John 5 as unassuming from the way he acts.

After parting ways with Manson, John 5 joined Rob Zombie's band where he continued to rock stadiums around the world with his arsenal of beloved Telecasters. Inspired by those childhood memories of *Hee Haw*, the guitarist possessed a significant Telecaster collection. The lifelong KISS fan had an extensive collection of rare posters from the band that fueled his vintage purchases

"I sold that poster collection for like $75,000," he said. "And I wanted to buy old Telecasters." Today, he had dozens and dozens of instruments including a seventies model that was once owned by Mick Mars of Mötley Crüe. A 1952 Esquire that he bought for $30,000 now worth $65,000 is notable, but the Holy Grail of the collection is a 1950 Fender Broadcaster, the first mass-produced solid-body electric guitar. Around 150 of these instruments were manufactured, but a rival company

had a line of drums called Broadcaster and they filed a lawsuit alleging trademark infringement. To avoid the issue, Fender stopped putting the Broadcaster label on the guitars and eventually changed to the Telecaster that we know today. As a result of the rarity of John 5's instrument, it is extraordinarily valuable. He said he paid about $135,000 for it and although the economic downturn has even affected vintage guitar prices, it's safe to say the Broadcaster has increased in value since John 5's acquisition.

The Fender Telecaster isn't an instrument usually associated with heavy metal guitarists like John 5. But then again, he's not like the usual musician either. Those solo records with all the spooky references are filled with bluegrass licks, country music swing, and even some classical guitar. He also favors unusual techniques like bending the string behind the nut, on the headstock of the guitar, instead of relying on the far more common whammy bar. Sure, songs like "Heretic's Fork" sound like the armies of hell have been unleashed on this mortal plane. But other tunes are downright cute and almost folksy. That range of skill is why so many different ages filled the seats at his appearances.

AT THE GRAMMY Museum, he played an opening medley of riffs and leads that ranged from bluegrass to surf music to classical. He tossed in bits of *The Munsters* television theme song and a little bit of Eddie Van Halen's instrumental masterpiece "Eruption." At audience request, he played Hendrix's "Voodoo Chile" and snippets of Marilyn Manson songs.

As fans asked questions, John 5 constantly returned to the concept of obsession in his responses. He said he gets up in the

middle of the night and sneaks over to the computer, careful not to wake his wife.

"You would think I'm looking at porn," he laughed. "But I'm really watching guitar videos."

He told me that if he's not on the road, he quite literally does nothing but practice his instrument. I asked what I could do, since I worked a day job and didn't have ten hours a day to devote to practice.

"Find a song that you really like," he advised. "That will give you something to shoot for and keep you inspired. Also practice with a metronome. Having good rhythm in your picking hand is really important, particularly on slow songs where the notes ring out for longer and there's more space in between the sounds."

Obsession and hard work combined with a humble attitude that belies appearances are what enabled John 5 to turn his idols into equals. The lifelong KISS fan wrote and recorded a song for Paul Stanley's 2006 solo record, *Live to Win*. The guy who recorded a tribute of the tune "Fractured Mirror" from Ace Frehley's 1978 solo album was now a close friend of the Spaceman. When Frehley visits Los Angeles, John 5 drives him around to pawnshops and vintage guitar stores, searching for cool gear.

"It's such a great feeling to have your heroes as friends," he said.

18

THE VIEW FROM THE KISS STAGE

My family's racehorses never came anywhere near the Triple Crown and glamorous tracks like Churchill Downs or Belmont. Our nags typically competed at much smaller venues. Winter sessions were at Latonia in Northern Kentucky. In the summer, we ran at River Downs, just outside Cincinnati, along the banks of the Ohio River. My memories of those two tracks are dominated by climate extremes.

The Latonia visits were frigid affairs where I was actually a little hopeful that our horse wouldn't win so I could avoid the subzero night air. In spite of my hesitations, we do have a few winner's circle photos from those days and I'm bundled up and puffy in bulky coats with a ski cap featuring a Snoopy patch pulled low over my ears.

River Downs, however, was characterized by sweat pouring down my face in the open and non-air-conditioned stands. Next to the track was a water park and, in the interminable wait between races, I would stare over the fence at the kids plunging down water slides, desperately wishing I were with them.

Sharing a sweltering parking lot with River Downs was Riverbend Music Center, an outdoor amphitheater that hosted concerts and performances throughout the summer. My senior year of high school, my pal Charlie and I saw Rush and Mr. Big play at Riverbend, sitting on the grass in the lawn section. I hadn't been back to the venue in twenty-five years.

I had an appointment with Tommy Thayer of KISS, the last of the Elders that I had any possibility of reaching. The band was bringing their Hottest Show on Earth tour to Riverbend and I arrived at the venue extremely early. A few folks milled about the parking lot since the amphitheater was not yet admitting the public. A tour bus wrapped with huge advertisements for Gene Simmons's show on A&E was parked out front, so that fans could take their picture in front of the vehicle.

I slipped through a gap in the fence and walked around River Downs, thinking of our horses, our family visits, and I remembered my dad buying me a T-shirt from the gift shop one day. I thought about all the musicians I had met, the lessons that I learned.

All the guitar players—god or mortal, genius or journeyman—were dedicated to their craft, regardless of the challenges or dreariness that faced them. They went out every night and performed to a handful of people or to an arena of fans. It was the act of plugging in and playing that kept them going.

And the guitar itself? Why did it occupy such a privileged place in our culture? There wasn't a simple answer, just lots of theories.

Glenn Tipton of Judas Priest thought the guitar's dominance resulted from the way a musician interacted with the instrument.

"You wear a guitar, don't you?" he had told me. "It's part of you. A piano you sit at and, in a sense, detach yourself from

it. You put on a guitar and it becomes molded to you, part of you. I think it's the perfect instrument, in that sense, to express yourself. For want of a better word, the 'shapes' you throw when you're playing a guitar just come naturally. They are an extension of the way you're feeling. It lends itself to expressing yourself and everybody can do their own thing with a guitar. I think that's why it's such an appealing instrument."

Steve Vai delivered a lengthy response worthy of a graduate-level workshop when I asked him why the guitar was so important to so many people, many of whom didn't even realize it.

"Well, because the guitar is the best instrument in the world," he had said, smiling.

"Obviously," I laughed. He went on to explain:

If you look at the instrument and its various permutations through history and adapting to various cultures, genres, trends. It is not like a new instrument came along and people had to discover it. It was there forever. You put a string on something and it goes *boing, boing, boing.* And you've got a guitar, so to speak.

In contemporary rock culture and pop culture, I think the guitar is really prevalent for a lot of reasons. One of them is it is gorgeous. It is sexy shaped. I don't say that because it is a cliché thing to say. I am telling you honestly, when you look at a guitar it just looks sexy, and that is an attraction. It has all the elements that attract us in a sexual way. It's got a body that has curves. It has a long neck. Maybe that is a subliminal thing, but it is part of it. Another reason is that this sound of the guitar can be processed and can accommodate any genre. It can play acoustically, and it fills the air with love and

sound. You can play electric blues. In metal music it is the quintessential instrument because it has the ability to be harshly and brutally distorted and hit really hard. It is a tremendously dynamic instrument. It's the most dynamic instrument in the world because it can go from being touched very, very subtly and tenderly with love and compassion to being brutally beaten. It responds. The guitar bends and moans and it weeps and it screams and it whispers. What other instrument does that? It's a friend, you know? You speak to it. You can tell it your secrets.

Guitar players charge their instrument with personality. You are putting your sweat and your DNA on that instrument. You are stamping it. And finally, the guitar just looks cool. It looks cooler than any other instrument. That's not my opinion. That's the majority of the opinion. When people who don't even know how to play a guitar want to act cool, they act like they are playing a guitar.

THE RIVERBEND SECURITY guard led me down a steep driveway to a restricted area behind the facility. He passed me off to a KISS roadie who took me inside the building. We stood in a busy hallway that smelled like onions from the food service concessions cranking up their operations. As we chatted, Doc McGhee walked by.

He was a short, slightly round guy, kind of like Batman's nemesis the Penguin. I had read about McGhee since the eighties when he managed some of the era's biggest groups including Mötley Crüe, Bon Jovi, and Skid Row. In one of the stranger

scenarios of the metal scene back then, McGhee organized the Moscow Music Peace Festival in 1989 to promote awareness of the dangers of drugs. The massive event featured McGhee's bands along with Cinderella, Ozzy Osbourne, the Scorpions, and others. The reason for his sudden altruism was that the manager had been arrested the previous year for conspiring to smuggle forty thousand pounds of Columbian marijuana into the United States. McGhee started managing KISS in 1996.

Tommy Thayer walked up and said hello. We were led to a small office where we could chat. The guitar player wore a white button-down shirt and jeans. His black hair was long, but styled. He wore a nice watch and a silver necklace around his throat. He would turn fifty in a couple of months but he looked young and cool—like a rock star who wasn't trying too hard to look like a rock star.

He's a journeyman musician, hardworking and lacking an ego, smart enough to know where the next paycheck is coming from and humble enough to not let pride get in the way. There are plenty of Thayer critics in the music world, and more than a few within the KISS army of fans, but he doesn't take it personally. And that quality is why he's onstage with the band every night while all the complainers type away in Internet chat rooms.

Just as we started to talk, a roadie came in and mentioned something about the placement of a special effect.

"Come on," Thayer motioned to me. "Want to see the stage?"

Equipment was piled high on all sides and for a few steps it was like walking in a cluttered warehouse. And then a cool breeze hit my face and I was facing the empty amphitheater. Thayer's gear was set up on stage left in a sort of cubicle formed by road cases. To the right were the massive banks of amplifiers and video screens that KISS used as a backdrop.

He started pulling guitars out of the road case.

"This is my main one," he said while holding a sunburst Les Paul. "It's a reissue of the 1960 model." He put it back in the stand and withdrew a black model. "This is the rocket guitar with firing system mounted on the headstock."

I had a hard time focusing on any single detail. I just couldn't accept the fact that I was looking at KISS's guitars on the side of their stage.

THAYER GREW UP in the Portland suburb of Beaverton, where his father had the largest independent office products and furniture company on the West Coast. Jim Thayer Sr. was a retired army bigwig and philanthropic force in the Pacific Northwest. The elder Thayer's business acumen was passed on to his son, which drove his later work with KISS.

Thayer's first memories of guitars echoed Vai's sentiments about how cool they looked. "Even before I played guitar, I just thought it was a very cool-looking thing, a guy with long hair playing an electric guitar up onstage with a bunch of screaming people," he said.

He played musical instruments throughout school, spending time with the saxophone in marching band and jazz ensembles. But he was more drawn toward rock and roll and by the time he was thirteen, he was messing around with his brother's Stella acoustic guitar. His mother eventually took Thayer to a store called American Music to purchase his first electric.

"I picked out a Fender Mustang, which was $135 brand new," he said. "This is a 1974 and it was blue with a light-blue racing stripe. I couldn't believe that I had a Fender guitar."

Thayer's history with the guitar wasn't marked by obsession

or compulsive practicing. He didn't use the instrument as an escape. He was popular in school and active in sports.

"Playing guitar wasn't my avenue to getting laid or something, because I got laid anyway. I just loved it because I loved rock-and-roll music. I loved performance. That was particularly true when I first saw KISS. I was bowled over before I even heard them because of the way they looked. The guitars they played, what they wore, what their hair looked like, the makeup, the boots, the platforms."

An early goal of Thayer's was to master barre chords. These are moveable shapes the musician can slide up and down the fingerboard. They're tough to handle for the beginner because your index finger has to apply constant pressure across five or even all six strings.

"Back then, you wanted to know how to play a barre chord," Thayer said. "If you could play a barre chord, then somehow you could play songs like 'Smoke on the Water,' even though that's not the way he plays it. We thought that was the way, but it's not."

Soon enough, some of Ace Frehley's famous licks were troubling the young Thayer.

"The one solo I really struggled with for a long time was Ace's solo in 'Firehouse' because it's got this *danka, danka, dank,*" Thayer said. "I didn't understand how he did that because to my ear it sounded like he was just going down the frets. I sat there for hours trying to figure out how he does that. I struggled with that. Riding home from school on the bus, sitting in the back, captivated with that solo."

After finishing high school, Thayer performed in a handful of bands before forming Black 'N Blue with singer Jaime St. James in 1981. Within a couple of years, the Los Angeles

music scene exploded and the band relocated there from the Pacific Northwest. Within six months of moving to Southern California, Black 'N Blue had a deal with Geffen Records. In 1985, the group opened for KISS on the *Asylum* tour, which made the initial connection between Thayer and Gene Simmons and Paul Stanley.

Black 'N Blue's 1986 album, *Nasty Nasty*, was my first exposure to the band because I read that Gene Simmons was the producer. The record featured a poppy single called "I'll Be There for You" that was foisted on the group by the label. Written by Jonathan Cain from Journey, the song wasn't any worse than any other hair metal radio singles of the day. Although the video does feature the singer Jaime St. James prancing around a soundstage in a humiliating full-body spandex outfit splashed with yellows, purples, and reds paired with what appear to be white dance shoes. Thayer, for his part, has a curly mop of permed blond hair and plays a black-and-blue (naturally) Hamer guitar. "You couldn't get arrested with a Les Paul in 1986, 1987," Thayer laughed.

After Black 'N Blue ran its course, the guitarist took stock of his possibilities.

"I was smart enough to know that you don't get many other shots," Thayer said. "You don't get to roll the dice more than once, maybe twice, at that level. I was always interested in the music business and behind-the-scenes work. So I was thinking along those lines, producing, managing."

His connection with Simmons and Stanley led to a part-time gig with the KISS organization, doing all sorts of odd jobs, sometimes writing songs, sometimes recording demos. Internet detractors claimed that Thayer retrieved Simmons's coffee and painted Paul Stanley's house. Thayer ultimately

assumed major responsibilities with the group, managing the KISS Convention tour.

"My ego didn't get in the way of doing things and working my way up the ladder, so to speak," he said. "You know, doing different jobs that I thought I was too good for . . . I never had that problem. If you're in a band twenty years ago that had a record deal like we did and made several records and toured on a pretty high level, and you have to start over and do things that some people might consider menial, I never had a problem doing that. I knew what I was capable of doing and I knew that I had to take certain steps and do certain things and work different jobs for a period of time to get where I wanted to go next. I'm just the kind of person that's always really wanted to work hard and do well and persevere. When I do something, I just don't stop. I don't give up. I keep going, and even if I get discouraged or [have a] set back or somebody says it's not happening, I don't believe them."

During this time period, Thayer also performed as the extraterrestrial guitarist in a KISS tribute act called Cold Gin. He learned the band's classic tunes and figured out how to honor Ace Frehley's parts while still injecting his own personality. In an almost unbelievable turnabout of fate, he was soon asked to tutor his hero.

As KISS prepared to launch their massive reunion tour in 1996, Thayer tutored Ace Frehley, helping the Spaceman to relearn his signature solos from the seventies. It was like when you put two mirrors across from each and that infinity of reflections appears.

"It's interesting how things just come full circle sometimes," Thayer said. "I remember when I was fourteen years old taking the school bus home, trying to figure out the solo

in 'Firehouse.' Fast forward to here in the midnineties and I'm sitting here showing him what he did. It's one of those surreal moments in life where it puts a smile on your face and you think, 'God, this is crazy.'"

The band's reunion tour was initially supposed to be a one-time thing. However, it was so successful that Simmons, Stanley, and management decided to continue the effort with records and more tours. But tensions within the group arose and both Peter Criss and Ace Frehley balked. In fact, Tommy Thayer was dressed as Ace Frehley for the band's performance at the 2002 Winter Olympics closing ceremony because there were fears that the genuine article wouldn't appear. A month later, Thayer stepped in for real during a private show in Jamaica. By the time the year was finished, he had the gig full-time.

At this point, KISS was a well-tuned machine. In spite of performing for almost thirty-five years, Gene Simmons and Paul Stanley still worked hard to give a tremendous show each night. Thayer and drummer Eric Singer were as regular as clockwork and also skilled musicians. And the group got along tremendously well with everyone comfortable in their role.

"There is no secret that this is Gene and Paul's band," Thayer said. "We do work for the band. But it's not an employer-employee situation because these guys are smart enough to not overemphasize that type of dynamic. It *is* a band and they make it that way. On the business end it's a certain thing. But for the band to be real, you need to treat it that way. There are no sidemen here. I'm very happy about that."

Makeup artists need not apply for KISS. The group handles their own face paint, part of a routine that stretches back over decades. Like a sports team huddling before each game, the

band kicks everyone out of the room and gets down to the business of assuming their stage personas.

"Putting on makeup and preparing before the show are a real part to the ritual that is so unique to KISS," he said. "It's unlike any other band. We start two or three hours before we go onstage. We all get together in the same room, listen to music, talk about the show. It's really a great time for everybody to bond. It makes us one. It makes us unified."

During my childhood years, I imagined that KISS really looked that way, that they were born with white-and-black faces. But now as an adult, I prefer the image of them putting the gunk on each and every evening.

AS THE CONCERT was about to start, I made my way down to the photography pit behind the barricade, one of the most challenging I had encountered during my adventures. It was incredibly narrow, just a couple of feet wide, with massive coils of wire and other gear creating a dangerous obstacle course. It was a great place to break an ankle as KISS attracted a number of photographers and everyone scrambled for position.

The show started with a short video and then the band thundered into "Modern Day Delilah," a song off their new album *Sonic Boom*. They were on a sort of cherry picker platform that lifted them up and over the massive banks of gear I had seen onstage. It was a contemporary allusion to one of their seventies-era stage sets when the band descended from the rafters. The second song was "Cold Gin," the Ace Frehley–penned tune about cheap booze. Fourth in the set was "Firehouse," the song that bedeviled a young Tommy Thayer and that he later retaught to the person who wrote it.

In concert, Thayer stuck to the classic renditions of the KISS tunes I had heard for decades.

"It's important to be faithful to the way the songs and solos were written and recorded," he told me earlier in the evening. "Guys that get off track and improvise and make up their own stuff, I don't enjoy that as much when I go see a band. Sometimes I'll have to adapt a tune from the eighties when they used Charvels and Jacksons with whammy bars. I'll change things slightly and adapt it to playing it on a Les Paul, but still be faithful to the recordings."

After the photographers clambered out from behind the hellish barricade, I could have stayed down near the stage. My pass was good pretty much anywhere. But I walked out of the covered seating area of the amphitheater and climbed the hill to the very top. I sat on the grass, near where my friend and I had crashed in high school, and took in the entire scene: the stage, the lights, the band, the multigenerational audience. The heat of the afternoon had broken and a cool breeze came in off the river. I laid back and closed my eyes. Those KISS guitar parts had been there for most of my life and I knew them by heart.

And after all these years, I neared a point where I could start to execute those songs. I had cut off my lessons from Doug to save some cash to apply to Lara and my doctor's bills. He had wished me well and I appreciated his kindness and patience during our lessons. For now, at least, I was on my own with the guitar. But armed with tons of lessons from my childhood idols.

And if I couldn't ever manage to perfectly mimic the solos of Ace Frehley, Bruce Kulick, and Tommy Thayer, that was okay. I could always close my eyes and imagine.

19

STAGE FRIGHT

Throughout my guitar player journey, I had never gotten over the childish need to grin like a dope fiend scoring a free fix whenever one of my heroes ripped off a blazing solo in front of me. Keeping a straight face in that situation was challenging enough. It was damn near impossible to remain stoic when getting a private concert by one of the biggest bands of the genre, a group that sold more than 75 million records.

At the amphitheater, Def Leppard was running through their sound check. And with the exception of two dudes dressed in black at the mixing board, I was the sole person in the stadium. The group had recently stopped their summer tour because of a death in the family and this was the first gig after shows resumed. Because of the shuffled schedule, the group had to work in new crew members. So the sound check was a full-on affair—full volume, full songs, full speed. In an empty arena, without thousands of bodies to absorb the vibrations, the thunderous bass rhythms shook my hands as I tried to scribble in my notebook.

Phil Collen, the fitness fanatic who took over lead guitar

chores for the group's third album, *Pyromania*, wore a white tank top, black cargo shorts, and black Converse sneakers. During the eighties, when massive manes of hair dominated arena stages around the world, Collen kept his blond hair practically nine-to-five office worker short. Maybe it wasn't CFO trimmed, but it was definitely IT guy short or graphic designer short. Now it was near military regulation closely cropped. A dedicated work-out fiend, the guitar player had biceps and delts more suited to a *Men's Health* model than a fifty-four-year-old rocker. The temperature was well over ninety degrees and other members of the band—and I—seemed to be on the verge of dissolving in a pool of sweat, but Collen appeared unaffected by the heat.

For the first song of the sound check, the group played "Hysteria," the midtempo ballad that was the title track of their 1987 record—one of my favorite tunes. The album—released after years of pursuing studio perfection and delays caused by a horrific auto accident in which drummer Rick Allen lost his left arm—started out slowly. Staggering under the weight of bloated expectations and recording costs that left the band $4 million in debt—by some estimates, the album needed to sell 3 million copies simply to break even—the first few singles did not perform well on the charts. Then the album's fortunes were altered by an unlikely group of constituents: Florida-based strippers.

Destiny and Chastity and Cherry and Cinnamon and Angel and all their bleached-blond and tan-lined friends discovered the tune "Pour Some Sugar On Me"—complete with its refer-ence to Southern slang for kisses and query about preferred number of lumps—and kicked up their clear acrylic heels to its heavy beat. Every second snare drum strike was accented, perfect for a hip thrust and a thong snap. They liked the song

so much that they inundated Sunshine State radio stations with requests, which in turn exposed the tune to a wider audience. To capitalize on the momentum, the band slapped together footage from their live shows that featured an innovative "in the round" stage positioned in the middle of the arena so there were, essentially, four front rows. Notable for singer Joe Elliott's shredded jeans that look like they've been run through a wood chipper and a cool laser effect that punctuated the instrumental break between the chorus and the verse, the video was ever present on MTV. Propelled by the single's success, *Hysteria* went on to sell more than 20 million records worldwide.

The second song of the sound check was "Love Bites," a slow song that became the group's only number 1 single, but that I never liked, with what seemed an interminable length, far longer than its five-minute-something running time. That was followed with "Rock of Ages," a new track called "Undefeated," and then acoustic versions of "Two Steps Behind" and "Bringing on the Heartbreak."

I felt odd, like an intruder watching the musicians swelter in their civilian clothes. I had not yet been introduced to anyone in the band and I wondered who they thought I was and why I was in the fifth row watching sound check.

I was ten years old when *Pyromania* was released. It was a gargantuan hit, selling 6 million copies in 1983 and eventually surpassing the 10 million mark, fueled by the singles "Photograph," "Foolin'," and "Rock of Ages." An older kid who lived a couple of houses down from my grandmother let me borrow his cassette until I saved enough money to purchase my own copy. I loved the crosshairs graphic on the cover and played the tape repeatedly in my little portable tape player. When Rick Allen hit the cowbell and played the percussive intro to "Rock of Ages"

during the sound check, I smiled. I vividly remember my grand-mother saying she didn't think it was appropriate for a rock band to appropriate the title of a sacred and beloved hymn.

IN THE AFTERNOON heat as I watched the Def Leppard sound check, I kept adjusting a series of blue-and-white paper wristbands that were getting soaked with sweat. A concertgoer with a wristband was not an unusual sight, as many venues used them to identify legal drinkers. But mine weren't for beer. They were for access to the neonatal intensive care unit at a children's hospital.

Although it took several tries, the in vitro fertilization process finally worked and we were given a package deal. Lara delivered three babies, two months premature but very healthy, all things considered. They would be in the hospital for about a month before coming home. For someone like me who had always reserved that final percentage point, for someone who always avoided going all-in, triplets were the equivalent of a sudden spotlight being directed on an amateur musician in front of a packed audience. I had no choice but to perform.

Over the course of my musical journey, I had realized that guitar heroes don't have a choice either. Like most people who occupy rarified positions in art, business, sports, or other industries, the majority of the guitar players I had met didn't so much choose to play. It was just their reality. They didn't know anything else.

PHIL COLLEN WAS born in the London borough of Hackney in 1957. His father, Ken, was a truck driver and his mother,

Connie, kept house. Money was tight in the Collen household, although the family's only child was largely unaware of their struggles. His parents were loving and supportive and Collen perceived the local decay as perfect playgrounds for a young boy. Recent revitalization efforts have transformed much of the area but it was dramatically different back then.

"I just saw where they built the new Olympic Stadium," Collen said, his British accent softened by almost twenty years of residence in Southern California. He was referring to the £537 million, eighty-thousand-seat venue that will serve as London's centerpiece for the 2012 Olympic Games. "That spot is where I learned to ride my bike. That's where my dad took the training wheels off. I'm going, 'Whoa, shit!' you know? This place was a dumpsite. World War II blitzkrieg wreckage. It was a very rough neighborhood, but when you're growing up, you don't know that. You don't realize it until you move away and you go back and you're, 'Oh my God. Mum, we're moving you out.'"

A culturally hip cousin who collected import records and bootlegs from America introduced the future musician to Jimi Hendrix, Led Zeppelin, Stevie Wonder, and other influential recording artists. That same relative took a fourteen-year-old Collen to a Deep Purple concert. The young kids somehow obtained front-row seats and were mere feet away from Ritchie Blackmore's onstage histrionics.

"Even now, I can't believe that we got that close. He's playing this stuff I'd never heard before then. I loved the sound of the guitar and everything, but when I saw him smashing it, not just the violence but the aggressiveness of the whole thing was really cool I thought. That incident really changed it all. He's the reason I play guitar."

There was an old Spanish acoustic guitar lying around the Collen household but he didn't touch it. Instead, he started playing guitar at sixteen, when his parents went into debt to obtain a red entry-level Gibson SG200 that he still owns to this day. A classmate gave Collen a few tips on the instrument that opened up a vast world of musical possibilities.

"He showed me a barre chord and I realized that you could play this chord anywhere and you could play any song in the world with this one chord, so that was cool."

Deep Purple's "Highway Star" and Hawkwind's "Silver Machine" were early staples of Phil Collen's budding musical repertoire. He spent hours in his bedroom each day, slaving away at the guitar.

The same year that he began practicing the instrument, Collen's parents divorced and he quit school to work in a factory. But he soon ditched the day job to concentrate on music full-time. His first band to attract any level of attention was Girl, a group that featured current L.A. Guns front man Phil Lewis as the vocalist. The group played the British club and small arena circuit, opening up for acts like Ozzy Osbourne, UFO, and others.

Meanwhile, Def Leppard, a group originally formed in Sheffield in the late seventies, had released the albums *On Through the Night* and *High 'n' Dry*. Initially they received a warmer reception in the United States than in their British homeland. They opened for many of the same bands as Girl, but on the North American legs of various world tours. So Collen was friendly with the guys in Leppard and they bumped into each other now and then.

Mainstream fans today who experience the group pairing with country stars like Taylor Swift on CMT's *Crossroads*

show and Tim McGraw on their 2008 recording "Nine Lives," or who listen to their sappy ballads like "Two Steps Behind" would be shocked to know that the band was originally considered part of the so-called New Wave of British Heavy Metal movement that consisted of groups like Saxon, Motörhead, Angel Witch, Witchfynde, Tygers of Pan Tang, and others. The genre was characterized as heavy metal performed with a dash of punk attitude and often featured sword and sorcery lyrics played by pasty-faced youths in blue jeans, patch-covered jackets, and a smattering of leather and studs tossed in for good thrashing measure.

No less a headbanging authority than Metallica's Lars Ulrich is quoted in *Enter Night: A Biography of Metallica* by Mick Wall as saying his teenage "heart and soul were in England with Iron Maiden, Def Leppard, and Diamond Head." It's a shocking reference for a band that would become more known for produced-and-polished-to-the-nth-degree tunes than for cranium-rattling speed and crunch.

In 1982, the band entered the studio to record *Pyromania* with producer Robert John "Mutt" Lange, a hit maker who attracted gossip-page attention many years later when he married, and allegedly betrayed, country music princess Shania Twain. During those recording sessions, Def Lep dismissed their original guitar player, Pete Willis, due to his troubles with alcohol. They asked Collen to contribute solos to the record since the rhythm guitar parts were complete. After coming up with the solo to "Photograph" and impressing the group with his vocal ability, he was asked to join the band and replace Pete Willis permanently.

As a result of Mutt Lange and the group's hyperfocused, methodical approach to music during those recording sessions,

much of *Pyromania* is unrecognizable if you break the songs down into their individual parts. In *Enter Night*, rock writer Wall references Lange's prohibition against musicians using whole chords. Instead, he "insisted guitarists strike one string at a time, over and over again in order for him to build up the sound of the chords himself on computer," Wall writes. Indeed, aspiring guitar players often asked Collen what the chord is for the intro to the single "Photograph" and he laughed. "There isn't one."

Most studio recordings feature overdubs to one degree or another. There might be a couple of rhythm guitar tracks with a particular lick floating on top. Some musicians layer track on top of track in an effort to build an orchestra of guitars. But frequently, these snippets of songs are still recognizable as discrete musical bits if you take them apart. Whereas on *Pyromania*, many of the guitar parts were just chugging noises or sustained wails that don't make any sense at all without the rest of the accompaniment. Driven to the extremes of perfection, the group matured under the producer's tutelage.

"With Mutt, his whole thing is, 'They can be really great but it takes a lot of effort.' It takes a lot more so he'd be pushing it. He really wanted it to be a cross between Queen and AC/DC. But by doing that we actually found our own shtick if you like."

Collen reached new levels of precision while working with Lange. He had initially been attracted to the flamboyant expressiveness of the guitar, so the militaristic focus of Lange was a new approach.

"He has this real amazing built-in rhythm thing and I was just like most rock guys, you know? He corrected that. He said, 'No, no, no, the snare drum!' A lot of guys go before [the beat],

R&B guys go late on purpose. We got it right on the nose. He taught me how to play like that. It's basically calming down without losing the fire. I learned that and it changed everything. All of a sudden, I saw things [messy playing] as being uncool. It was a bit like premature ejaculation. It's the same thing with vibrato. My main thing is controlling the vibrato; don't let it control you."

The concept of maintaining control came into play when Collen quit boozing. As a rule, the boys in Def Leppard were fairly clean-cut by rock-and-roll standards. Certainly they didn't revel in—or brag about—sleaze and hard narcotics like Ratt or Mötley Crüe. Collen attributed the band's restraint to honoring their families and the fans along with a focused work ethic.

"You've got to have a bit of respect," he said. "You don't need to diminish anyone. You don't need to do that and I think with a lot of bands I saw that. We never did, you know? We didn't see the point. To us, the music was obviously a lot more important. We were in the studio for three years. We were going in debt cause we really wanted to put in so much. We wanted to make something that sounded different. The way to do that wasn't just hanging out. I think that was a big difference between us and all the others and the clean-cut-ness came from that, being a bit serious about—as silly and banal as some of the lyrics are, on purpose—there was so much that went into the whole thing. It was really strong and powerful stuff."

In spite of their relatively restrained lifestyles, members of the group did develop a healthy taste for alcohol. In fact, Collen and guitar mate Steve Clark were known as the "Terror Twins" due to their partying ways. But by 1987, Collen was having

alcohol-induced blackouts and during a Parisian celebration for a girlfriend's birthday, he set aside a champagne bottle and didn't finish the beverage.

"I didn't want it at that point," he said. "I didn't want to be in that place and that was it really."

He tried to help his best friend, Clark, find sobriety. Unfortunately it didn't work and Steve Clark died in 1991 from a toxic mixture of codeine, Valium, morphine, and alcohol.

"I'd already stopped and we used to talk about this because with Steve it was like a downward spiral. He just got worse. We would talk; we'd have deep conversations about it. He'd go, 'Oh shit, I don't like being like this.' I would say, 'Well, what are you gonna do? You wanna try the rehab thing?' He said, 'Yeah, cause I'm sick of this.' It's just really unfortunate. Some people can't control it, and especially if there are other issues at hand and there's other things, you know, family issues. You're in a rock band, for a start. Everyone's trying to take advantage of you, from guys hanging out, with girls, everything. You've got all these dynamics kind of hitting you and it's so easy to just be not weak, but to be human. That's really what happened to Steve."

Collen's reference to the girls dynamic immediately made me think of the tales of under-the-stage debauchery that I had heard about. Certainly I wasn't seeing anything like that backstage now. As rock writer Lonn Friend had predicted, the bowels of the amphitheater were more like family fun time than any kind of Caligula scene. Collen's seven-year-old daughter played nearby as we talked. And his new wife, Helen, had met me at the gate and helped me navigate the arena hallways. Tall with a friendly smile, she was welcoming and generous with her time. I didn't want to be rude given the family members

present, but I just had to ask Collen about Def Leppard's dabbling in groupie goodness. For years, I had heard all these stories. Weren't they true?

"We literally just had photos with girls with their tops off and that was it," he said, silver earrings in his left ear waving as he laughed. "Everyone's going, 'You're having orgies under there.' We wish. It was like, no, nothing. It was an urban myth."

An urban myth that I had tried to expose as a teenager.

IN 1987, DEF Leppard brought the *Hysteria* tour to Lexington, Kentucky. My buddy got sick at the last moment and couldn't go. So I had my older brother drop me off at Rupp Arena and I put my plan into action solo.

I had worn black baggy shorts and a black T-shirt, affecting what I thought was a roadie look. I figured that might fool a few people. I had also brought a lanyard from soccer camp and thought that might appease a few more sets of appraising eyes. How closely could they actually examine a backstage pass in the darkness of an arena?

My floor seats were pretty good, and I would have seen a great show had I remained in place. But after the initial flurry of opening songs "Stagefright" and "Rock! Rock! (Till You Drop)" and a couple of new tunes, I eased toward the front-row barriers. Security was much looser back in those days than today, when beefy bouncers line up shoulder-to-shoulder to form a human wall. Hell, some of those concert setups in the eighties actually seemed to encourage fans to jump onstage, particularly hot girls who would cling to the guitar player as roadies dragged them away.

During the quiet, ringing chords of the intro to "Too Late

for Love," I squeezed through a gap in the metal barriers and found myself looking at a wall of metal supports and black draping. About five and a half or six feet high was the lip of the stage. I made sure the lanyard string was visible around my neck but turned the soccer camp logo inward, toward my chest. I briskly walked the perimeter of the stage, trying to hold my head high and act like I belonged. I was looking for some sliver of an opening to that legendary lair beneath the stage. I had no earthly idea *what* I would do if I found one. Clearly this wasn't the most intelligent or practical of capers. I did, however, think this sneak attack was more strategic than trying to infiltrate the usual backstage area that most bands frequented, located in the bowels of the arena. There weren't many ways in and out for that situation. But Leppard's in-the-middle-of-the-arena setup was surrounded by a sea of fans. I figured I could slip back into the crowd to make a getaway.

Like most heavy rock fans of the era, I had read Stephen Davis's *Hammer of the Gods: The Led Zeppelin Saga* multiple times until the binding was falling apart. I was always struck by Richard Cole, the notorious swashbuckling road manager for Zeppelin, who protected his band at all costs while indulging in a fair amount of rock-and-roll fun himself. I imagined that all roadies were like Cole. Rough, quick to fight, but with a playful streak. So I assumed two things would happen to me as I probed the Def Leppard stage perimeter.

One, whoever their version of Richard Cole was would kick my ass.

Two, their version of the mischievous Cole would be impressed by my audacity, clap me on the back, and usher me into a world of backstage, well, *under*stage, excess of girls, alcohol, and forbidden fruits of the rock gods.

Quite frankly, I would have been happy to just have a peek. My girlfriends were usually the well-behaved kind and their parents, and mine, were unerringly strict. Friends always had tales of parents who were away for the weekend, but my folks wouldn't even go to dinner without me, much less leave the city limits. As a result, at that stage in my dating life, I had experienced a set of real-life female breasts exactly twice. So I thought if I could even just get a glimpse into whatever debauchery was going on, that would be a plus.

Suddenly I noticed a pair of sneakers in front of me, at eye level. I looked up and Phil Collen stood directly above my head, dressed in acid-washed jeans and a ripped tank top. He was thin back then, not the fitness god he is today, and pale, not yet having the benefit of California sun. He played a Jackson guitar with a black-and-silver crackle finish, so that it looked like smashed glass. "Too Late for Love" was primarily a vehicle for guitarist Steve Clark, so Collen didn't have a whole lot of spotlight moments. But there he was, and I had spent so many hours listening to his guitar parts over the years that I just froze.

And then they grabbed me.

All in all, the security guards were pretty cool about the whole thing. They walked me through the loading dock of Rupp Arena, flung open a heavy metal door, and pushed me out—no black eyes, no bloody lips.

THAT IN-THE-ROUND STAGE set I had tried to break in to like some ham-fisted jewel thief provided a practical challenge to Def Leppard each night on the *Hysteria* tour: how to get to and from the stage without being seen by fans. The show

began with huge curtains on all sides of the stage and the band pumping out the opening to "Stagefright." After the first verse, the curtains dropped, dramatically revealing the musicians onstage. The effect would have been spoiled if the crowd watched the musicians going through the arena.

So they smuggled themselves out in laundry carts pushed by roadies. And sometimes, pushed by rock royalty.

"One night, Robert Plant pushed us out, me and Sav. First off, he's in disguise, obviously, because he's fucking Robert Plant! And we're just going crazy. We're in this thing going, 'Fuck, Robert Plant.' It was really cool."

Since that time, as the years have passed, Collen moved away from the almost computerlike precision he applied to the instrument, coming back around to a more intuitive and emotional approach.

"Later on, on the *Adrenalize* tour, I used to practice an hour before I went onstage and I got a bit clinical," he said. "I could do all this stuff and then one day I was like, 'Fuck, I'm not gonna do that,' and I enjoyed it so much more from that point onwards. I do now: I start closing my eyes, just hearing it, feeling it, and loving it way more than I did. A lot of people think they know it all but I'm constantly learning. Just this year I had an amazing experience doing the Man Raze [a side project] record where it flowed so easily that it actually felt like we were being channeled. It just had this thing, like I never experienced before. That was pretty cool. It's great to be able to have these new experiences come along still."

Today in concert, Collen spent a great deal of time with his eyes shut, leaning back slightly, right arm dangling in the air as he sustains a note for extended periods of time. It's a

unique pose that he's perfected. You get the feeling that he is completely lost in the moment, like an athlete playing "in the zone." But in spite of how it looked, those moments of unconscious brilliance are rare, even for someone who has played the instrument for decades.

"Guitar playing–wise, I think probably about five times in my life I hit something where it was that," he said. "I've experienced it and it's blown me away a bit. Actually, onstage it happened a couple of times. Once in the house it happened and I was just, I was playing and singing and I was walking around then I said, 'Oh fuck.' I could sing in a range that I don't usually sing in and the notes were right. I was playing and it was like, 'Well, this is really weird, to actually sing like magic,' that freaky weird. I've been onstage a couple of times doing a gig and I'm like, 'This is unbelievable.' Your fingers just go where, you don't think about it. You don't have to look at it. You're just like, breathing and singing, like fucking awesome. You live for those moments."

Athletic analogies are apt when discussing Collen's life and work given his legendary fitness regimen. After giving up alcohol, the musician began exploring healthy lifestyles and workout routines. Today, he's a dedicated vegetarian and practitioner of the combat sport Muay Thai who trains with world champion Jean Carrillo. Videos on the Internet show the guitar player doing fifty waist-high kicks in twenty seconds. He often brought his trainer on the road, to stay in shape in spite of the rigors of touring. The physical fitness achievements do influence his approach to music.

"I used to have asthma as a kid," he said. "I didn't run. I couldn't do all this stuff. Then physically I could do stuff at

fifty-three that I couldn't even dream of doing, like the cardio stuff. It gives you so much confidence and when you actually express yourself and what you're trying to express actually comes out, you get a real confidence. I think there's some insecurities that haunt a lot of guitar players. No one's going to notice if they fuck up because it doesn't matter. It just factors in to every other element of your life, I think, the confidence thing. For me, it changed when I started closing my eyes and stopped practicing."

When I asked for tips on playing, he said to simply enjoy it.

"People take it too seriously and I think you should enjoy it," he said. "I mean, I really enjoy it. I love it. It's great. I meet guitar players who are not enjoying it. They're fucking great players but they've really got a stick up their ass. They're anal retentive because they can't let go. That's the key to it right there, you know? You're going back to Jimi Hendrix. He was like loose. It was like it didn't matter. It was like it's out of tune, but who gives a fuck? Just listen to it. It's freedom. It's total freedom and I think I stumbled upon that."

"If I were going to learn any Def Leppard song, from either *Pyromania* or *Hysteria*, what do you think I should tackle?" I asked.

"It would be the song 'Hysteria,'" he advised. "There's so much to do but it's so simple. There are so many easy chords in it but it's as complex as you want it to be. You can actually just hear it for surface value. If you dig in there, then you go, 'Oh shit, there's this other stuff going on.' There's depth. There's rhythm. There's melody. Just initially, do the surface thing, and that would depend on how far you want to go because you could have all these other things going off as well, if you wanted to."

IN SPITE OF the heat and the fact that the weekend concert was rescheduled for a weeknight, Riverbend was packed when the houselights went down and Def Leppard took the stage. A security guard told me they expected about seventeen thousand fans. Like most eighties rock bands, Leppard suffered a bit during the nineties grunge fascination, but they had reestablished themselves as a solid summer amphitheater act, drawing perfectly healthy audience numbers each night. Part of that was the result of savvy package deals that saw the group tour with other established acts like Journey and Heart. Another part of their continued success came from their understanding that the majority of fans wanted to hear the hits.

"I'm sure you get buried with questions like 'Why don't you play early tracks like 'Wasted' or 'Let It Go' on your tours," I said.

"When we do, it's interesting because half the audience goes to the concession stand," he said. "They want to hear 'Pour Some Sugar On Me' and 'Photograph.' There's a big difference between twenty-five hard-core fans in the audience and twenty thousand or, you know, whatever the ratio is."

Accordingly, to a band that drew such healthy numbers, the group seemed to live a comfortable lifestyle. They may not be flying to gigs in private planes, but their tour buses were nice, backstage catering was nice, they had a good crew, and it seemed they were generally well taken care of. And on a personal level, there aren't stories of vanished fortunes either. Collen, for example, drives an Aston Martin around his Orange County neighborhood. But he still plays with abandon every single night.

As usual, he was shirtless during the concert. His arms seemed bigger than when I had seen him backstage and I wondered if push-ups and maybe some bicep curls were part of his preconcert warm up. He chewed gum and closed his eyes and dropped his right arm as the notes sustained and carried out over the Ohio River. The crowd never sat down. And I finally, after almost a quarter century, got to see a complete Def Leppard show.

20

G·OING· KAMIKAZE

hortly after the Def Leppard concert, I plugged in my Paul Reed Smith SE Custom 24. The guitar builder made his name constructing high-quality—and highly expensive—instruments for Carlos Santana, Sting, jazz virtuoso Al Di Meola, and others. The SE line was their import, more economical line. I like the guitar because it had a wide neck, simple controls, and a translucent-orange finish that allowed the wood grain to show through. It looked, in many respects, like the Jackson Phil Collen signature guitar that sold for almost $3,000.

My amplifier didn't have a setting for the "Hysteria" tone so I manually fiddled with the knobs and struck the strings over and over again until I arrived at a mixture that resembled the echoey, clean tones of Collen and Clark's guitars. I laid the tablature next to me and watched the notations as the song played on my iPod. The song begins with ringing arpeggios layered on top of each other and then later moves into fairly basic chords like D, G, E minor, C, and others.

I stopped the iPod and played the first three notes. They

immediately sounded amazingly good. So I played the pattern over a couple of times. Just the fifth string at the fifth fret, then the fourth string at the fourth fret, then back to the fifth again. It cycles through this three times before you work in the sixth string at the third fret.

Lara was in the room and she set her book down and came over.

"Is that the first time you've tried that?" she asked.

"Yep."

"Wow, that was pretty good."

I tried to play it cool. That's what rockers are supposed to do, right? But inside, I was falling to my knees in full-on guitar hero glory. This was the first time I had ever attempted a song and gotten immediate results. Now, I wasn't ready for rocking arena stages anytime soon. I don't want to overstate the situation. But on my very first attempt, there was a perfectly reasonable reproduction of a tune. It was a huge success for me, and I felt like I should be hanging a gold record on the wall.

I kept playing the opening to "Hysteria" over and over again, tweaking the knobs on the amp to adjust the tones. But my eyes kept drifting up to a spot near the wall where the George Lynch Kamikaze sat on a guitar stand. It was the first guitar I obtained when I began accumulating the instruments of my idols. It's garish red, black, and yellow color scheme evoked a totally different mood than the ballad I was playing, but then again, George Lynch was a different type of player—one that I was going to meet back where this whole journey began, at the Alrosa Villa.

By this point, Henry was off the road full-time, working and settled in the Big Apple.

"Try not to get into any fucking artist and media scraps this time," he laughed when I told him where I was going for the final interview.

I HAD NEVER seen Lynch in concert, either with Dokken, the band that made him famous, or with his other groups, Lynch Mob or Souls of We. I had heard him perform on live concert recordings such as Dokken's 1998 *Beast from the East* and his guitar parts were wild, full of trills and additional tweaks to the tunes. I didn't know if he would do the same thing tonight because this was going to be an unusual show for the guitar player.

He had launched a summer concert tour for Lynch Mob, intending to take out a lineup of vocalist Oni Logan, Robbie Crane (who also performed with Ratt) on bass, and drummer Scot Coogan (who also played with Ace Frehley's band and had been in the Brides of Destruction with Tracii Guns). On the day the tour began, as the group gathered at the airport for their departure, Logan sent a text message that he was quitting the group. The band issued a press comment that stated, "Oni let the band and our fans down. He quit the band at 5:30 a.m. before our 7:30 a.m. scheduled flight. He left us high and dry and did not fulfill his commitment. We are saddened and disappointed—but as a band, we are committed to honoring our obligations." They ended up adding vocalist Chaz West, who had performed with Bonham back in the eighties.

Then, for some undisclosed reason, drummer Coogan dropped out of the Columbus gig. A drummer named Ray Brown was brought in two days before the show to fill out the

band. It was just part of the carousel that is life for many hard rock bands playing on the fringes. "The turnover rate in this band is worse than McDonald's," Lynch later told the *Fox Cities Hub* in an interview. "If you were in Lynch Mob and you were making X amount of money and playing X amount of dates at clubs and you got the call from David Coverdale or Neal Schon and it's double the money, twice the amount of dates, better venues, you get your own room, and travel in a tour bus, what would you do? You've got to do what you've got to do. I get that. I never throw guilt on people when they have to move on, but it's been a running joke that Lynch Mob is a rite of passage before you go on to bigger and better things."

For most of this tour, Lynch Mob was headlining clubs, but tonight, at the Alrosa, they were opening up for Mr. Big, another eighties metal group that had recently reformed.

Behind the venue, parked in a gravel-and-dirt parking lot beside an electrical substation that was enclosed by a chain-link fence was a white Winnebago. Lynch stepped outside the vehicle, leaned an acoustic guitar against the front fender, and chatted with fans in the dissipating summer heat. He wore a gray tank top and light-gray cargo pants, cut off above the ankles. He had on white socks and black sandals. A cigarette dangled from his lips. In the eighties, he was painfully thin, with dark hair that was streaked with blond highlights. Today, his arms were muscular and thick and his hair was dark. He posed for photos with fans who had purchased VIP packages.

The road manager introduced me to Lynch and led us to the back of the Winnebago, to a sort of storage area so we could chat. The rest of the band was in the front section, watching movies on a television. Lynch lit a cigarette and held the

acoustic during our entire conversation, fingers flying up and down the fret board in an absentminded manner.

GEORGE LYNCH WAS born in 1954. His father was a salesman and the family moved a great deal, briefly settling in places like New Haven, Spokane, Auburn, California, and other places. His dad was an audiophile who collected the latest gear and sat the family down in front of equipment ranging from reel-to-reel tape decks to console stereos.

"We had reels and reels of great old jazz music and flamenco music and classical music. I wasn't as much interested in guitar particularly, but just music. Music would run through my head. I would just sort of hear stuff and try to emulate things. Not just on guitar, but whatever I had on hand."

He started focusing on guitar at ten years old. His early instruments included a cheap acoustic guitar with a coconut tree painted on it, a Teisco Del Ray, and then a 1960 Gibson Les Paul Special. While his early interests were in flamenco and classical guitar, he soon discovered the blues. And then the British invasion of the Beatles changed the course of Lynch's musical tastes.

"It was like how a twelve-year-old girl would be affected by Justin Bieber today. That's how the world was with the Beatles. Everyone was infatuated with them. It was fascinating to watch how they evolved. I loved that about bands back then, that they did evolve and change and it was a growing process. Also the fact that rock and roll was in its infancy and nothing had really been tried, so it was a giant experiment."

The budding guitarist was also heavily influenced in the

sixties and early seventies by Jeff Beck, Eric Clapton, Jimmy Page, and Jimi Hendrix. The wildly inventive and diverse sounds of these titans of the instrument captivated and inspired Lynch.

"I was fortunate to be playing guitar in an era where these guitar giants were emerging." Indeed, Lynch says that his signature style evolved by taking bits and pieces of all his idols and morphing them together. He spent hours and hours working on the guitar, but was largely self-taught. There were lessons and teachers along the way, but Lynch always described himself as being "not schooled" in music.

He also spent a large amount of time in the great outdoors, backpacking and hiking throughout mountain trails and desert landscapes.

"I wanted to be Daniel Boone and live in the wilderness like the Indians and build my own log cabin," Lynch remembered. "In my early teens, I would get on my bicycle and go off by myself for weeks and hop freight trains and hitchhike and go to different states. My parents let me do this and I loved being on the road and hanging with hobos and hiking and camping. I just lived off maps and I was fascinated with the space between the roads and that's how I like to equate music, too. It's like the wilderness of the mind. I love the physical wilderness and I love the wilderness of the mind, just the strange place where there are no answers and it's all mysterious."

Those formative years immersed in sixties music also instilled in the guitar player a possibility of changing the world, of tackling important subjects.

"There was an outgrowth of political urgency and things that were happening in the world, specifically the war in Vietnam," he said. "Music spoke to those things and it was really a message, which I thought was very important and which you

don't have much anymore. I don't think rock and roll represents that mind-set as much as it did, so it doesn't have that depth of a very important message and an agent of social change. It was a lot deeper and meant a lot more to me and that's what I grew up thinking rock and roll was all about, so I've become disappointed in how it's become so much part of the status quo now."

His first band was called Tungus Grump and played tunes inspired by Mountain and Black Sabbath. From there, he worked in a band called the Boyz, which segued into a group using the Xciter moniker. During this time, he auditioned for Ozzy Osbourne's band, losing out on the spot to Randy Rhoads. In 1979, vocalist Don Dokken approached Xciter to be a part of his new, self-titled project. The group flew to Europe to record their debut album, a trip that turned out to be a happy accident when one of Lynch's guitars was damaged on a flight to Iceland.

"I didn't have a guitar case, so I wrapped the instrument in a blanket and a bungee cord and put it on the plane. That cracked the finish, which actually looks quite beautiful."

Before the record came out, Lynch tried out for Ozzy's band again, this time to replace Brad Gillis, who had left to concentrate on Night Ranger. The gig eventually went to Jake E. Lee (which, coincidentally opened up a spot in Ratt, who hired Warren DeMartini). Lynch struggled to teach himself how to read music on the trip to the audition.

"I was trying to learn the circle of fifths on the plane, which worked," he said in reference to a music theory technique of figuring out what key a song happens to be in. "I value knowledge and I'm actually insecure about the fact that I've never been able to read music and barely notation. I don't really understand the concept of written music or you know, Western

music in general. When I'm talking to other musicians, I have to fake my way through a lot of stuff and I'm not ashamed of it and I'm not prideful of it. It just is. But I'm constantly trying to learn. I'm buying books and I'm watching DVDs and I ask people questions. To me, it's all a mystery and I kind of like that because I don't know the rules. I don't know what I'm not supposed to do, which I think is a happy accident right there, so I'll go with that. But I don't know scales or modes or anything like that. I'm just hearing things and I'm reacting. That's the simplest way of putting it."

Starting with 1983's *Breaking the Chains*, Dokken released a string of albums, each selling more than the one before it. I believe I discovered that record primarily because Juan Croucier, who I knew from Ratt, played bass on it. Then, starting with 1984's *Tooth and Nail*, I was a hard-core Dokken fan. Captivated by Lynch's fiery solo work, his very full-sounding rhythm guitar, use of muting the strings, and two-hand tapping, I pored over Dokken records and, like many fans, wished Lynch had an opportunity to work with a more heavy, more "serious" band as opposed to being lumped in with hair metal posers.

In 1985, Dokken released *Under Lock and Key*, which featured "In My Dreams." The video to the song mesmerized me and I loved Lynch's Kamikaze guitar and the fact that he actually wore a black leather glove on his right hand during the guitar solo. It was, admittedly, a cheesy video with singer Don Dokken punching the air in time to his lyrics while standing in a downpour of rain and wearing a fringed leather jacket and one of those flat gaucho hats. The images of Lynch aren't much better, including a split screen mirror effect in which two Lynches face each other and play the solo superimposed on clouds in a blue sky.

The corny images in those hair metal videos and the lyrical references to being a prisoner chained by love don't jibe with high-minded ideals about the power of protest music that served as the musical foundation for the guitar player.

"I'm an absolute hypocrite," Lynch said. "It really kind of encapsulates my whole dilemma, the contradiction in my life. My biggest obstacle is really I'm not a singer like Hendrix was and I'm not a really great lyricist. I've never really had that singer that's aligned with me politically and spiritually and all those things. I always knew there was going to be a problem for me and I've actually been working on that all my life trying to bring that back around. I made an attempt in 1992 to write some songs. I wrote 'Cry of the Brave' and 'We Don't Own The World,' which ended up being kind of corny. People laughed about it, but it's hard to write. We can't all be Woody Guthrie."

Media reports back in the day in *Hit Parader* and *Circus* always referred to the constant feuding of Lynch and Dokken. As early as 1986, Don Dokken was quoted as saying, "George and I hate each other. We're not the best of friends." A 1988 issue of *Hit Parader* posed the guitarist and singer back-to-back, holding toy cap guns, duel style. By 1989, the frictions split up the group. The axe slinger formed his own group called Lynch Mob, which released *Wicked Sensation* in 1990. The album was a more complex, intricate affair than Dokken had been but was washed away in the grunge tidal wave. In spite of the flannel movement, Lynch maintained a high profile among guitar players because of his numerous products and gear in the marketplace, most notably those ESP Guitars like the one I owned. All total, he designed eighteen different models over a twenty-year relationship with the company. His name also appeared on amplifiers, pickups, foot pedals, and strings.

At one point, during the grunge apocalypse in the nineties, Lynch relocated to Arizona and began working out. Internet reports were that he had injured his back and began mountain biking and lifting weights as rehabilitation. His changing physique certainly indicated that the guitar player was pouring his heart and soul into pumping iron. Photos at the time show a bulked-up guitarist, whose size seems to overwhelm the instrument. He has since slimmed down, retaining muscle without quite so much mass.

After that, Lynch has performed as a solo artist, with Lynch Mob, with the band Souls of We, and he has periodically participated in a couple of Dokken reunions that never seemed to fully come together. He returned to Southern California and even designed a shed of a studio in the mountains frequently referred to as a "solar studio," where he placed amplifier stacks in canyons against massive boulders to allow the sounds to reverberate through the rocks.

Most recently, in 2010, another reunion was in the works and Don Dokken and George Lynch appeared on VH1's *That Metal Show* together. They claimed the group's friction was nothing more than a publicity stunt. But shortly thereafter, the group fell apart again in conflicting claims and allegations from both Dokken and Lynch. So he was back out on the road with Lynch Mob, applying a blue-collar work ethic to his music. Several months before the Occupy Wall Street movement grabbed national headlines, he used percentages to refer to the people he admired.

"My heroes are guys who get up in the morning and go to work and don't ask for anything," he said. "They barely make a living wage and hopefully have a union behind them so they can support their families and care about their neighbors. You

know, the ninety percenters versus the elite. I'm a working musician, you know. I'm not a rich person. I have a big family. I have six kids, six grandkids, and I love what I do and I can't do anything else because I've been fired from every other job I've ever had. I'm missing my son's birthday because I'm out here for a month and I missed the birth of my sixth grandson because I'm out here. That hurts. But it's how I make a living; it's what I've got to do. And my band is my second family and I love playing with my friends."

As a way of reconciling the conflicting history of hair metal debauchery and a protest music background, the guitar player was also working on a project designed to bring attention to the challenges facing the Native American community.

"I'm doing a movie now called *Shadowtrain*, a band of guys that drive around in an old Jeep with a horse trailer retrofitted to carry our solar panels and generators, camp out, and play on Indian reservations with the Native Americans. I'm doing it with the Documentary Channel and Sundance is involved with it and it's a completely improv band because that's where I come from. All the music we played in the sixties and early seventies, we never had songs. It was all seat of your pants, make shit up right now. People were experiencing the creative moment rather than the re-creative moment, re-creating something you played on a record two years ago or ten years ago, which is dead to me. It's not alive. So that's how I'm resolving these internal issues with myself and doing things I'm passionate about. My parents, my family are very disappointed in me that I haven't done more things. Since I have a small soapbox and fans and people that maybe listen to me, they wish I'd been more vocal."

It was an unusual conversation to end my quest of guitar hero interactions because we actually spoke very little about

the instrument or the music itself. Lynch turned out to have a surprisingly diverse set of interests, not the least of which was an affinity for social activist literature. And I think he was happy that my bookish leanings and the fact that I had no editor-directed agenda for this conversation meant we could chat about other shit besides string gauges and pickup winding.

INSIDE THE VENUE, I was floored to see that the very same cover band that opened for Great White all that time ago was opening for Lynch Mob and Mr. Big. They played the same tunes about as well as before, which was perfectly fine. Although I kept applying guitar hero labels to the folks I met on this journey, most of them actually rejected the term.

I had asked Def Leppard's Phil Collen what riff or lick he would want to be remembered for, what guitar part should go on his tombstone.

"See, I don't think I'd want that," he said. "I think right there that's exactly what I'm talking about, the self-importance, the ego, and the underlying insecurity of a lot of guitar players. It's just about having fun and expressing yourself."

This is exactly what those Columbus, Ohio, cover bands were doing. They were playing guitar, enjoying being onstage, and entertaining an audience.

Unfortunately, Lynch had a hard time expressing himself that evening. His concerts were usually explorations of guitar, based on interacting with his band and seeing where the creative energies took them.

"I throw out a riff; we just go for it," he told me. "We never know what's going to happen and I love flying by the seat of my

pants and making like a high wire. Is he going to fall off? It's the Flying Wallendas."

But Lynch Mob's personnel changes sliced through that high wire like a sushi chef's favorite blade.

The group began with "Breaking the Chains," the title track of Dokken's debut album. From the start, Lynch appeared frustrated. He kept his head down, staring at his tiger-striped guitar, hair hanging down over his face. Several times I was afraid his cigarette would spark up his hair, creating dangerous pyrotechnics to match what he normally achieves on the guitar.

The new drummer, Ray Brown, struggled with keeping the appropriate beat and several times Lynch turned to him, shook his head no, and barked instructions during "Into The Fire." Bass player Robbie Crane, consummate veteran of the metal circuit, took a permanent place next to the drum kit, encouraging and prompting the percussionist.

Lynch's signature tune is an instrumental song called "Mr. Scary" from Dokken's 1987 album *Back for the Attack*. It's a hugely complex song that features so many layered guitars that it's impossible to play as it's recorded in a live setting—even under the best of circumstances. With a new drummer and vocalist, it was a lost cause and the group cut the tune short. The recorded version is four minutes and thirty seconds in length, but Lynch Mob only made it through slightly more than two minutes before sliding into silence and a darkened stage.

It was a tough gig—and not the way I would have preferred to see George Lynch perform. But I knew he would have better nights. And I would have my Kamikaze guitar waiting for me at home. I also would have his advice. Before we wrapped up our chat in the Winnebago, I asked Lynch for some tips. He responded with a big picture prescription.

"I can only tell you what worked for me," he said. "I went out and bought the Jeff Beck Group and Cream and Hendrix and Zeppelin and all that stuff. And I played along to Johnny Winter, all that stuff, and I closed my eyes and pretended I was in the band. Pretended I was playing with Hendrix and what would he think? I would get into that and I know it sounds silly, but when you're a kid and you imagine something, you try to capture the essence and the spirit, not necessarily the licks specifically. Today, people get the tablature and they try to learn the licks verbatim. Don't do it. You don't want to do that. You want to interpret it in your own way and build on the shoulders of your predecessors, like all great things have been a result of, whether it's science or music or anything else."

I wasn't sure that I would be able to develop anything that might be called great, anything that might make my predecessors proud, but I knew I could try. And there wouldn't be any reservations.

Although headlining his own series of club dates, Lynch opened for Mr. Big that particular evening. Most well-known for their 1991 acoustic smash single "To Be with You," the band featured the masterful Paul Gilbert on guitar and Billy Sheehan (who had also performed with Steve Vai over the years) on bass. I had seen the group perform live several times in high school and college. Under normal circumstances, I would have been thrilled to watch this reunion of theirs. But after Lynch completed his set, I exited the Alrosa Villa and headed to my car.

The kids were home from the hospital. And I had to warm up some bottles.

EPILOGUE

I was facing a much smaller crowd than at my previous performance. And the venue was the basement of my home. So quite a bit was different, not the least of which was the fact that I would actually produce noises that could be heard by the human ear.

In the months after my guitar hero quest ended, I continued working on those songs that I had written down after meeting with Steve Vai at Kripalu. And I had, to a certain degree, finally finished them all. I could make my way through the songs in a fairly respectable manner.

My buddy Biggs was in town to visit his family and I told him to bring along his guitar on this trip. He pulled his red semi-hollow-body instrument out of a case and tuned up. I started to pick up my black Telecaster, but paused. I was ready to show off, to attract a bit more attention. So I selected the Warren DeMartini Charvel with a skull on it and plugged in.

Our audience consisted of just one person, my wife, Lara, who smiled and waited patiently. The triplets slept upstairs, far enough away from the guitars—our wireless baby monitor quiet and calm.

We began with the slower tunes "Forever," "The Ballad of Jayne," and "Hysteria" before moving into "Breaking the Law" and "Lay It Down." It wasn't perfect and I had to stop completely a couple of times. But it was good enough. I thought about the miles I had logged traveling to Los Angeles, to Oklahoma, to Massachusetts, to Minnesota, and to other places to meet the musicians who inspired me as a kid and who continued to inspire me as an adult. I felt like I had finally given that last 1 percent, that I had finally gone all-in. And while the kids were quiet now, I knew that my headphones and the guitar heroes would be there to provide a periodic escape during noisy moments of bedlam in the future.

Afterward, Biggs asked me what I was going to focus on now that I had learned those four tunes.

"I've got a library of guitar solos that fill outer space to concentrate on," I said as I lifted the stack of tablature I had printed of Ace Frehley tunes.

"And then, I've gotta touch base with some old bandmates, maybe get the group back together."

ACKNOWLEDGMENTS

First and foremost, I owe a lifelong debt to the guitarists who created the music that I loved so much—not just the axe slingers included in these pages, but also the countless other heroes who changed the course of my life.

You have to deal with a lot of people in order to reach a rock star. Jayne Andrews, Kimm Britton, Liam Collopy, Melissa Dragich, Carol Kaye, Anne Leighton, Lisa Margaroli, Brian Mayes, Jessica Ricci, Lee Runchey, Amy Sciaretto, Ruta Sepetys, Ben Watson, and many others helped set up interviews or provided other assistance. David Fishoff's team at the Rock 'n' Roll Fantasy Camp makes it possible for everyday joes to interact with musical legends. Thank you for your attention and efforts.

I've been tremendously lucky to interact with a huge group of encouraging and supportive writers, editors, booksellers, and publishing industry professionals. Ace Atkins, Anthony Bozza, Ed Champion, Leigh Feldman, David Galef, A. J. Jacobs, John Grisham, Stephen Graham Jones, Shawn Hammond, Richard Howorth, Mike Magnuson, T. R. Pearson, Mark Richard, Monique Sacks, Cynthia Shearer, Dayne Sherman, Pat Walsh,

Dan Wickett, and Marian Young have all assisted me in ways that they may not even know. But I am grateful to them all.

Farley Chase and Cal Morgan both took a chance on this book and I appreciate their faith and guidance. Jennifer Schuster provided expert guidance and support. Paula Cooper's keen eye was much appreciated.

Neil Strauss has been a colleague, a mentor, and a friend. His rock biographies—along with a simple offhanded comment—were the start of this whole nonfiction thing for me.

While my work doesn't even remotely resemble theirs, the late Larry Brown and the late Barry Hannah were both tremendous inspirations in my life and career. Their skill on the page was matched only by their generosity in person and I am honored to have spent time with them.

Some friends have assisted in different ways to certainly earn a tour jacket and a roadie patch. Brian Harman, Dessi Quito, and Amy Sutherland all helped out tremendously.

My partner in crime John Biggs got me back to writing after several years off and was responsible for my first national magazine publication. In addition to being a fine writer and editor, he plays a mean folk guitar.

My wife, Lara, not only stood by but even encouraged these crazy adventures and never once asked me to turn the volume down. She's so cool that she even suggested I hire a stripper to accompany me on some adventures. I owe her a huge debt of gratitude that I'll never be able to repay. Our triplets Parker, Holden, and Harper have taught me a whole new meaning for the word "volume."

And finally, thanks to my parents and brother, who never once questioned my love of loud music.